THE

# LIFE

Guide to

# DIGITAL PHOTOGRAPHY

EVERYTHING YOU NEED TO SHOOT LIKE THE PROS

DEDICATION

This book is for those who went before. To what they saw, and how they saw it. And to the fact that, sometimes at great peril, in impossible conditions, with all odds against them, they shot it well and beautifully, and shared it with us. Their work is the stuff of all our memories.

—Joe McNally

**LIFE Books**
Managing Editor  **Robert Sullivan**
President  **Andrew Blau**
Business Manager  **Roger Adler**
Business Development Manager  **Jeff Burak**
Editorial Operations Manager  **Brian Fellows**
Copy Editors  **Kathleen Berger, Parlan McGaw**

**Book packaged by Moseley Road Inc.**
President  **Sean Moore**
Art Director  **Brian MacMullen**
Editorial Director  **Lisa Purcell**
Editor  **Amber Rose**

**Joe McNally Studio**
Lynn DelMastro
Drew Gurian
Lynda Peckham
Will Foster
Karen Lenz
Mike Grippi
Mike Cali

**Time Home Entertainment**
Publisher  **Richard Fraiman**
General Manager  **Steven Sandonato**
Executive Director, Marketing Services  **Carol Pittard**
Director, Retail & Special Sales  **Tom Mifsud**
Director, New Product Development  **Peter Harper**
Director, Bookazine Development & Marketing  **Laura Adam**
Publishing Director, Brand Marketing  **Joy Butts**
Assistant General Counsel  **Helen Wan**
Book Production Manager  **Suzanne Janso**
Design & Prepress Manager  **Anne-Michelle Gallero**
Brand Manager  **Roshni Patel**

THE

# LIFE
## Guide to
# DIGITAL PHOTOGRAPHY
## EVERYTHING YOU NEED TO SHOOT LIKE THE PROS

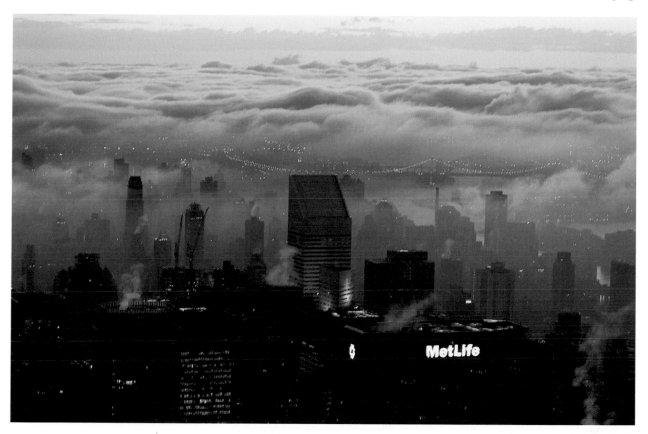

MetLife

By **Joe McNally**, winner of the Alfred Eisenstaedt Award for Magazine Photography

Foreword by **John Loengard**

# CONTENTS

Foreword: The Right Photographer, the Right Guide . . . . . . . . . . . . . . . . 6
Introduction: Welcome to Our Book . . . . . . . . . . . . . . . . . . . . . . . . . . . 8

PART ONE: LIGHT. . . . . . . . . . . . . . . . . . . . . . . . . . . . . . . . . . . . . . . . . .16
Exposure . . . . . . . . . . . . . . . . . . . . . . . . . . . . . . . . . . . . . . . . . . . . . .18
A WALK IN THE EXPOSURE WOODS . . . . . . . . . . . . . . . . . . . . . . . .22
DON'T BE RIGHT ON TIME. . . . . . . . . . . . . . . . . . . . . . . . . . . . . . .27
Components of Light . . . . . . . . . . . . . . . . . . . . . . . . . . . . . . . . . . . .28
RIGHT OR WRONG EXPOSURE? . . . . . . . . . . . . . . . . . . . . . . . . . .34
The Camera's Brain (Pictures à la Mode) . . . . . . . . . . . . . . . . . . . .36
SPECIALTY LIGHT . . . . . . . . . . . . . . . . . . . . . . . . . . . . . . . . . . . .42
Shooting with Low Light. . . . . . . . . . . . . . . . . . . . . . . . . . . . . . . . . .46
PLACES WHERE THERE ARE GOOD PICTURES BUT NO LIGHT . . . . . . . . . . .51
THE ALMOST SILHOUETTE . . . . . . . . . . . . . . . . . . . . . . . . . . . . . .54
Artificial Light. . . . . . . . . . . . . . . . . . . . . . . . . . . . . . . . . . . . . . . . . .58
THEATER LIGHT. . . . . . . . . . . . . . . . . . . . . . . . . . . . . . . . . . . . . .62
Shooting Fireworks . . . . . . . . . . . . . . . . . . . . . . . . . . . . . . . . . . . . .64
Flash! . . . . . . . . . . . . . . . . . . . . . . . . . . . . . . . . . . . . . . . . . . . . . . .68
The Home Studio . . . . . . . . . . . . . . . . . . . . . . . . . . . . . . . . . . . . . .74
THE STUDIO GOES WITH YOU. . . . . . . . . . . . . . . . . . . . . . . . . . . . .78

PART TWO: THE LENS . . . . . . . . . . . . . . . . . . . . . . . . . . . . . . . . . . . . .82
The Eye of the Camera . . . . . . . . . . . . . . . . . . . . . . . . . . . . . . . . . .84
DEPTH OF FIELD . . . . . . . . . . . . . . . . . . . . . . . . . . . . . . . . . . . . .88
Wide Glass. . . . . . . . . . . . . . . . . . . . . . . . . . . . . . . . . . . . . . . . . . .92
YOU DID WHAT? . . . . . . . . . . . . . . . . . . . . . . . . . . . . . . . . . . . . .96
TIGHT SPACES, WIDE GLASS . . . . . . . . . . . . . . . . . . . . . . . . . . . .100
Telephoto. . . . . . . . . . . . . . . . . . . . . . . . . . . . . . . . . . . . . . . . . . .104
DOS AND DON'TS . . . . . . . . . . . . . . . . . . . . . . . . . . . . . . . . . . .110
PORTRAITS AND DOF . . . . . . . . . . . . . . . . . . . . . . . . . . . . . . . .114
Macro Shooting. . . . . . . . . . . . . . . . . . . . . . . . . . . . . . . . . . . . . . .118
SHALLOW DEPTH, DEEP DEPTH . . . . . . . . . . . . . . . . . . . . . . . . . .122
Motion . . . . . . . . . . . . . . . . . . . . . . . . . . . . . . . . . . . . . . . . . . . . .124
TIMING. . . . . . . . . . . . . . . . . . . . . . . . . . . . . . . . . . . . . . . . . . .126

PART THREE: DESIGN ELEMENTS. . . . . . . . . . . . . . . . . . . . . . . . . . . .128
Texture . . . . . . . . . . . . . . . . . . . . . . . . . . . . . . . . . . . . . . . . . . . . .130
TELLING A STORY WITH TEXTURE . . . . . . . . . . . . . . . . . . . . . . . . .134

Pattern . . . . . . . . . . . . . . . . . . . . . . . . . . . . . . . . . . . . . . . . . . . . . . .138
    BREAKING YOUR PATTERN . . . . . . . . . . . . . . . . . . . . . . . . . . . . .142
Light and Form . . . . . . . . . . . . . . . . . . . . . . . . . . . . . . . . . . . . . . . .146
    FROM THE FUTURE . . . . . . . . . . . . . . . . . . . . . . . . . . . . . . . . . . .150

PART FOUR: COLOR . . . . . . . . . . . . . . . . . . . . . . . . . . . . . . . . . . . . . .154
Talking Color . . . . . . . . . . . . . . . . . . . . . . . . . . . . . . . . . . . . . . . . . .156
    POW! ZAP! WHAM! . . . . . . . . . . . . . . . . . . . . . . . . . . . . . . . . . .160
Composition and Color . . . . . . . . . . . . . . . . . . . . . . . . . . . . . . . . . .166
    HOW ABOUT NO COLOR? . . . . . . . . . . . . . . . . . . . . . . . . . . . . .170

PART FIVE: COMPOSITION . . . . . . . . . . . . . . . . . . . . . . . . . . . . . . . .176
Basics of Composition . . . . . . . . . . . . . . . . . . . . . . . . . . . . . . . . . .178
    CHOOSING AN APPROACH . . . . . . . . . . . . . . . . . . . . . . . . . . . .182
Rules of Composition . . . . . . . . . . . . . . . . . . . . . . . . . . . . . . . . . . .184
    THIRDS, WORKING TWO WAYS . . . . . . . . . . . . . . . . . . . . . . . . .190
    SHOOT IT LOOSE! ROCK AND ROLL! . . . . . . . . . . . . . . . . . . . . .192
Pictures within Pictures . . . . . . . . . . . . . . . . . . . . . . . . . . . . . . . . .196
    BULL'S-EYE! . . . . . . . . . . . . . . . . . . . . . . . . . . . . . . . . . . . . . . .199
Play the Angles . . . . . . . . . . . . . . . . . . . . . . . . . . . . . . . . . . . . . . .202
    WIDE COMPOSITION: STAY CLOSE . . . . . . . . . . . . . . . . . . . . . . .206
Portraits . . . . . . . . . . . . . . . . . . . . . . . . . . . . . . . . . . . . . . . . . . . . .210
Take a Piece of the Action . . . . . . . . . . . . . . . . . . . . . . . . . . . . . . .214
Moments . . . . . . . . . . . . . . . . . . . . . . . . . . . . . . . . . . . . . . . . . . . .216
Heroes . . . . . . . . . . . . . . . . . . . . . . . . . . . . . . . . . . . . . . . . . . . . . .218
Show Environment . . . . . . . . . . . . . . . . . . . . . . . . . . . . . . . . . . . . .220
    FIND QUIET MOMENTS . . . . . . . . . . . . . . . . . . . . . . . . . . . . . . .223
Groups . . . . . . . . . . . . . . . . . . . . . . . . . . . . . . . . . . . . . . . . . . . . . .224

PART SIX: JOE'S LAST TIPS . . . . . . . . . . . . . . . . . . . . . . . . . . . . . . .228
Hold Steady . . . . . . . . . . . . . . . . . . . . . . . . . . . . . . . . . . . . . . . . . .230
At Home and Abroad . . . . . . . . . . . . . . . . . . . . . . . . . . . . . . . . . . .233
Joe's Last Tip . . . . . . . . . . . . . . . . . . . . . . . . . . . . . . . . . . . . . . . . .236

Glossary . . . . . . . . . . . . . . . . . . . . . . . . . . . . . . . . . . . . . . . . . . . . .237
Index . . . . . . . . . . . . . . . . . . . . . . . . . . . . . . . . . . . . . . . . . . . . . . .253

# FOREWORD   THE RIGHT PHOTOGRAPHER, THE RIGHT GUIDE

Nearly 75 years ago, four photographers were listed on the masthead of the first issue of LIFE magazine. They, and the technical wizards who followed them on the staff, were quite willing to explain how they took their eye-catching pictures. They felt there was little danger of being copied. "A good photograph is one that can't be repeated," says Harry Benson. What mattered was catching the moment, and each LIFE photographer felt he or she knew how to do that better than anyone else. Joe McNally, the 90th (and last) photographer to join LIFE's staff, brings this benign egoism into the digital age.

McNally is a talented photographer with a wise voice. He once draped movie star Michelle Pfeiffer with diamonds and, on a separate occasion, he talked the U.S. Olympic water polo team into posing naked for a LIFE cover. He writes in a friendly, conversational tone that makes him an ideal choice to pen a guide for the beginning photographer. His pictures speak for themselves.

This is a beautiful book, but McNally's advice is not limited to amateurs. He has never been to the moon. If he were to go, he would point out that, on the near side, we see that the light is the same as on the beach at Malibu or in the Hamptons. Working on the moon's far, dark side is a problem. I'd really like to know what advice he'd offer. He knows from experience what is important in photography and what's just distraction.

With today's digital cameras, photography appears to be as complicated as boiling an egg (which is not quite so simple as you might think, of course—a two-minute egg in Denver being quite different from a two-minute egg in New York City). Indeed, as McNally explains, digital cameras can be used to skirt such problems as focus, color balance and exposure that long bedeviled even the greatest photographers of the past. And we do not have to wait for days to see if the picture came out. There are even little gyroscopes built into lenses to counteract the shakiness of our hands. Those of us who worked with film in the 20th century can only smack our foreheads and exclaim how easy things would have been if we'd had digital way back when. We are free today to concentrate on timing and perspective, on quality of light and composition. All of these topics McNally discusses at the proper length.

Still, I should add a note of caution. "You could have the most modern cameras and not see picture possibilities," the wonderful

John Loengard and Joe McNally, July 2010

LIFE photographer Alfred Eisenstaedt told me when he was
94 years old. "I scc picture possibilities in many things. I could
stay for hours and watch a raindrop. I see pictures all the time.
I think like this."

So does Joe McNally. And you should, too.

JOHN LOENGARD

*Acclaimed photographer John Loengard joined LIFE's staff in 1961
and later became the magazine's seventh picture editor, as well as the
founding picture editor of* People *magazine.*

# INTRODUCTION WELCOME TO OUR BOOK

## THE DEMOCRACY OF DIGITAL

I've been doing this for a long time—I've been living in this world we call *photography* for a long, long time—and I remember a few things from the old days. The olden days. The days of yore.

Photography used to be not for the faint of heart. Its rigors would weed out the not-so-committed pretty quickly. You had to crank the f-stop ring yourself! And you often had to focus lenses that were so slow and dark, it was like peering down a side alley through a dirty window. Then you needed a basement or a bathtub, plumbing, tubes, clamps, drainage, pans, reels, chemicals, red lights, clothespins, special paper and drying racks—just to see what you thought you just shot. Many times, you were wrong about what you thought you'd just shot.

You also needed a good-sized chunk of that amazing thing we always seemed to run out of: time.

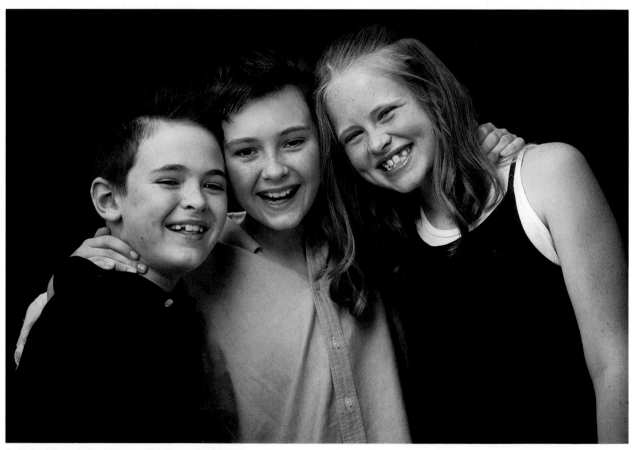

Portrait of three kids, 150mm, 1/250th at f/8, ISO 200

There was a tremendous gulf between the pro and the enthusiast. Ansel Adams rattled around the Southwest with his battered truck and his view camera, which looked like a giant accordion with a lens attached to it. Richard Avedon shot legendary beauties in Manhattan lofts and was therefore worshipped by fashionistas and attended to by legions of assistants. There were these luminaries, these magicians, and then there was pretty much everybody else, punting along with Brownies or Instamatics, making hopeful trips to the drugstore and generally picking up packages filled with disappointment a week or so later.

It all seemed pretty hard, right? And unfair.

Now we live in a place and age I refer to as the Democracy of Digital. Technology has eliminated the basement darkroom and the whole notion of photography as an intense labor of love for obsessives and replaced them with a sense of immediacy and instant gratification. Shoot the picture; look at the picture. Shoot and look, shoot and look. If it doesn't look good, shoot again. And again . . . and again. It's just reusable ones and zeroes now, not frames of film winding around in a cassette, each cassette with a processing price tag.

The result has been like turning a two-lane country road traveled by just a hardy few into a multilane superhighway, with lots and lots of folks driving fancy machines real, real fast—even if they don't have a clue where they're going.

Digital technology has thrown a closed shop wide open, and there are more people out there snapping away than ever before. Some of the pictures are bad, some of them are good and many of them need some seasoning and direction. But the point is, a lot of people are doing photography—there are record numbers of shooters everywhere.

Presumably, if you have this book in your hands, you're one of them. Perhaps you've been at it a while but feel you could take better pictures. Maybe you just got the camera. You found it under the tree or you received it for your birthday or you bought it yourself after much agonizing about which of the myriad models out there might suit your fancy, your visual ambition and your budget.

You found during your research that digital photography is a fast-moving river; you just have to jump in at some point and start swimming. No more waiting to see if a new model is coming out next month. You already know it is, and it will have 20 or 30 million more pixels than the model you bought today. No matter. You now have a camera, which is this miracle device you've been longing for, a tool designed to catch, record and interpret light. To freeze a moment and a memory. And this magical instrument can go with you everywhere.

In our blog-mad, tweeting, Facebooking, Citizen Journalist world, where everybody out there is screaming in one way or another NOTICE *ME!*, this digital camera is not just required of the ardent hobbyist, it is needed by just about everyone. You record, therefore you are. In one way or another—be it in a blog or on Flickr or in an electronic album that you put together for the family and then print—you publish. You share your news with the world. The airwaves no longer belong to networks. The news is no longer gathered and disseminated by the select few. You are the news. You are the editor and publisher of your own life and times. And just like any cranky, old-time newspaper editor with a hole to fill in the Metro section, you need pictures to go with the story.

So, let's make them good pictures, shall we?

## GETTING STARTED

As I said at the top, I've been doing this a long time, but I haven't yet lost so many memory cells that I don't remember way back when. I can still recall those first, awkward, fumbling attempts with a camera that was, in its basic way, far simpler to operate than today's digital marvels—if you choose to employ all the latest bells and whistles. Back then, I would shoot, then curse, knowing I had just missed a moment. Then I would curse some more back in the darkroom when what drifted up to me through the liquid in the tray looked nothing like what my over-reaching mind and imagination had hoped for when I'd clicked.

You know something? I still get frustrated. I still shout at the rain and the sun and the wind when they conspire against my aspirations. When I'm frustrated, I entirely forget the time just last week when the sun and wind and a light rain all worked in concert for me, as if I were a conductor with a baton standing before the natural elements, not a plain ol' photog with a camera.

The simple truth of it is that even the most experienced shooters still miss the moment, still make mistakes—sometimes mistakes so basic that they wonder if there's ever any way to really and reliably learn this art and craft.

In this way, digital photography is no different from old-time photography. Good pictures are good pictures; you make some, you miss some. Not all of the photographs on the following pages were shot digitally, but those that weren't were selected because they could have been. Digital has changed the game, to be sure, but as in sports, the same rule applies eternally: The one who performs best—the one with the most points—wins. Whether we're talking football or tennis or photography, you play the game the right way, you win. I hope some of the info and tips that follow allow you to win more than you lose.

It's an unfortunate truth that the magic box you just feverishly unpacked is a machine designed to do two things—make pictures and drive you mad. But here's the thing: If you didn't

Two boats,
50mm, 1/2500th
at f/1.4, ISO 200

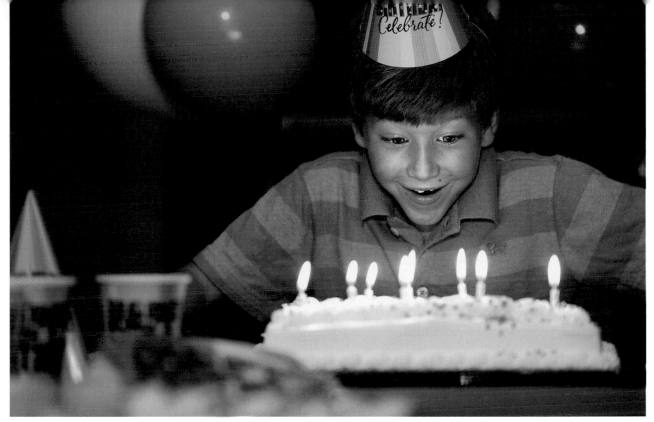

Birthday party, 125mm, 1/60th at f/2.8, ISO 800

care, you wouldn't get upset, right? If you weren't passionate and determined about all of this, you would just put your camera down like yesterday's newspaper. But you can't, just like I can't, all these years downstream.

Remember this: Good pictures demand care, and truly good pictures are hard to make. The manufacturers are out there selling us the digital dream, telling us that the camera does it all. And some of these machines almost do; they are marvelous contraptions. But no matter how fancy the gear, photography itself, at the end of the day, rules. Just like Mother Nature, the photo gods are mercurial indeed and smile upon us only occasionally and reluctantly.

So relax. You will make mistakes! As someone much smarter than I once said, "Failure is a form of progress." He must have been thinking about photography.

Do these things first:

- Take the camera out of the box and attach the shoulder strap. I generally put a little bit of gaffer tape (not duct tape, but photographer's gaffer tape) around the tails of the strap so they don't flap around and slip.
- Fully charge the battery. It usually comes from the manufacturer only partially loaded.
- Don't read the manual right away. You'll either get discouraged or fall asleep.
- Most cameras come with a "quick guide" designed to get you taking pictures right away. Do read that.
- Make sure you have either the cord to connect the camera directly to your computer or some sort of card reader by which you can pull your images off the card and onto your desktop.
- Make sure you have some sort of browsing software so you can take a look at the pictures. Many digital cameras come with viewing software bundled with the hardware. If yours doesn't, there are many, many fairly simple, not-too-expensive viewing programs out there.

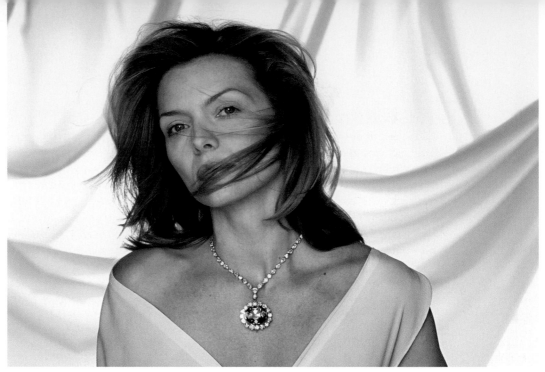

Michelle Pfeiffer wearing the Hope Diamond, 150mm, 1/250th at f/8, ISO 100

• Then, put the camera on P. It stands for "program," but it is also jokingly referred to as "perfect" or "professional." No matter. In this mode, you let the camera drive, and for your first few spins, that's a good strategy. Most of these cameras have such a high level of technology and sophistication that they will sort things out for you very well, without you expending any thought (or sweat) whatsoever. This allows you to . . .

Have fun! Picture-making can be hard to do, yes, but it shouldn't be in any way miserable. Shoot pictures. Look at the hits, near misses and complete disasters. Make some more of them. Get used to the feel of the camera.

Many cameras now come with a "kit" lens, a reasonably decent, all-purpose zoom that goes pretty wide to sorta telephoto. Work both ends of the lens, and see what the wide view and telephoto view can do for you. Start thinking about when it might be suitable to use one or the other.

Put yourself in different situations: bright sun, interiors, birthday parties, on the sidelines of ball games. See how the camera handles all this nutty stuff you see out there, the stuff that constitutes your world. Continue to shoot; take lots of pictures. Remember, you don't have to run to the drugstore to develop these. No pixels have to die! If something is intriguing enough to make you lift your camera to your eye, then it is worth making 50 pictures of it, not just 5. Shoot! You will only get better at this after you do it repeatedly. Many folks have asked me over the years how I got to be a LIFE photographer—how I got to be a guy who actually gets Michelle Pfeiffer to pose for his camera. The question always reminds me of that old joke about the lost tourist in Manhattan asking a New Yorker, "How do I get to Carnegie Hall?"

Reply? "Practice!"

After shooting many, many pictures on P, you upload them to your computer and find yourself with a bunch of thumbnails in front of you on your screen. Look at them. Which ones move your head and your heart? Which are utterly without redeeming content? Which are in between?

Now, after this process, your compass has been set. To a degree. Now's the time to read the manual. Or read this book. It's a lot less boring than the manual.

## A FEW THINGS TO KNOW RIGHT OFF THE BAT

There won't be a test at the end of this book, but there are some photography basics and terms that you should know as you navigate your way through it. Yes, there's a glossary in the back—of course there is—and some of these intro concepts will be covered back there, too. But these items are good to get under your belt now. I've listed below the barest few concepts and technical terms. Come on back here if you need a little memory refresher as you travel through the pages that follow.

First we have the word **aperture**. This is an adjustable, circular opening inside the lens that regulates how much light goes through the lens and hits the sensor. It's basically a hole in the lens that you can control by making it bigger or smaller. Small hole, very little light gets to the sensor. Big hole, and the lens becomes like an open water main with light pouring through it. This is your light spigot.

And now let's explain **exposure**. This is the end of, and extension of, the aperture equation. This is how much light hits the sensor, and for how long (two things you have control over). You'll hear the terms "bad exposure" and "good exposure" all the time. You'll hear "underexposed" and "overexposed" as long as you shoot. With practice, you will produce more good than bad, fewer overs and unders.

Generally, the exposure is described by the time it took to make the picture, plus the amount of light you were allowing in. For example, you'd say, "I shot that at 1/60th at f/5.6 and ISO 400."

What?!

Okay: The 1/60th is 1/60th of a second. This is the **shutter speed**—easily understood as the duration of the exposure. Fast speeds are usually 1/250th of a second on up to 1/8000th of a second, and these fast shutter speeds are generally used in bright conditions. Darker environments demand slower shutter speeds, ranging down from 1/30th of a second or so all the way to 8 or 10 seconds, depending on subject matter. Shutter speed is a critical issue because it will directly affect how sharp your photos are. The slower the shutter, the greater the chance of camera shake. Shooting sharp at slow shutter speeds requires practice, a steady hand and, sometimes, a tripod.

The f/5.6 in the notation above brings us to **f-stops** (or **f-numbers**). These define how wide your aperture is open or closed. They are the clicks on your camera's aperture dial. Among the most common are f/2.8, f/4, f/5.6, f/8, f/11 and f/16. These are "full" stops of light. Each f-stop number is 1.4 times larger than the one preceding it, and each full click from one stop to the next either doubles the light going through the lens or cuts it in half, depending on which way you are clicking. The smaller numbers, somewhat counterintuitively, denote the larger lens openings. Conversely, the larger the f-number, the smaller the lens opening. Go figure. Here's a handy alliteration I once heard to remember this formula: Large (numbers), less light. LLL!

Now what was that last thing: **ISO**? This refers to the sensitivity of the chip, or sensor, and expresses in numeric fashion the "speed" at which the sensor will accept light. High ISO numbers, such as 1600, will enable photography in low-light conditions. In bright sun, ISO 100 or 200 is plenty. "ISO" comes from the International Organization for Standardization. This organization defines how these standards are determined.

The last term I would like to touch on here before we march forth is **white balance**. Light has color, and different lights have different colors. Daylight has different color casts, depending on time of day and atmospheric conditions. Fluorescent and tungsten, or incandescent, bulbs give off shades of green and yellow, respectively. Digital cameras can compensate for these different colors, and you can adjust for them on the fly with a flick of a button.

There's a world of weird color out there; you have to sort it out at the lens, and program your camera accordingly.

City street at dusk, 600mm, 1/30th at f/11, ISO 800

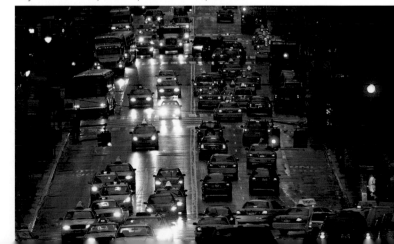

## THE BEST WAY TO USE THIS BOOK

Well, it's not *War and Peace*. And I hope it's not *Crime and Punishment*. So you don't have to read it front to back, although you certainly could.

It's a guide, which is to say it's got a lot of how-tos, a bunch of pictures to illustrate my points and a ton of tips. It has a glossary, as we've mentioned, and an index, and you can and should refer to them regularly when your memory of a particular term falters, or when you want to zoom in on "zoom lenses." I have tried to structure the book so that it eases you into photography: Here's how to expose a picture correctly; here's how to work your lenses; and now, here's how to get a little fancy. But life in the world of photography does not always proceed in a linear fashion, and so you might want some guidance on composition, which is way back in Part Five, even before you want to start goofing around with exotic lenses. Perfectly okay, and please do skip around. As you'll see in the pages that follow, I'm not big on rules.

Still, it's prudent to build a foundation when approaching anything new. Here's a not-so-sneak preview of what's coming up.

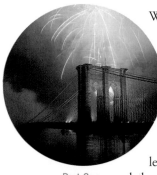

**Part One:**
**Light**

We deal first with light—what's good light, what's bad light and is there a way to turn bad light into good light. (There sure is!) The stars of Part One, as pertains to your camera, are what I call the holy trinity of an exposure: aperture (how wide or how closed or small), shutter speed (how fast or slow it should be) and ISO. We will learn, in this part of the book, how to balance this triumvirate of adjustable factors to allow just the right amount of light in for just the right period of time. There are many things that you could describe as the be-all and end-all of photography, including composition or color (or lack thereof). But for most of us, the be-all and end-all is light and the ability to use it to make a good, sharp exposure. And so we begin here.

**Part Two:**
**The Lens**

In Part Two we look at—and through—the eye of the camera, the lens. This is the instrument that drinks in not only light but the subject matter as well, and sends this information on to the camera's sensor. First off, we'll discuss depth of field—what's in focus where (in the background or foreground or both) and why you might want one effect or another, and how to achieve it. Then we start playing with toys: wide–angles, zooms, telephotos. I think you'll be interested to see how each lens pertains not only to the kind of photography you might guess it pertains to—this kind of lens is for macro shooting, and that one's for when you're far away—but can also produce many different results in a variety of situations. As I said, these are toys. It's fun to play around.

**Part Three:**
**Design Elements**

In Part Three, Design Elements, I'm going to ask you to look hard at what's in the lens. You don't want to just line things up; you don't want to just focus, click and record. You want to produce an interesting, entertaining picture—even if it's just of little Julie blowing out the candles. What are the textures in the image, and how might you choose the right one to emphasize? What patterns do you see, and could this triangular shape in the left half direct the viewer to the precise spot you want him or her to focus on? Don't worry, this isn't geometry class. Design elements are more fun than that.

**Part Four:**
**Color**

Part Four is one I'm partial to: Color. I'm a color guy, as you'll learn. I do appreciate and occasionally choose black-and-white because it inarguably possesses unique qualities that convey, in photography, certain moods and emotions. We'll surely discuss all that, and I hope that I can hint at when black-and-white may be, sometimes surprisingly, the way to go. But I'm no B&W aesthete. I like gaudy color

and subtle color, muted color and mad color. The capturing and employment of color is, of course, an adjunct to how we deal with light. By Part Four, we'll know how to handle that. So let's get colorful.

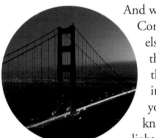

Part Five:
Composition

And we next arrive at Part Five, Composition. If something else hadn't already claimed the be-all and end-all title, this surely would. This is it, isn't it? This is where you play the painter. You know what expressions of light and color are appropriate for this picture, and now comes the big question: What do you include in your canvas?

A quick note here: So far, we've been talking about f-stops and ISOs and all these ways to take good pictures with a digital rig that you can play around with—and that *is* what our book is going to be mostly about. But we're not going to ignore you point-and-shoot and cell-phone photogs in these pages. Anytime you look in a viewfinder (*any* viewfinder), you can take your best shot or your second-best shot. The choice is yours. When I talk about composition, I'm talking to all of you.

Now, then: Here we discuss the famous Rule of Thirds, which allows you, every time you put the camera to your eye, to situate that rectangular view perfectly to draw the viewer's eye whither you will. You divide the field into sections, think things through and then put your subject in an interesting place—often not the center, although sometimes the center—and then and only then, click! Lenses come into play again—this might be cool from a wide angle, this could be cool up close—and we talk about all sorts of portraiture: classic, environmental, group. Your kid's peewee soccer team is a portrait, not just a snap, and you can make it a better one by taking 20 additional seconds to arrange the kids and consider what's in your viewfinder before you press that shutter. Compose yourself, compose the picture.

Part Six:
Joe's Last Tips

Part Six of the book might easily have been Part One because it's just some last hints and tips that could have been first hints and tips: how to hold the camera, how to walk with a camera, et cetera. You'll find your own way, I'm sure—maybe you already have—but these suggestions are what's worked for me. I think they might help you. If not, forget we ever talked.

One last thing about this particular guide (which is another way of saying "as opposed to the hundred other guides out there"): In each of these sections of the book, you're going to see, first, pages with a white background, and then pages drenched in gray. It might not be obvious, but the former have the nut and bolts and the how-tos, and the latter have the experiential stuff (plus some more useful how-tos). The editors of LIFE, enablers that they are, have encouraged me to draw on what some would call "my years of experience" and try to get you not only better at photography, but also psyched about it. They've heard my war stories over and over, and they felt it was about time I inflicted them on someone else.

And so I have. That someone else is you.

But I've selectively chosen the stories, and I hope each one inspires you to think about another way, another approach—or, even, an instance when you simply have to play within the rules. That happens, too.

I hope what comes through in all of these stories, or at least in the sum of them, is that I've had fun along the winding way that has been my journey through the world of photography. That's what I wish for you above all else as you unwrap that package and open the box with the gleaming toy inside. Smile first, then withdraw the camera, lift it to your eye, and prepare to . . .

Have fun!

PART **ONE:**
[LIGHT]

# EXPOSURE

WHEN YOU TAKE A PICTURE, YOU CAN SAY you just took a "shot," or a "frame," or an "exposure." All of those expressions are true, perhaps none more true than the term *exposure*. When you go *click*, what you are doing is exposing photosensitive material (used to be film, now it's pixels) to light. The light transits the lens of the camera to the sensor via the aperture, which has already been discussed in our introduction as a hole of varying size in the lens. (This hole is also referred to as a diaphragm.)

How much light hits that sensor is regulated by the size of the aperture and the length of time the sensor is seeing light. That very crucial timing factor is regulated by the camera's shutter, which will stay open for a very brief or quite long period of time. Exactly how long or short that gateway to the sensor is open is called "shutter speed."

We're not quite done. A third factor is always present in the making of an exposure: ISO speed (the initials come from the International Organization for Standardization, as we've learned). The ISO, to reiterate, refers to the camera's sensitivity to light. Predictably, the higher the ISO number, the more sensitive the camera's pixels will be and the less light is needed to take the

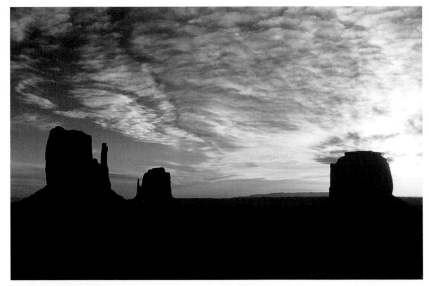

Monument Valley, Utah, 28mm, 1/15th at f/11, ISO 100

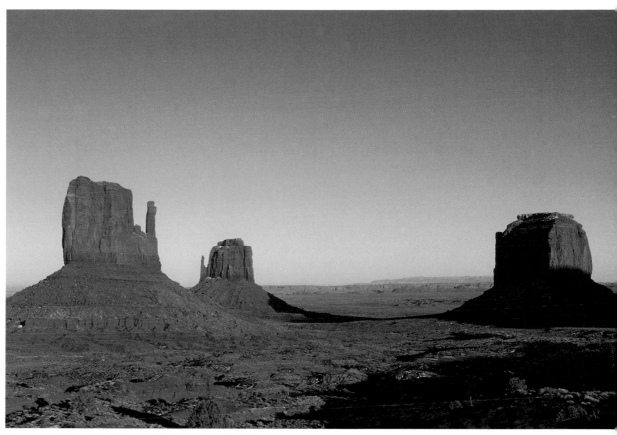

Monument Valley, Utah, 28mm, 1/125th at f/11, ISO 100

picture. A lower ISO number means less sensitivity, which trans-
lates into the need to operate in brighter conditions.

There you have it: The holy trinity of any exposure—aperture,
shutter speed and ISO. These factors have been in play, in concert,
ever since 1826, when Nicéphore Niépce poked a camera obscura
out of the window of his workroom in the French countryside and
made an eight-hour exposure, generally recognized as the first
photo. Niépce's aperture was a hole in a box, and his pixels a pewter
plate covered with bitumen. He let sunlight pour onto it for all that
time because he rightly guessed that his "film" had a very low ISO.

Now we have cameras that do all these things for us, automati-
cally. Set the camera on program mode, or P, and let the machine
decide. Most of the higher-end digital cameras out there today
decide relatively correctly, at least some of the time, what to do. So
why bother knowing all this stuff?

Because we humans can do better. Understanding ISO is crucial for any photographer because the camera is a machine without a scintilla of artistic intent or taste. It renders an exposure based on how its mechanical programming reacts to what the lens sees. When confronted with an average scene with even illumination, a camera will most likely perform quite admirably. Stress it a little bit by introducing extremes of either amount or direction of light, and, oh my, that fancy pixel machine can get downright befuddled—and rather quickly.

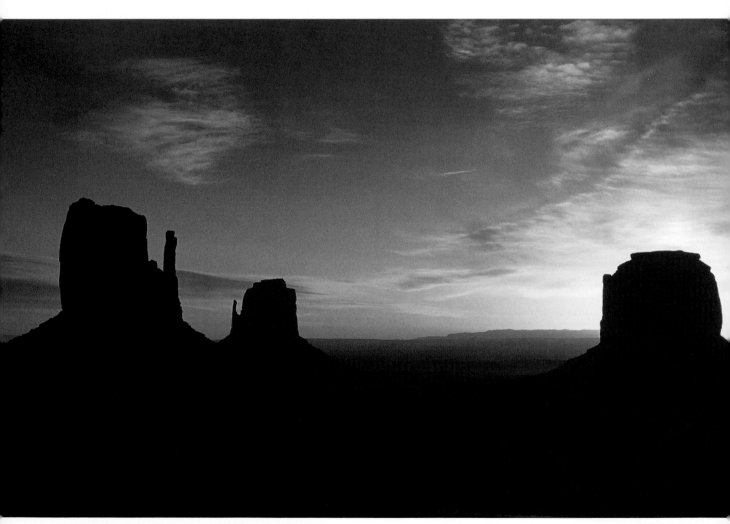

Monument Valley, Utah, 28mm, 1/10th at f/11, ISO 100

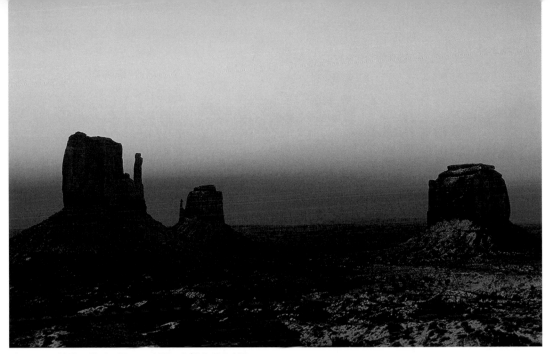

Monument Valley, Utah, 28mm, 1/4th at f/11, ISO 100

Put the camera on P mode, for instance, and stand Grandma in front of a brightly lit window and shoot her picture while facing the lens toward the window. The camera reacts to the sunlit window, exposing accordingly. Bye-bye, Grandma! The photo might work if she has a very interesting silhouette, because that's all you're going to get.

Likewise, imagine a scene where your daughter, who has a beautiful voice, is singing a solo onstage. A bright spotlight bathes her in a luminous glow, while the rest of the stage dims to utter blackness. With only a limited zoom lens, from your seat in row four, your daughter is a tiny piece of the scene. Most of what the camera sees is the black stage. Again, bye-bye. The camera reacts to all that darkness and opens up the exposure. Your poor kid ends up as burnt pixels, glowing and unrecognizable—even to you.

Look at these four pictures of Monument Valley, Utah, above and on the preceding three pages. They are exposed for various effects: to capture the sky and throw the buttes into silhouette, or to show detail of the rock and let the sky lose vibrancy—the holy trinity at play. Same place, same rocks. But different light, different exposure, and—most important—different moods and emotions.

Here's the deal: Think of the camera as a very expensive blender. It takes in everything it sees, dumps it into its computerized brain and spits back to you what *it* thinks is the right exposure. Call it an educated guess. That's why you have to learn how to control exposure yourself. You don't want to feel like you're spinning a roulette wheel every time you pick up a camera. Read on.

# [A WALK IN THE EXPOSURE WOODS]

S ling the camera over your shoulder and take a walk with me. Not a walk, really, more of a meander. It is the kind of thing you do with a camera. Walk slowly. Follow light or perhaps color or human activity. No agenda except the next frame, out there, waiting to be captured by your camera.

   If it turns out to be "the" frame, the keeper, the one you've been waiting for, you don't want to miss it. And you don't want to blow your exposure when you shoot it. The keeper photos are hard to find. They come along only once in a while. Do you really want to blindly trust this machine to get them for you?

   No. That's why you have to learn about the basics of exposure. When you get them under your belt (and trust me, this is not hard), you will be driving the train. The camera will not be driving you.

   So—take a deep breath first—move the mode dial off P to M. Okay. As Obi Wan said to young Luke Skywalker, "You've just taken your first steps into a larger world." *M* stands for "manual," and it is the mode in which you are in control of all of the elements of the exposure—ISO, shutter speed and aperture.

   We're outside, so set your ISO to a reasonable number, say 200—even on a relatively cloudy day, ISO ratings around 200 to 400 will give you a good crack at an optimal f-stop/ shutter speed combination. Now set your f-stop. Nothing wide open, nothing too closed. A setting of f/5.6 or f/8 would be a reasonable place to start. Now crank your shutter speed dial until the exposure markers (they differ from camera system to camera system) line up in the viewfinder. When the hash marks indicate 0, right in the middle, it means the camera meter is judging this combination of settings to be an accurate exposure.

## DO THIS FIRST

To make a manual exposure, you need to set the aperture, shutter speed and ISO yourself. Become familiar with how to set those on your camera. You will want to take a look at your camera's manual to become acquainted.

**"The keeper photos are hard to find. They come along only once in a while. Do you really want to blindly trust this machine to get them for you?"**

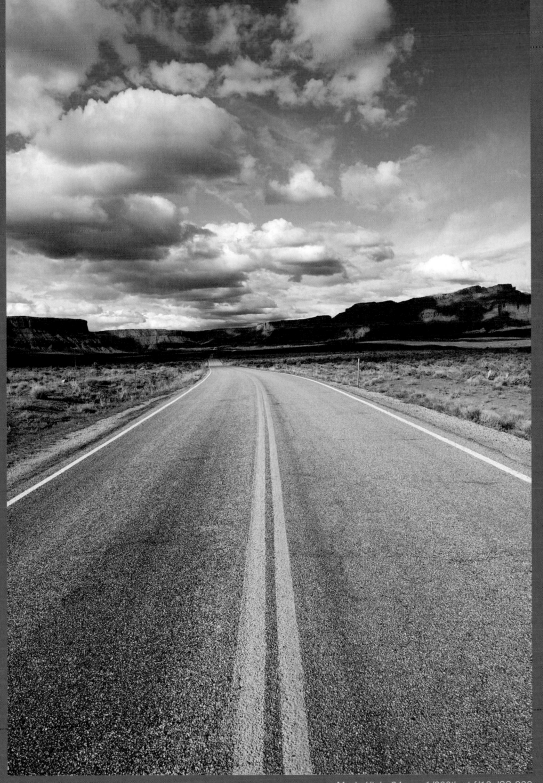

Moab, Utah, 24mm, 1/800th at f/10, ISO 200

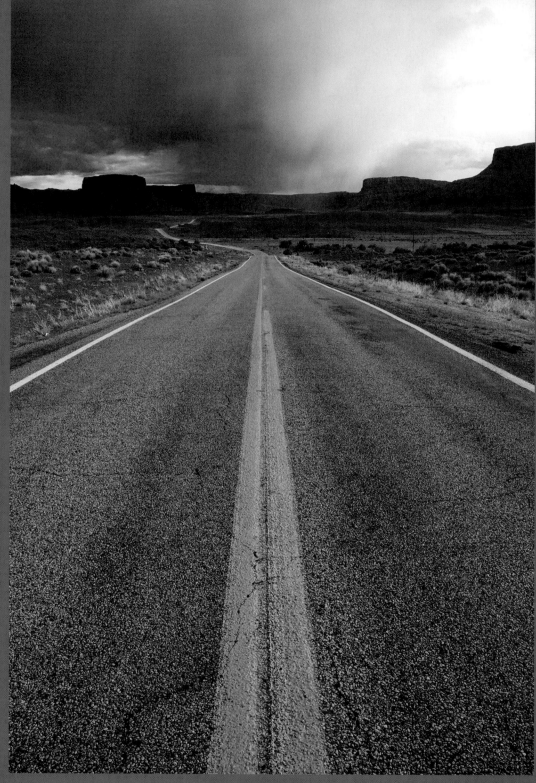

Moab, Utah, 24mm, 1/50th at f/11, ISO 200

Go *click*. You've just made an accurate, manual exposure. Say it was 1/125th of a second at f/8. Okay, close the aperture ring down one full stop to f/11. A setting of f/11 provides a smaller opening than f/8, so the shutter speed has to get slower to accommodate the loss of light f/11 represents. It has to get slower by one full shutter speed. In other words, it now needs to be set at 1/60th.

Rome wasn't built in a day, and likewise your familiarity with a digital camera will take time. But these elements of exposure—aperture, shutter speed and  ISO—will be with you every step of the way. Experiment! Put an accommodating friend or your ever-patient spouse in front of the lens, and see where these manual combinations lead you. Then compare them to what the P mode would do in the same situation. There will be overlap—but there will also be differences. When you become familiar with the conditions that produce those differences, you will start to really understand the camera's brain and how it behaves in different lighting situations.

And then you will be able to outthink it.

## JOE'S TIP

To make a manual exposure on a digital single-lens reflex (DSLR) camera, you need to know the following things about your model:

CHECKLIST ☑:

☐ Set the aperture, shutter speed and ISO. In manual mode, which is where you want to play around to learn camera basics, the camera won't help you with this. You control everything—each setting in concert with the other two—through the magic of buttons or dials or menus. You create the right balance—the balance that's right for *you*.

☐ Knowing what a correct exposure looks like before you actually make one is now up to you, but your camera can help you, even in manual mode. There are hash marks in the viewfinder (on the right-hand side or at the bottom edge of the frame, depending upon model) and an indicator that points to under- or overexposure. If you get that indicator to settle in the middle, the camera is agreeing with you that you've found a good exposure.

☐ Just because the camera indicates agreement doesn't mean it's the "right" exposure. The scene may in fact call for under- or overexposure for effect, and you can program this yourself. Here we have a theme that will be repeated throughout this book: Experiment. Find your own vision.

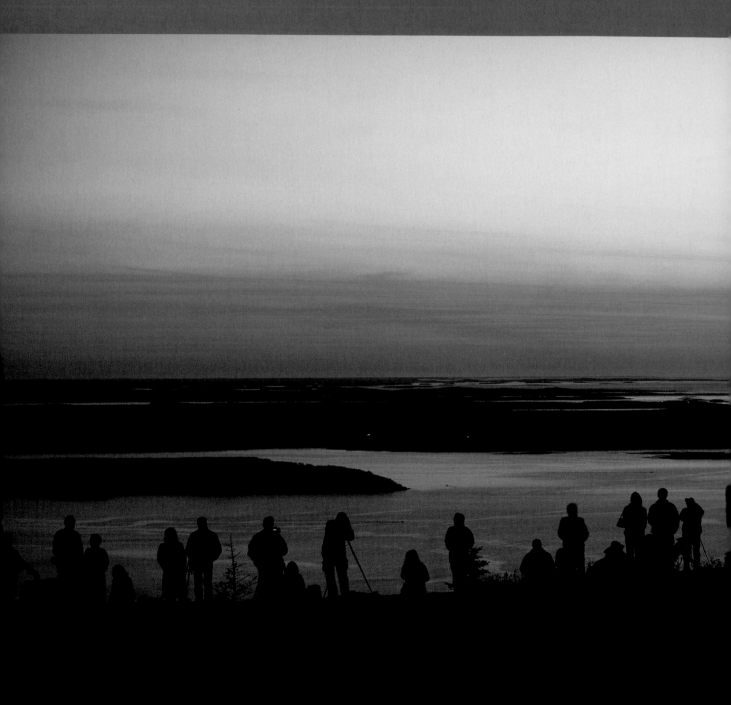

Photographers at sunrise, Maine, 70mm, 1/13th at f/5.6, ISO 200

"Don't get up to meet the dawn. Get there well before the sun rises. And don't close up shop when the sun disappears."

# [DON'T BE RIGHT ON TIME]

As soon as that sun hits the horizon, you can hear the sounds of lens caps everywhere snapping back on the glass, tripods collapsing and photo backpacks zipping up. Sun's gone, time to go eat dinner, just like the normal people.

Or, the weatherman says sunrise is 6:20 a.m. tomorrow. Okay, I'll set my alarm for 6:00 a.m. and stumble out the door just in time to meet our golden orb at the horizon line.

At a screening of *The Bridges of Madison County* held at the National Geographic Society, there was, quite logically, a considerable sprinkling of *Nat Geo* shooters in the audience, a number of them no doubt each thinking that he was about to watch a movie about himself. There's a scene in which the photographer, played by Clint Eastwood, driving a suitably battered pickup, is tooling along in absolutely gorgeous dawn light, presumably arriving to shoot the glory of the early morning.

Spontaneously, collectively, the real photogs in the audience called out in a unified voice: "Too late!"

How true. Don't get up to meet the dawn. Get there well before the sun rises. Don't close up shop when the sun disappears. Some really great light occurs just when you think there is none.

## DO THIS FIRST

Scout your location ahead of time. Good photography is about many things, including planning. Just as an athlete does, visualize your play, then go back and execute it when the light is just right.

## JOE'S TIP

The best way to get the golden light at sunrise or sunset is to remember the following:

CHECKLIST ☑:

☐ There are luxury items out there to help you with this. There are portable GPS software applications that you can program to your phone that tell you not only the exact time of the sunrise but also its precise location on the horizon. Now then: Take in that info, and get there *earlier*.

☐ If you want to capture the sun setting, set up before the twilight comes. Also, stay a little later and you may catch a beautiful sky that you didn't expect.

☐ As twilight deepens, your shutter speeds will get very long, which will require a sturdy tripod (or nerves of steel).

# COMPONENTS OF LIGHT

THE BIG THREE OF LIGHT ARE QUALITY, COLOR AND DIRECTION. These three things are components of any light you may see. Think of all the adjectives used to describe light—*bright, harsh, soft, pale, dim. Backlight. Frontlight. Sidelight. Low light. Warm, cool.* Not to mention *slashing, angled, hard, sumptuous, rich, hot, beautiful, contrasty, smoky, blazing, big, bounced, shaded . . .*

You could fill a romance novel!

The real reason we talk of light in such ornate language is the very fact that for us, as photographers, light *is* language. It's how we, well, tell stories. It's how we flatter our subjects—or not. It has all the flavors of those words above: tone, inflection, color, emotion. You can make someone look like an angel, or look like the devil, depending on the light you use.

## THE QUALITY, COLOR AND DIRECTION OF LIGHT

To speak effectively in this language, you need to know how to recognize the big three—and learn how to manipulate them.

First up: the quality of light. Is it soft or hard? Does it create harsh shadows, or does it drape easily on the scene? What kind of light works best for what you are trying to shoot? There are times of the day—for example, high noon on a sunny day—when the light is so unforgiving that it is generally advisable to beat a hasty retreat indoors or under trees or beneath the shadows of buildings. There you can find the beaming sun filtered or tamed and you can work with it, carefully (more on this later). There are other times, say, sunset, when the light is so beautiful you stay out as long as possible, and you literally can't click the shutter fast enough.

Light has color. The sunrise and sunset times of day are often referred to as "golden hours," for their warm, richly beautiful glow. As the day progresses, color drains from the light, and the high, hard daylight relentlessly bleaches the richness of color away. If cloud cover comes in, the light filtering through those clouds turns cooler. But the very softness of the cloudy daylight allows the colors out there on the street to return, rendering them rich and saturated.

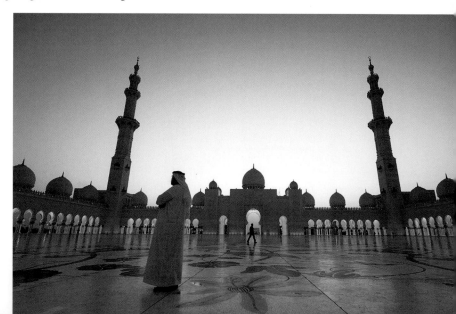

Mosque in Abu Dhabi at dawn,
19mm, 1/25th at f/5.6, ISO 200

Light also picks up the color of what it hits. Light bouncing back off a red barn will be distinctly ruddy. Hard daylight pouring in a kitchen window and ricocheting off a natural wood floor will fill the room with a warm, yellow glow.

And what about cityscapes at night? Fuhgeddaboudit! There's fluorescent, tungsten, mercury and sodium vapor—all of them vying for the title of "most obnoxious." These lights end up in the sickly yellow-green part of the spectrum.

Later in this book, we'll get around to programming camera white balance in response to all these teeming color possibilities. For now, just remember that it's essential to watch the light and discern its color.

Finally, light has direction. This is the easy one to spot. Where's the light coming from? Which way do the shadows fall? Are there shadows at all, or is the quality of light so diffuse and soft that they have disappeared? Direction of light teams up with quality and color to hand you, the shooter, either sublime opportunities or a problem to solve. Let's take a look at some examples.

## SOFT LIGHT

Soft, cloudy daylight graces this New Delhi street with a lovely quality that lets colors speak. Faces remain open, unhidden by the shadows that strong sunlight would produce. This is perfect street-shooting light, if you are looking to do informal portraits or details. Soft light is easy light to work in.

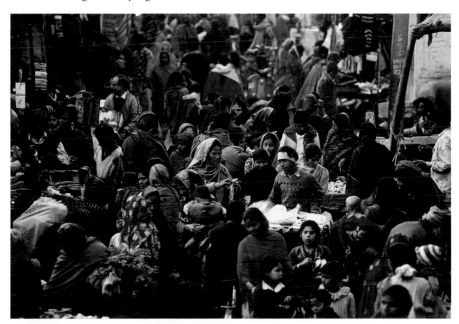

Soft light on a New Delhi street, 200mm, 1/100th at f/5.6, ISO 100

## SOFT LIGHT ON SNOW OR BEACH

I offer this as a notion to tuck away. Soft light is nice light, right? We've already seen that. But, admittedly, it can be a little boring. What will give it that extra edge? What may add just a little more flavor? Sand and snow, those summer and winter delights for anyone who has kids, are the answer. To children, these are things to sled on or make castles out of. To the photog mom or dad, these surfaces can become a "fill card," a huge, natural reflector. This little bit of extra light bounced from below (obviously snow has more bounce than sand) can make for wonderful portrait possibilities.

Soft light at the beach, 50mm, 1/125th at f/5.6, ISO 100

Hard light, Los Mochis, Mexico, 35mm, 1/250th at f/11, ISO 64

## HARD LIGHT

When the sun is high with no cloud cover, the quality of light is crazy hard and the shadows are as sharp as knives. That doesn't mean the light can't be worked. You just have to be selective. This is not light for portraits: Eyes will turn into black shadow pools. But for graphic impact and intensity, raw sun has real appeal and power. Look for shadow play as people move through the streets. Expose for the highlights, and let shadows go black—because they're going there anyway.

## WINDOW LIGHT

Beautiful. Soft light through a window (or hard light hitting a diffused, gauzy window curtain) is one of the most lovely, forgiving kinds of light for a portrait of a face or a still life of items in a room. It often has a graceful, gradual falloff, letting the highlights rotate into shadows in a slow, easy way. Think of a Vermeer painting or, alternatively, an Irish pub. No hard edges. Round tones and rich details.

Window light on woman, 35mm, 1/60th at f/5.6, ISO 200

## CITY LIGHT

Imagine the sound of an orchestra warming up: A disconnected, mixed bag of noises. Nothing in sync. Cacophony. The same is true of nighttime cityscapes. Every type of light presents itself, with nothing in arrangement or equal measure. Greens, yellows, reds, all banging into one another like a messy traffic accident. My advice? Put the camera into auto white balance and go for it. If you want to be a bit experimental, shoot some frames while you work your way through the camera's white balance settings. Some bad frames will result, but they will offer valuable information to store away.

Also important: For nightscapes, get set up and ready well before the sun goes down. This way, you'll still have glow and detail in the sky (or rich sunset colors, if you get lucky) just as the city lights start to really shine. Start snapping too soon, when the sky is still bright, and your shutter speed will be too fast to properly expose the city lights. If you start shooting too late, the night sky will appear black and less than interesting. Postscript: To capture the most city lights, make sure that you try during the workweek, when people are in their offices. On weekends, many windows and buildings are dark.

City light in Manhattan, 17mm, 1/5th at f/5.6, ISO 200

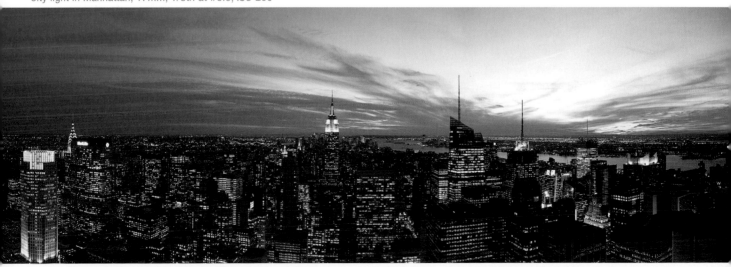

## MUTED LIGHT

Haze often produces an almost ethereal quality of light. It acts as a gigantic filter that sometimes turns the rising or setting sun into a big soft ball. This can be wonderful because you can expose for the color of the sun and still render detail in the foreground, something not possible when looking into clear, hard, directional sunlight. The lush detail in the foreground of this French countryside is made possible by the hazy conditions, which mute the power of the sun.

Muted, hazy sunrise over the French countryside, 200mm, 1/30th at f/4, ISO 100

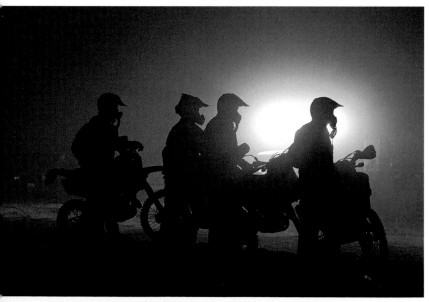

Backlight on Baja bikers, 98mm, 1/15th at f/3.5, ISO 400

## BACKLIGHT

Backlight means drama, color and silhouettes. Remember to choose interesting, storytelling shapes to silhouette because you have no recognizable details to help out. Backlight can give you a good opportunity to saturate the color of the scene; in other words, underexpose it just a bit. (But be careful! Pointing the camera directly into the source of the backlight will cause it to close the exposure down too severely, and you will end up with a very dark frame with a big spectral highlight in it.) These helmeted Baja bikers, backlit by truck headlights in the dust, make distinctive shapes that tell the viewer their story, even though there is no detail in their faces or their bikes.

## SIDELIGHT

Light coming from the side generally produces a distinct highlight. Elsewhere in the frame, because of the light's steep angle to the subject, there is shadow. The discrepancy can sometimes be too severe, and the shadow area may require "fill light," such as the kind provided with flash. Other times, this type of light, exposed properly, can be truly dramatic, exciting even. The light on the church steeple is coming from camera right, at a steep angle to both the spire and the lens. It highlights one side and drops the other into shadow, which in turn gives the steeple some volume and dimension. The same thing is happening with the trees. There is a wonderful play of highlight and shadow, all produced by sidelight. If this scene were lit by flat, frontal light, you might not even put the camera to your eye.

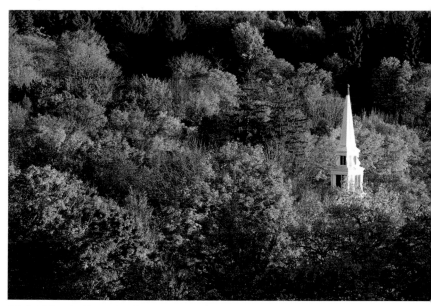

Sidelight illuminating a church steeple rising through the trees, Vermont, 200mm, 1/125th at f/7.1, ISO 200

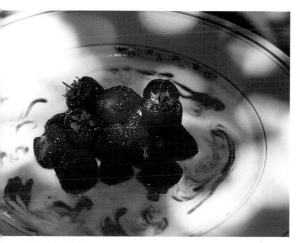

Dappled light on strawberries, 70mm, 1/60th at f/2.8, ISO 100

## DAPPLED LIGHT

Dappled light can make you nuts. The beautiful patterns of splashy highlights and instantly dark shadows are often caused by swaying trees or swatches of fast-moving clouds that quickly cover and uncover the sun. In other words, dappling can occur when you think you might be set, and then the light changes. This is a situation in which bracketing is advisable, especially if your subject is static, like mine is at left. (Bracketing is all about changing your exposure up and down the scale to make sure that you end up with a properly exposed frame somewhere in the group. After you shoot a photo, try slightly underexposing the same scene and then slightly overexposing a third. One of the exposures is bound to be right.)

Here's the thing: That which drives you to distraction—the constantly changing pattern of light and shadow—is exactly what might produce magic. Splotchy, irregular, unpredictable light can take something pretty ordinary, such as a plate of strawberries, and make it more interesting.

Remember I said light is like language. Used well, it makes for a lively read indeed.

# [RIGHT OR WRONG EXPOSURE?]

Is there such a thing as a "right" or "wrong" exposure? If your exposure expresses your intent, then no, not really.

Let's say you are looking to do a "normal" exposure, and you blow it up so badly that when you check your LCD it looks like someone just turned on a high-powered flashlight in your face. That is, of course, a wrong, or bad, exposure. Likewise, if you underexpose a portrait so incorrectly it cannot be resuscitated or reproduced, then again, it can be classified as a throwaway, or bad exposure.

The camera's meter will attempt, as best it can, to save you from yourself. But, as smart as the meter is, it has limitations and can be fooled, sometimes quite easily. Although there are many, many advantages to today's meters (they are tech marvels, compared with what they once were) there are still instances in which they are outmatched. Also (and this happens much more frequently than outright failed exposures), the meter will sometimes return a solution that may be technically accurate but not in line with your creative intent. Remember I said to think of the camera and its metering system as a very expensive blender? Does your blender know anything about art?

The meter is like those folks long ago who thought the world was flat and didn't dare sail out too far from home, for fear they would fall off the earth. The meter doesn't like to go near the edges. But you can, if you think things through and set your camera for underexposure or overexposure to produce the effect you want.

Later in this book, we'll get into the various metering modes, histograms, blinking lights and the like. Here, we are making broad strokes and talking about using the meter well, as an informed guide to good exposure that needs tweaking and adjusting, not as an ironclad set of rules that must be followed. Like the opening statement in any argument, this initial opinion is subject to interpretation and discussion.

Take a look at these portraits. The two images exist at opposite ends of the histogram, your camera's display graph of how light is distributed in a picture.

The top image, a deliberately underexposed, or "low-key," image, lives near zero. A Tanzanian woman, blinded by trachoma, sits alone in her hut, in a single shaft of light. The scene is dramatic and, like her world, almost entirely dark. All you really see are the highlights gracing her sculpted face and her sightless eyes, which are the focus of the small but strong source of light. There's very little to see here. Is it a bad exposure?

Drama of a different sort attends the bottom image, awash in a sea of dead white. This deliberately overexposed, "high-key" image is a study in blown-out backlight that

## JOE'S TIP

When shooting a high-key or low-key image, you should remember the following:

CHECKLIST ☑:

☐ *You* control the exposure—you're responsible for it. Always remember that. So don't choose a completely automatic exposure mode. Choose one that gives you the decision-making power.

☐ High-key and low-key exposures send a powerful message to your viewer, so don't deal with them lightly. And also remember: You're driving here, and the middle of the road—i.e., a "perfect" exposure, one that is neither over nor under—might be not only the safest but also the best way to travel. Sometimes we are tempted to get too artsy, and we miss the true art that is staring us in the face, which might be easily captured if we temper our enthusiasms.

## DO THIS FIRST

Before you go to your camera, make a decision: Overexposure? Underexposure? You don't want exposures to be accidental, but instead deliberate. You might not be entirely happy with the result—*Underexposing wasn't the way to go, after all!*—smack forehead. But if you think one or the other might produce the effect you want, make that choice and then choose your settings. In short: Think it through. Then pick up the camera.

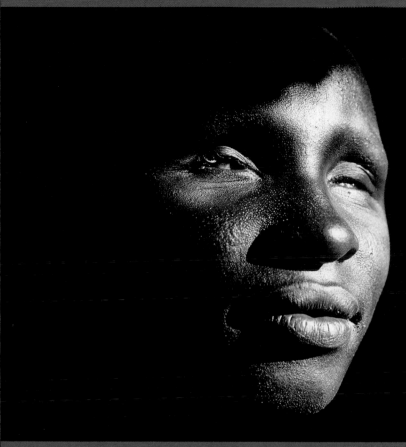

Low key portrait, 70mm, 1/30th at f/5.6, ISO 100

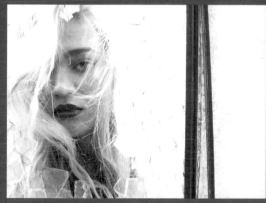

High-key portrait, 75mm, 1/50th at f/4, ISO 400

**"The camera's meter will attempt, as best it can, to save you from yourself. But it has limitations and can be fooled, sometimes quite easily."**

pushes the right-hand edge of the histogram. But detail is retained in the subject's lips and eye—the focus of the picture. If your average camera meter

saw this scene, it would just have a highlight heart attack. But by setting the camera in the direction of overexposure, it reflects what I was hoping for.

# THE CAMERA'S BRAIN (PICTURES À LA MODE)

THE CAMERA'S EXPOSURE METER, at the heart of its computerized brain, has different exposure modes. I've already mentioned a couple of them. Let's take them all in turn, with a bit of review.

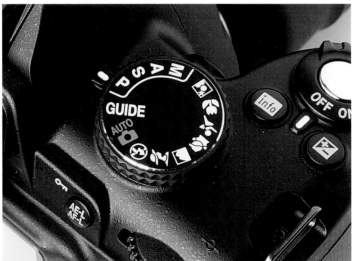

DSLR mode dial set at P, or program mode

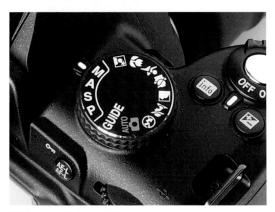

DSLR mode dial set at M, or manual mode

## PROGRAM MODE

Known as P mode, this is that cautionary mode in which you let the camera do all the work. Set it on P, and it looks at the scene and then, based on predetermined parameters, selects the aperture–shutter speed combo. As I've said, this is a dangerous way to fly because you are surrendering complete control to a machine. But it's not the worst place to be when you take the camera out of the box and are eager to go make a few pix. Use it initially, while you are getting the feel of the camera in your hands and seeing the possibilities of whatever lens you may have purchased. Depending on the model, the camera will likely return a pretty good result, most of the time. But it may not represent your vision.

## MANUAL MODE

Okay, this is where the rubber meets the road. You've already experimented with this mode and found out how truly easy it is. On M, you drive the train. You select your aperture setting and then match shutter speed to it. I encourage you to experiment here, knowing that smaller aperture openings yield greater across-the-board sharpness, but slower shutter speeds might lead to camera shake and sharpness issues. If you choose a fast shutter speed, you will have to open up the aperture to a wider opening to let in more light. Playing with settings in this way immediately establishes in your head the very direct relationship between shutter speed and f-stop. You're a shooter.

## APERTURE PRIORITY MODE

Now that you are getting a bit more comfortable, it's time to become acquainted with a couple of additional exposure modes in which you, the photographer, set one parameter and let the camera automatically react to it.

In aperture priority you select, as you might guess, the lens opening. You might do this for depth-of-field concerns (which we'll address in more detail later). Say you are shooting a big grouping of long-lost cousins at Aunt Tillie's wedding reception. Because your subjects are numerous and thus at different distances to the lens (front row, back row, some kneeling) you want to use a small aperture, perhaps around f/11, to guarantee that everyone in the frame will be sharp. You set that f-stop, and the camera in A mode will automatically shift the shutter speed. And because it is a high f-stop (big number, small opening) it will be a slower shutter speed.

Then your attention is drawn to the cute flower girl, and you want to snap her portrait. There's only one face in the picture, so no need for f/11. You open up to f/4, a reasonable aperture for a single portrait. Because you're opening up the aperture, you will see the shutter go up the scale and get faster. All well and good.

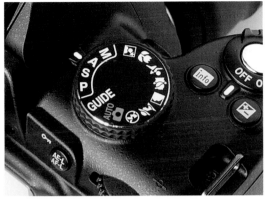

DSLR mode dial set at A, or aperture priority mode

## SHUTTER PRIORITY MODE

Same procedure as above, just in reverse. In S mode, you set the shutter speed and the aperture will slide open or closed, automatically, depending on that shutter speed. Say you are at the rails for the finish of a horse race. Your intent is to freeze the action as the horses come toward the finish line. You need a fast shutter speed, something around 1/1,000th of a second or at least 1/500th. The camera's meter will react by opening up the aperture, or making the hole in the lens bigger, to accommodate the fact that the shutter is moving so quickly.

If your intent, however, is to follow the horses with the camera, keeping the horses sharp while letting the background blur away to indicate how fast they are going, you would do the reverse. Select a shutter speed that can indicate movement (with fast-moving thoroughbreds, this can be 1/60th or slower), and then the meter will react by closing down the aperture to a smaller opening.

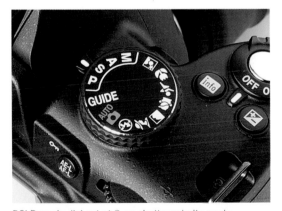

DSLR mode dial set at S, or shutter priority mode

## HOW TO DETERMINE THE RIGHT EXPOSURE SETTINGS

The camera's pretty darn smart—as you've probably figured out by now. Point those pixels at something, and the camera starts a lightning-fast series of calculations that turns the reality you see through the lens into the amazingly complex bunch of ones and zeroes that constitute a digital image.

But the camera is not, as already discussed, always factoring accurately. That assessment is somewhat unfair, of course. When it makes a "mistake," it is just being its analytical self. Call it a left-brain/right-brain thing. The camera is an engineer, not a poet.

You, on the other hand, have to think with both sides of your brain when you're out there making pictures. You strive for visual poetry, but you have a machine in your hands, not a pen and paper. You have to make that machine think like you do.

Below is a good example of the camera returning what it thinks is a completely logical result that is way off base considering where I wanted to go. My portrait subject is the lovely young woman Robin. The camera doesn't know she's a lovely young woman. To the camera, she's just a bunch of darker pixels. So this first frame is, in

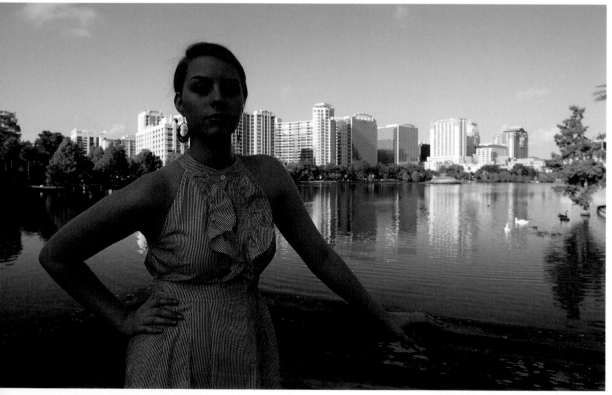

24mm, 1/320th at f/8, ISO 200

fact, a good exposure—by the camera's lights. On aperture priority, set at f/8, it measures the sky, the cityscape, the lake and Robin. It makes an exposure based on the overall scene. Bye-bye, Robin!

The camera has not goofed. It did its job well by returning a result that is a "good" exposure across the board, foreground through background. What it is not aware of is the fact that I wanted to make a picture of *Robin*.

In the series of exposures on the following pages, I'm going to take control. I will redirect the meter to accommodate my intent. The first exposure is at 1/320th at f/8, with the camera set on aperture priority. I used this mode because I wanted to set a lens opening that would render Robin sharply but also have reasonable sharpness extending out to the scene behind her. The shutter speed reacts to the scene brightness by setting itself at 1/320th.

In straight-up aperture priority mode, I can't make the camera see any differently than this. Remember I said that as I adjust my f-stop, the camera will shift the shutter speed accordingly? The camera strives to return the same overall exposure value relative to what it sees. So here, if I shifted one f-stop more open, to f/5.6, would the scene get brighter?

No. The meter would then move the speed to 1/640th, a shutter that is twice as fast, reacting to the fact that I just let in twice as much light through the lens opening.

So, to make this brighter and see Robin, do I have to go to manual? That would be a solution, for sure. I could switch to M mode and start pushing and pulling f-stops and shutter speeds until I got where I wanted to go. But I can make adjustments, right here in aperture priority mode, using exposure value compensation.

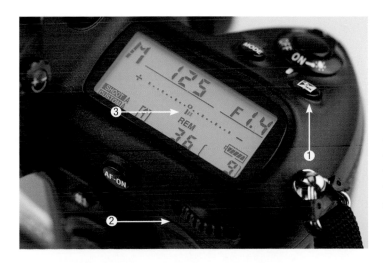

On this DSLR, to adjust the exposure value compensation, you would press the EV button (1) to activate while turning the adjustment wheel (2) to set the value to plus or minus. The LCD readout (3) shows your setting.

The exposure compensation, or EV control, is, on most digital cameras, a small button usually located near the shutter button. Small button, big impact. When I depress this button, the camera allows me to adjust the existing exposure it has sorted out. I can make it brighter (plus EV) or darker (minus EV). These moves correspond to aperture adjustments or shutter adjustments, depending on which mode I am in.

For Robin's picture, I know I need to make things brighter. So I punch the EV button and program in "plus one stop." You can see the result. She gets brighter—not enough, but a bit. (Funny, she gets brighter by about one stop.)

That means I redirected the camera meter to overexpose one full stop of light. Because I am in

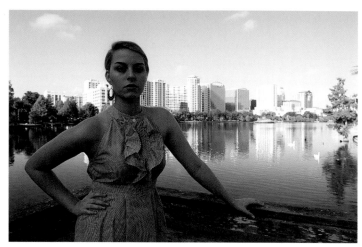

24mm, 1/200th at f/8, ISO 200, +1 EV

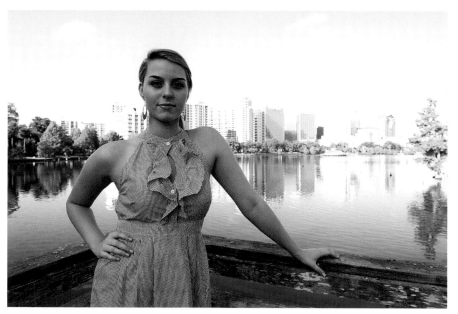

24mm, 1/100th at f/8, ISO 200, +2 EV

aperture priority mode, and I have designated (prioritized) my aperture of choice, the shutter becomes the slider, or variable. It now pulls in at 1/200th of a second, slower than the original 1/320th, thus letting light hit the sensor for a longer duration.

Okay, more work to do. Hit the EV button again, this time going to plus two EV. Now the shutter speed floats to 1/100th. Slower still. Robin gets brighter. What also gets brighter? The background. We are, in full-stop increments of light, saying goodbye to the city of Orlando.

To get Robin fully up to speed in terms of exposure, once again I hit the EV button,

programming plus three EV. Shutter is now
1/50th. She is good to go exposure-wise. The
city and background are blown out.

In shutter priority mode, the same process
would occur, but the variable would be the
f-stop. Each "plus one" move on the EV dial
would result in the f-stop going from f/8 to f/5.6
to f/4 to f/2.8. The shutter, prioritized in this
mode, stays where you put it.

The camera's brain fires in consistent fashion.
What is not consistent, of course, is the world it
encounters, a world full of backlight, sidelight,
hard light, shadows and drama. Our heads, hearts
and eyes have to show it the way. And, once you
get proficient at pushing these buttons and mov-
ing these dials, the camera will follow.

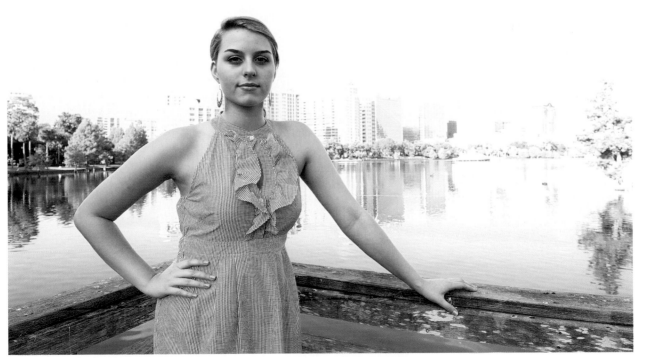

24mm, 1/50th at f/8, ISO 200, +3 EV

# [SPECIALTY LIGHT]

One of the maddening, endearing things about photography is that it's an always-fresh experience. Whenever you go out with a camera, you can expect it to be different, 24-7-365. Hence, though general photographic principles are worth knowing and are by and large unchanged over time, the specifics of what you do in the field is all over the lot on a day-to-day basis.

Here's what it's like to be a professional photographer: Imagine going to work, your regular job, and all the people in your office are different, every day. As a shooter, you segue from job to job, situation to situation, the perennial new kid. In other words, what worked yesterday, isn't going to work today.

One of the big reasons for this truism is that photography is so much about light. The roots of the word *photography* are from the Greek: *photo*, meaning "light," and *graphein*, meaning "to write." To write with light. This is the mission of photographers, and because the light changes every day, so must our approach.

When the clouds are overhead and the light is flat, there is a sameness to the scene. This is also true at the beach with bright sun: Nothing out there to throw shadows or interrupt the relentless nature of strong sunlight. It's a big blast of light, scrubbing down the whole beach, obliterating nuance, details, subtlety of color—the whole deal.

Those are situations I can think of in which your metering strategy could potentially be the same for just about everything. Same quality and quantity of light all over the place. But what about those days and situations in which the light gets very specific—or just plain weird?

Let's talk some strategies.

I photographed this aristocratic Indian woman during Diwali, the Festival of Lights, in Jaipur. At this time, the castles and important buildings are all lit with candles—very beautifully, and to great effect. It's not only amazing, but also an interesting challenge to shoot.

Working with her to create this portrait, in which the sole source of illumination is the candle, I had to *think like the camera thinks*. Let's take it in steps: I'm in tight, and the source of illumination for the photograph is *in* the photograph. Interesting problem. Usually it's coming from outside of the frame. So, the candle is the brightest part of the picture—and it's in the picture.

## DO THIS FIRST

*Testing . . . testing.* Specialty light requires testing, so before you start shooting, it's a good idea to check your settings as well as to take a few test shots to see that everything looks good. If something is off, now is the best time to adjust before you take a thousand shots of your niece's wedding.

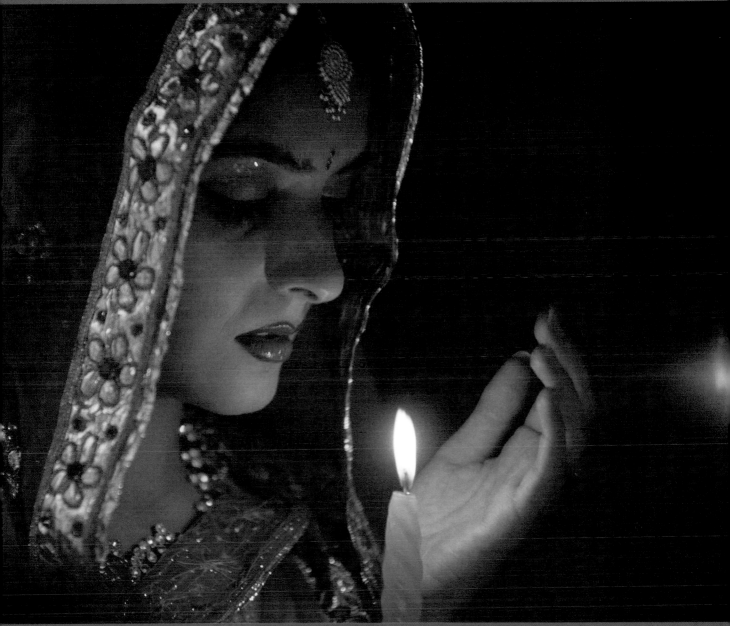

Woman lit by candlelight, 200mm, 1/30th at f/2.8, ISO 200, +1 EV

"I'm in tight, and the source of illumination for the photograph is *in* the photograph. Interesting problem. Usually it's coming from outside of the frame."

Will the camera react to that bright, bright thing? Of course. It doesn't know my subject is the face. It is a machine, and it sees what it sees. (Again, all of this is situational and will change with framing, type of camera, how good the meter is . . . all that.)

But, presuming your camera behaves as mine does, in a metering mode that evaluates the whole frame, it will react to the bright flame and close down the exposure. In aperture priority mode—the mode in which you set, or prioritize, your f-stop and let the camera spit out the shutter speed—the camera will see that glowing source of light and set the shutter speed faster, which will result in a darker picture.

To me, a candle classifies as a low-light situation, so I immediately go to f/2.8 on my aperture dial, maximum for the lens I am using (70–200mm, zoomed to 200). That wide-open f-stop will give me a fighting chance at a shutter speed that I can hold effectively. (I shoot this at 1/30th of second. I really have to concentrate on holding the camera steady.)

But that's not what the camera would have thought. The camera would have placed me at a faster shutter, which would have made my subject's face darker. This being a portrait, I need to see her clearly. So I take control and overexpose the scene by one f-stop. Programming plus one EV (exposure value) into the camera's meter gives me a glowing candle and detail in my subject's face.

So the camera wanted me to be at 1/60th at f/2.8, and the scene, for me to render the subject properly, was really 1/30th at f/2.8.

There's another way to fool the meter, or make sure it stays in line with your artistic intent. Go to spot-meter mode. In overall metering, the camera is looking at the whole enchilada. Switching to spot mode on the

## JOE'S TIP

When you let the camera do the driving, it's occasionally going to make the wrong choice. To compensate for that, remember the following:

CHECKLIST ☑:

☐ If your image is looking dark, you need to overexpose it a bit. There's an exposure compensation button (which is technically called an "exposure value" or EV button) that allows you to adjust to a brighter exposure. If your initial shot is looking too bright, do the reverse and set the EV lower. Perhaps +1 for brighter or -1 for darker will set things right.

☐ If your point of interest is a small portion of the frame, you can change the meter mode of the camera so that it switches from judging the whole scene to judging just a piece of it; this is called "spot metering." Just about every camera has this function. Your general metering mode, in which the camera is assessing the big picture, goes by different names depending upon the model—matrix metering, evaluative metering, other terms—and under any name is, of course, essential. Spot metering, a selective adjustment for certain circumstances, is highly useful when you're going for the details.

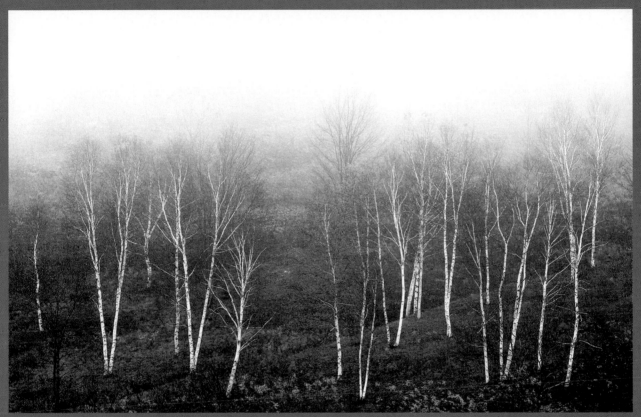

Vermont in the autumn with morning fog, 200mm, 1/10th at f/5.6, ISO 200

meter tells the camera to look only at a small field—about 1 to 5 percent of the overall frame, quite literally, a spot. Direct that spot to the woman's face. *Boom*, the camera now knows to expose for her skin tone and not the candle. (Just remember to take your camera off spot-meter mode. Otherwise you will be metering off small bits and pieces of the frame for the rest of your photo outing, which could return some really bizarre-looking pictures.)

Other "special" metering situations you might encounter include photographing fog or snow. Again, remember the meter is part of a machine that is most comfortable in the middle ranges, not out there on the edges. It reacts to the brightness of the fog or snow and has a tendency to close down a bit, rendering the scene darker than it appears to your marvelously supple eyes. A general rule of thumb? In bright conditions, be prepared for some underexposure, generally in the neighborhood of one f-stop. You might have to counter by opening up one stop, making things brighter. This will make the fog or snow look white, not gray.

These are but two situations that will potentially defeat the meter. That's why we want to move past  P mode. It isn't Perfect!

# SHOOTING WITH LOW LIGHT

As WE JUST NOTED, the word *photography* comes from Greek roots. *Photo* means "light." *Graphein* means "to write." To write with light. Very expressive, those Greeks.

So what do you do when there is hardly any light? Put down your pencil, close your notebook (the camera) and go home? I would caution against that. Those who go home early lose.

Stay for the darkness. The less light there is, the more shadows there are. The more shadows, the more intrigue and mystery. Low light imparts a softness that fades to black in the most magical of ways. This is where the arts of photography and painting converge. This is where

you, the shooter, are like a hunter in a quiet forest. There is simplicity of form and content. You can hear yourself breathe behind the lens. As opposed to the carnival at high noon—a riot of garish color, abundant light, odd smells and loud sounds—there is a quietude in low light, a peace. You have to find it. This requires patience . . . and skill. At these low-light hours of the day, predawn or twilight, light is like a whisper.

Listen.

Ballet dancer waiting in the wings, shot in low light, 70mm, 1/30th at f/2.8, ISO 6400

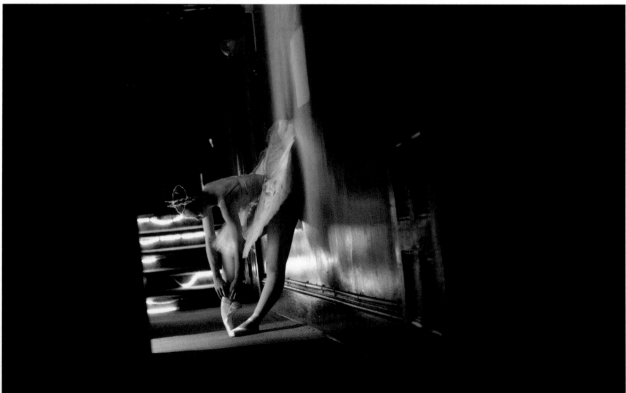

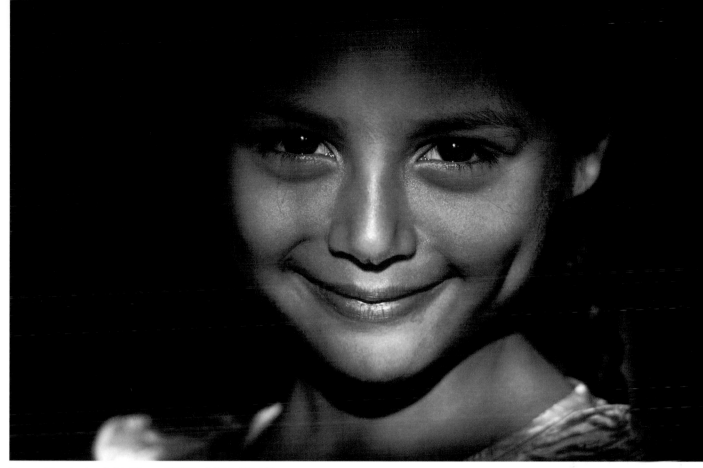

Young girl under low light, 50mm, 1/125th at f/2.8, ISO 100

Because you have a bunch of plastic, glass and wiring in your hands to see with—and not just your enormously adaptive eyes that record all this dimness with relative ease—there are, of course, techniques you should observe when shooting in low light. Low light means slow shutter speeds. As we have discussed, the slower, or longer, the shutter speed, the more light is allowed to pass through the lens and hit the chip. It's like opening a window to let in some fresh air: The longer you have it open, the more fresh air comes in. Same with a camera and a lens. Low light demands that you open that gate to the sensor for longer and longer periods of time—maybe 1/8th of a second, or even 1/4th. That doesn't seem all that long, but when you are trying to hold a camera steady, it's an eternity.

For most people, especially those just coming out of the blocks with a digital camera, slow shutter speeds are killers. They lead to blurry pictures and disappointment. Disappointment leads to disillusionment and discouragement, which leads to putting the camera back in the box. Which leads to clicking online to eBay. OUT-OF-FOCUS CAMERA FOR SALE! CHEAP!

Don't do it. Shooting in low light requires special skills, but it has very special rewards. Read on, and let's talk.

## YOUR CAMERA AND LOW LIGHT

Does your camera like low light? Not really. Of course, I've been talking throughout this section about the camera being a machine and not knowing or liking much of anything. But low light presents it with a challenge. After all, a camera is designed to record light, so as you might imagine, it can get a little balky when confronted with minimal amounts of it. There are things *it* will do, and things *you* should do to compensate.

Work on a tripod. The three-legged beast, as vexing as it is to tote around, will save your neck in low light. As the light level dives, your shutter speeds slow down. There comes a point at which prudence dictates the use of a tripod, even for experienced, seasoned shooters, who may have developed deft camera-holding techniques over the years.

Tripods come in all sizes. A rule of thumb: The longer and heavier the lens-camera combo, the sturdier the tripod needs to be. There is no sense mounting a 600mm lens on the handy-dandy, cheapo rig the salesman talked you into, the one with the swizzle sticks for legs and the ball head that wouldn't effectively stabilize a cup of coffee, much less long glass. Get a brand-name, sturdy tripod. It doesn't have to be a monster, just something that isn't going to tip over in the first stiff breeze.

What to do if there is no tripod at hand? Improvise! Crouch down. Sacrifice a smidge of the perfect angle you had and rest your elbows on your knees. Find a wall to lean against or a telephone pole to wrap yourself around. Do you have a jacket or a hoodie? Take it off and make a beanbag out of it, and then nestle the camera down on that. Look around: There's bound to be something you can prop the camera on that will help you keep this picture you desperately want sharp.

Oh, and when you are in improv, seat-of-the-pants mode, shoot lots of frames. Lots—it will improve your odds.

If the going gets interminably slow, and that shutter of yours is open long enough to play a game of Risk, then it might be time for a cable release. This small but potentially crucial piece of gear is simply a plunger that connects to the shutter and allows you to fire the camera without actually touching it. In this digital age, most cable releases are electronic rather than the older push-plunger (squeeze) types (which still exist and interface with certain film cameras, especially larger format ones). The new breed of cable release is simply a button attached to a cord that hooks up to the camera.

There are simple cable releases and fancy ones. Any good camera system has its own dedicated, proprietary type of release that plugs into its particular electronic interface, located on the camera body, and runs from there through a length of electrical cord to a button you can press. The higher-end systems feature timers that will give you control of extremely long exposures and control over when those exposures will occur. Others are really simple: You push the button, the camera fires. (There are also camera models out there that have, as an additional piece of equipment, a wireless trigger that allows you to fire the camera as long as you are within a few feet of it.)

Whatever the mechanism, a cable release allows the camera to make an exposure without you touching it—which is the point. Even when you have your camera mounted on a tripod, simply pushing the shutter button during an extremely long exposure might cause problems. Depending on how much coffee you've had that day, you could shake the whole rig and wind up with a blurry photo.

These are important things to be concerned about when you backstop yourself during times of low light. While you are being sensible and doing what you can to take the best possible picture, what is the camera doing?

Ballet dancers at rest illuminated by low, blue light, 35mm, 1/30th at f/2.8, ISO 100

## LOW-LIGHT SETTINGS

Whether there's an abundance of light or very little, the camera continues being its robotic self—which is not necessarily a bad thing. There are a number of ways it reacts to dark conditions, and you should familiarize yourself with them.

If you are in P mode, or a completely auto type of exposure, the camera will be setting the f-stop–shutter speed combo for you. If it gets to a point where it thinks you are in danger of shooting a blurry photo, it will warn you. (This generally occurs when it drifts below 1/60th of a second.) Depending on the camera model, you might get a *beep*, or even a little hand symbol waving at you, indicating that the camera thinks your hand-holding technique isn't worth spit.

If you are in aperture or shutter priority exposure mode, you will be responsible for setting, or programming, either the shutter speed or f-stop. In aperture mode, push your f-stop to its widest opening, in hopes that the shutter speed will stay in an area you feel comfortable handling. In shutter mode, you will have to keep slowing down your shutter to accommodate low-light conditions and the speed of your lens. If it is a slow lens, an f/4 to f/5.6, for example, you will be forced to keep your shutter open longer than you would if your lens were faster, such as an f/2.8.

You can make adjustments to the camera's settings that will enable it to deal with low light, the major one being its ISO. If you've been reading through the book from page 1, you know that ISO governs the speed at which the sensor will accept and react to light. For low light, expect to push your ISO numbers up there toward 1600, 3200 or even (gasp!) 6400.

These superhigh ISO ratings will get you a picture, but boy will you pay a price, at least in the middle-of-the-road type of digital camera. High ISOs tend to result in digital "noise," or what we used to call "grain" in film. A noisy picture generally lacks contrast and detail, and printing such a frame is a nightmare. (The flagship digital

Young girl lit by soft, low light, 150mm, 1/100th at f/5.6, ISO 100

cameras can handle high ISOs really well, by the way. This performance factor is one reason pros use them and why they cost a boatload of dough. Really high-end digital cameras are magical at superhigh ISO settings because their chips perform brilliantly at those ratings. They are also very expensive. Cheaper or even moderately priced cameras don't perform as effectively at these accelerated ISOs.)

Many digital cameras come equipped with a feature that can take your mind off constantly fiddling with your ISO number in response to changes in light. Predictably, it's called Auto ISO. This mode allows the camera to shift ISO all on its own. I always rail about surrendering such a crucial decision to the camera, but I've seen this one perform and, frankly, it's a pretty useful feature of the powerful new digital machines we make pictures with. You can set parameters in this mode so that it doesn't run amok. It stays within the limits you are comfortable with.

Practice, and play with the various bells and whistles on your digital camera. The more you practice and refer to your own notes on the picture-making process, the easier shooting with your camera becomes. Push it, pull it, adjust it. Get to know the soul of the digital machine.

Biker at sunrise, Moab, Utah, 20mm, 1/100th at f/8, ISO 100

"With a sharp, black figure in the foreground
set against a vividly saturated backdrop that
is dripping luscious color—hoo boy, you have
a photo that crackles with intensity."

# [PLACES WHERE THERE ARE] [GOOD PICTURES BUT NO LIGHT]

Seek out dark places. Sounds nuts, right? Go where there isn't any light and shoot a picture? Yes . . . and no. I'm not suggesting that you head into a coal mine or generally avoid good light. When you have it, celebrate it. But when it is not there, or there only in small amounts or in remote places, don't despair. There might be light, but it is over there, not over here, where your camera is. The large point is: Don't be daunted—it should not be an automatic reaction to just pack up the gear when the lights go dim.

Silhouettes can result from such no-light situations. Generally, they occur at dusk or dawn (though silhouettes may also happen in blinding high-noon light, and they can occur with artificial light as well). Look for them. They can be powerful graphic statements, beautiful and strong.

When shooting a straightforward picture, you are usually concerned about at least two major areas of exposure: the foreground and background. You want detail, say, in the face or the flower you have up front, and you want detail behind it. Silhouettes remove one area of concern—the foreground. You simply acknowledge that it's going black, and if you want a clean, sharp sense of silhouette, it should be the deepest, inkiest black. No noisy grayed-out fuzziness allowed. No almost-there pixels. Kill 'em all. Go for pure black.

Letting the foreground go black gives you tremendous leverage over the color palette of the background. Experiment with extreme underexposure in these scenes. (Remember with underexposure I am talking about minus EV, or exposure value. Try minus one, minus two—even minus three.) Allow the brightness of the background to drive the camera's meter to a solution, which is, I know, a bit odd as a strategy. You usually take your cue, exposure-wise, from what's up front. But with a sharp, black figure in the foreground set against a vividly saturated backdrop that is dripping luscious color—hoo boy, you have a photo that crackles with intensity.

And you may get this intense photo even though there is no detail in that foreground object. Without that up-front detail—say, a recognizable face—you have to look for something else to get your

## DO THIS FIRST

For silhouettes, find a situation in which the background is much brighter than the foreground. If the reverse is true, simply forget about making a silhouette and start thinking about another kind of picture.

U.S. Navy SEALs in training, 70mm, 1/500th at f/8, ISO 100

message across. By this I mean, basically, body language. Look for emblematic objects that silhouette well—such as a cowboy hat or a fishing pole—to help you tell the story of what's going on with that blacked-out subject. The simple human form works well, too; just make sure to arrange it so that legs and arms have some separation. Remember that the head generally needs to be in profile to the camera. This is the time to coach your subject into a stance that has some dynamic qualities and doesn't make him or her look like a legless, lifeless lump out there in the sunset.

Be careful to get your subjects up and into the background color and light so that they turn into silhouettes. This can mean getting your camera low to the ground so that they loom up into the sky, or positioning them up high on a rock or building. If you are shooting a rock or a tree or a building, remember to notice what's behind. If a significant piece of the background is also in silhouette, or even somewhat dark, that foreground form will disappear right into it. Try for some measure of distinction, color and brightness behind the object or person you are trying to shoot.

## JOE'S TIP

To get ready for a shot like this, remember to do the following:

CHECKLIST ☑:

☐ Let the camera meter evaluate the whole scene, and then experiment with underexposure to saturate the background.

☐ Make sure that your main subject is cleanly against the bright part of the picture.

☐ If the sun is in the picture, beware of lens flare! One strategy may be to use your subject to block the sun. Also: Virtually every lens comes with a lens shade. A good lens shade can be employed to minimize flare—flare that could simply ruin your picture. Having said that, flare can be a terrific graphic enhancement, so judge the situation and if the flare looks good to you, give it a try. You might shoot it both ways.

# [THE ALMOST SILHOUETTE]

You can live dangerously on the knife edge of light. Imagine one of those deep, baritone voice-over guys intoning at the beginning of a cool sci-fi flick: "He lived on the knife edge of light. For this photographer, between the world of light and darkness, there existed just a dangerously thin line . . . ."

Really: This is exciting stuff.

There's silhouette, and there's mostly silhouette. Remember Miracle Max in *The Princess Bride*? "There's a big difference between mostly

dead and all dead." Well, there are pictures in which the foreground figure is *all* dark, and then there are those where it is *mostly* dark. That thin line of light, that crucial sliver, can be just like a rope you throw to your picture, which is about to drown in a sea of darkness.

I spent time in Rwanda after the genocide there, and the country was a tragic mess. The wanton bloodshed had displaced hundreds of thousands, and LIFE sent me to document this desperate suffering. Across the northwest border of the country is a tiny place called Goma.

Young girl in Goma, 20mm, 1/30th at f/16, ISO 100

In Goma, a mere speck on the map of Africa, an impromptu refugee city of more 300,000 displaced souls living in makeshift plastic housing had been born.

It's tough for a white Westerner to wander a camp like this in Africa without drawing notice. Drape a few cameras around your neck and you become, especially for kids, that day's movie. I was doing my ramble, attended by

## DO THIS FIRST

Determine if sidelight could be a strength. Find this light; it's coming from an oblique source, a window perhaps, and illuminating one side of your subject while leaving the other side in shadow. It can create a dramatic effect.

bunches of people, when I saw this youngster (shown on the previous page), apparently oblivious to the hubbub surrounding me.

I shot fast, not wanting her to move, and got only a few frames as she stood there, poignantly framed by the camp, the light and the mountains. The light is behind her, starting to descend over the distant range. Notice the small hill she is standing on: It is completely dark. If she goes to that quality, the picture is utterly gone. But the light graces her, just slightly, yet enough, glancing off the beautiful shape of her head and lighting up just a sliver of her blessedly light shirt. She pops and anchors the photo. Because of this tiny little bit of hard, angled light, the picture ran as the lead photo in a story called "The Panorama of War."

The picture opposite is also of a small child, one in a very different environment than that of the refugee camp. It also takes advantage of limited light. I traveled to rural China with the ORBIS Flying Eye Hospital, a winged medical center that transports surgeons all over the world to places that have no access to sophisticated eye care. Cases are selected, and the surgeons operate right on the plane.

This little girl desperately needed corrective surgery, a common kind most Westerners take for granted but that is unavailable where she lived. I photographed the surgical procedure and, the next day, visited the traditional Chinese hospital where she had spent the night recuperating. I hovered outside her room, not wanting to disturb her or the moment I was hoping would occur.

There is no light in the room; it is all coming from the window, and I am shooting straight into it. The camera manuals will generally tell you that this is bad behavior and will caution you against being so irresponsible. But, operating on my general field theory—that the Lord looks after a fool—I plunged ahead, quietly snapping pictures at her doorway as she turned to the light with her newly repaired eyes.

The window blows away, but not *entirely*, and the soft way the light spreads across her bed drapes her tiny form like a gentle blanket. Turning to the window, she picks up the tiniest highlights and detail. Expose for the brightness of the window, and she becomes a small black hole in the bed. With just a bit of light, she radiates hope. This was the picture that closed the story.

## JOE'S TIP

Capture the mood; think about the drama. Expose for highlights, and let the shadows play. In the picture opposite, if I had exposed for detail in the trees outside the window, the interior would have faded to near black. If I had exposed to get serious detail in the dark shadows inside the room, then the window goes nuclear and the girl is looking at nothing. I had to strike a middle ground and let the play of highlight and shadow tell the story.

CHECKLIST ☑:
- ☐ Consider what your settings might be doing to the exposure in each quadrant of the picture you see in your viewfinder.
- ☐ Crucially, determine how you are exposing your subject. Do not let this object of principal focus fall victim to exposure settings that may be appropriate for secondary objects that appear elsewhere in the image.

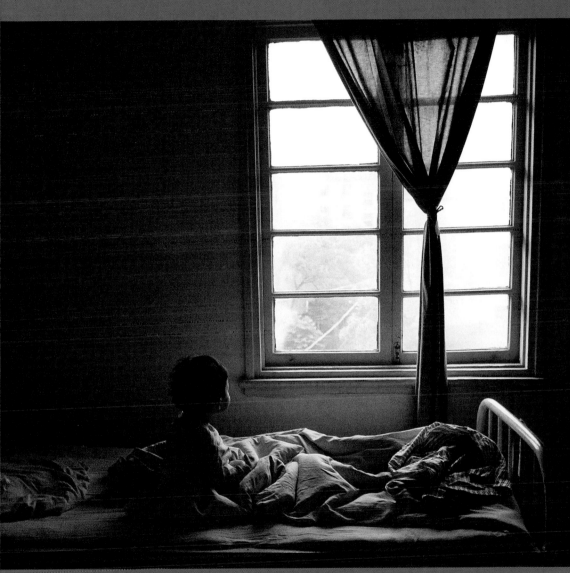

Young girl recovering from surgery in rural China, 28mm, 1/30th at f/2.8, ISO 200

**"That thin line of light, that crucial sliver, can be like a rope you throw to your picture, which is about to drown in a sea of darkness."**

# ARTIFICIAL LIGHT

I'VE ALWAYS BALKED at the term *artificial light*. Artificial light? Is it phony, false or shallow? It's still light, right? I can live with the term *man-made light*. That is what it is.

## MAN-MADE LIGHT

And what man-made light is, is any light that does not come from the sun. Myriad sources fall into this category: bedroom lamps, streetlights, flashlights, headlights, stoplights, classroom fluorescents—a pretty endless list, really. All this man-made light has color and tonality. That can be tricky. If you shoot a man in a fluorescent environment with the camera set to a daylight white balance, he will most likely look a sickly warmish green, as if he had just spent the day on a boat pitching around in high seas. Ever shoot a picture in a living room lit by tungsten (incandescent) lamps, again using daylight balance? Everybody looks like the Great Pumpkin, very warm and yellow.

Café tables under red light, 300mm, 1/100th at f/8, ISO 800

I'd like to give you an absolute and say, "Always match your white balance to the environment," but I'd be wrong. There may be times the warm glow of incandescent bulbs is just what the doctor ordered. There might even be a situation in which your goal is to make someone or someplace look kind of creepy, so you let the fluorescence play. The fact is, when you shoot in artificial light, it is just about impossible to adjust the camera to an absolutely proper response to the existing light every time out.

Times Square, New York City, with a wide variety of artificial light, 230mm, 1/100th at f/8, ISO 800

Take, for example, a situation in which you need to shoot pictures in your kid's science class. (And you will need to, if the word gets around that you're "into photography." When my youngest daughter was in grammar school, the PTA found out that Claire's dad was a LIFE photographer. Guess who shot the school

Dancers putting on makeup, 27mm, 1/100th at f/11, ISO 6400

brochures?) When you walk into that classroom what you find is an onslaught of artificial light. For the sake of simplicity, let's say it's fluorescent, a very common institutional lighting solution. It's inexpensive and ugly. Look up at the ceiling. When were those bulbs installed? There could be tubes there that were put up during the Truman administration and others that got replaced last week. Some are cool white, others warm white: different types burn with different colors. And, depending on the school budget, some tubes could be knockoff brands bought cheap. Now you look around and find that one whole wall of the classroom is . . . windows! Natural daylight, mixing in, strongly influences that side of the room, but diminishes in impact as you move away from the windows and the fluorescence dominates. What to do?

This is not a precise science. You, the beleaguered shooter, need to juggle a million other things such as exposure, expression and timing, while at the same time working quickly and staying out of

the way of the teacher. And now you have to figure out the light. (I mean, there might be folks out there who would attempt precision and walk around the room with a color temperature meter, sussing out zones of color. But guess what—their pictures will most likely turn out to be a bunch of neutrally color-balanced boredom.)

You have to attack a challenge such as the one I'm describing with the eyes and enthusiasm of a child, and not only because that's who you're photographing. You have to work quickly and intuitively here. You'll make mistakes, and some of those mistakes may end up being your best pictures. At the end of the day, in a tough spot, my advice is to go for skin tone and let everything else fade in importance. Capture pleasing (or even decent) skin tone, and you've won more than half the battle.

The spectrum of artificial light is, in fact, a lot wider than plain old daylight. It zooms all over the place and gives off what is referred to in photography as a color cast. (Actually, this happens in nature, too, with the presence of clouds and time of day being crucial factors.)

When it comes to light, what is proper, anyway? Tinker with white balance, striving for good skin tone and a scene that is not shifted radically in one color direction or another. Then try something a little more adventurous, still paying attention, first, to skin tones—your humans must look human. Letting your color palette slide around a bit in response to artificial light sources is not sloppiness. It's experimenting and seeing what works.

The world is a nonstop color roller coaster. Hop on, and hang on.

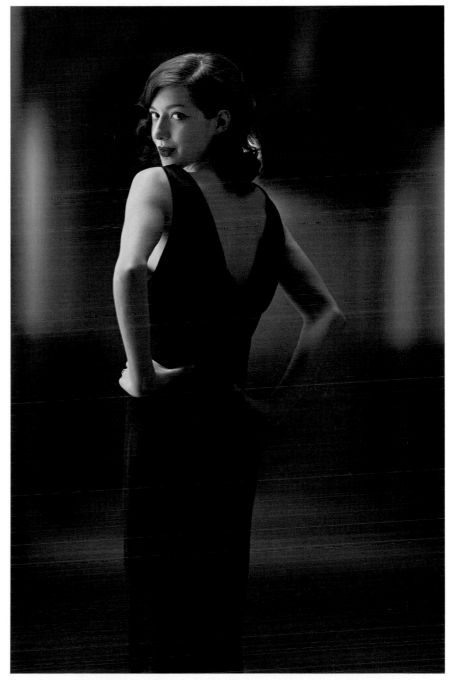

Portrait of a woman, 200mm, 1/60th at f/2, 200 ISO

# [THEATER LIGHT]

Onstage, it's another world. Magic and mystery occur up there, and we in the audience gaze in wonder. Much of that magic comes from the light, usually produced by the artistry of a person known as the lighting director.

The folks who design theater lighting know about the mechanics of the lights themselves, and all their technical particulars. But, more important, what really drives what they design is the emotion they seek to evoke. Lighting technicians know how to direct the eye and how to shape color so that it pulls heartstrings and engages everyone in the theater. They are conscious that they are creating an atmosphere, hence their lighting shows us only that which we are meant to see. The color they deploy hooks the audience; it is created to rivet our attention.

It is good for us photogs in the audience to heed what they are trying to tell us. Follow their lead—and their light. Play with the white balance selection on your camera so that the result it gives you is close to what your eye is seeing. Also, theater light is so specific (spotlights, for instance) that this is an opportunity to use spot-metering or center-weighted-metering mode. Really home in.

## DO THIS FIRST

If your kid is in a show and you are allowed to attend a practice or rehearsal, do so. You want to be ready when his or her star turn comes and not be surprised by it. Scouting a rehearsal will give you ideas about the pacing of the show and allow you to anticipate the climactic, preserve-in-amber moment. If the rehearsal takes place on the performance stage, all the better—you can analyze lighting possibilities as well.

Stars of *Madame Butterfly* under stage light with a blue cast, 300mm, 1/80th at f/2.0, ISO 400

## JOE'S TIP

To get ready for a shot like this, remember the following:

CHECKLIST ☑:

☐ This is definitely the time for "fast glass," which is to say a lens with the widest aperture you've got (f/2 to f/2.8 or 4) to help capture the action while keeping a reasonable shutter speed, one that still allows for handheld shooting. (Part of this equation, as you will see when you balance your measurements, is: This is *definitely* an occasion for a higher ISO.)

☐ From your vantage point in the audience, you will almost certainly need a telephoto lens or telephoto zoom lens to get closeups.

Stage production of *Madame Butterfly*, featuring a strong red spotlight, 66mm, 1/8th at f/2.8, ISO 200

**"Lighting technicians know how to direct the eye and how to shape color so that it pulls heartstrings and engages everyone in the theater. Follow their lead."**

# SHOOTING FIREWORKS

WHO DOESN'T LOVE TO WATCH—and shoot—fire-works? Looking at the pictures later, we think of holidays, patriotism, hot dogs, kids, family. Good times, good memories. The photographs on these pages spur, for me, great reminiscences. I shot them at two of the biggest-ever fireworks displays in history: The pyrotechnic show over the Statue of Liberty, celebrating her centennial, and the Brooklyn Bridge Centennial, honoring one of the most famous spans in the world.

Okay, make a checklist: Camera. Wide-angle zoom lens. Telephoto zoom lens. Flash cards. Cable release. Spare camera battery. Tripod. Headlamp and handheld flashlight. Watch with timer function. Black card.

That's pretty much the photo kit. What else to think of? Rain gear, both for your cameras and for you. You can get fancy rain gear designed for cam-eras and lenses, or you can just use plastic bags and baggies. Add a couple of bungee cords to keep the bags around the camera if the wind starts whip-ping. Drinking water and power bars—you'll be out there awhile. Bug repellent. Comfortable clothing and shoes. The car might be parked far away, and you'll be walking a fair piece. Ibuprofen. (Ibuprofen is always on my equipment list.)

Anything to do beforehand? You bet. Scout the location. It's best to know what you are getting into: Where will they shoot the fireworks from? What will the background look like? How big will the display be? How long will the show last? Most fireworks displays wind up in a half hour or less, and if you are stumbling around in the crowd looking for a spot and trying to set up in the dark, you'll be just starting to make decent exposures as they light up the sky with the cre-scendo and say good night until next year.

That's right, next year. Most big shoot-'em-ups are yearly events. Argh, the pressure!

So scout. Get your spot. Get there early. I mean *early*. Like, be the first car in the parking lot. Pack an insulated sling bag, throw in an ice pack and know that in that bag is your sustenance until

maybe late at night. For jobs such as this, my MP3 player and earphones are a must. Maybe a collapsible chair and a small waterproof tarp. Think your way through this: What could go wrong? It's a photo shoot, so the answer to that is "just about everything."

Yes, all of the above is for a serious, even a professional, fireworks shoot. You don't have to do all this if you're more into family fun than just recording the explosions. But what follows may be of use, either way.

Try to ensure success by envisioning the shot and the potential problems in making that shot before you walk out the door. Think about details, like, for example, you know you need a tripod. So, do you need a permit from the town to place this tripod down to shoot this patriotic event? Most likely not, but in this post–9/11 world, photogra-phers are often looked upon as something akin to recidivist offenders, so it might be worth a phone call to the local authorities.

So you're now prepped and ready. Time to frame up the shot, which is a bit trickier than you might think. First off, when I shoot fire-works, I get my frame, plus about 20 percent. I can always tighten up, but I want to give those fireworks room to play up there in the heavens. Frame too tightly and you'll have tracer lines of color going out of the upper part of your picture, creating lines of interest that will lead your view-er's eye right out of the frame.

So give those fireworks room to breathe, and determine whether the shot is horizontal or

vertical. Remember that most fireworks photos, if they just contain the explosions in the sky, are, at the end of the day, an exercise in color—nothing more. Even something as splashy as a pyrotechnic display needs context, so perhaps you can frame up with the object that is being celebrated, such as the Statue of Liberty or the flag flying in the town square. You can use the semisilhouetted crowd as a foreground element, or boats and bridges out in the water, with the water acting as a giant reflector board filled with color.

Have at least a couple of lenses with you, to allow yourself to vary your framing. As mentioned above, two reasonable zooms, one wide and one telephoto, should do just fine.

Metering? Yikes, how do you meter a fast-moving rocket whizzing through the black sky? The answer is, you don't, not really. This is a situation in which you should turn off much of the auto stuff on the camera and go manual. (Some basic models of DSLR have a fireworks setting, or mode, you can click into, but for our discussion, we'll talk manual operation.) Also, make sure to turn off the flash. Some cameras will read the darkness in certain modes and activate that puppy. Ever see the opening ceremony of an Olympics, where thousands of people are using point-and-shoots, and their flashes are going off like crazy? Know what they're lighting? The shoulder of the person in front of them. Fireworks, unless you are trying a radically different approach, are generally a no-flash zone.

You're now set up in manual mode. Fireworks are brighter than you might think, so you don't need to open the lens really wide. This is a bit counterintuitive, I know, because it's dark out there. But my experience with fireworks shot with a lens wide open is that you drain the color out of them. They'll just register as white streaks. Be careful: You can quite easily overexpose fireworks.

An aperture of f/8 is a reasonable starting point. Some photogs I know go even lower on the aperture scale, down to f/11 or even f/16.

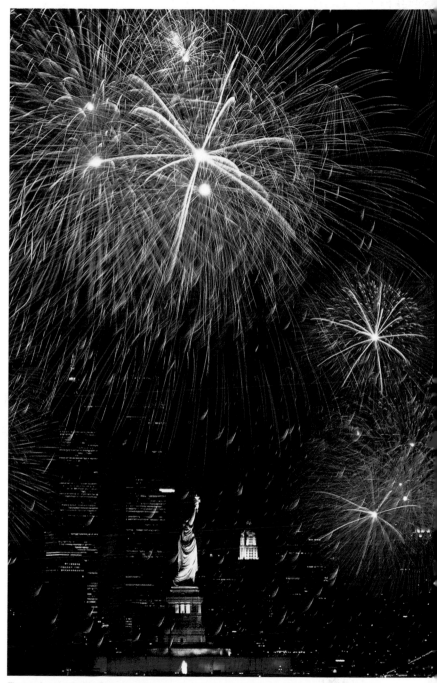

Fireworks above the Statue of Liberty, New York City, 200mm, 5 sec. at f/8, ISO 100

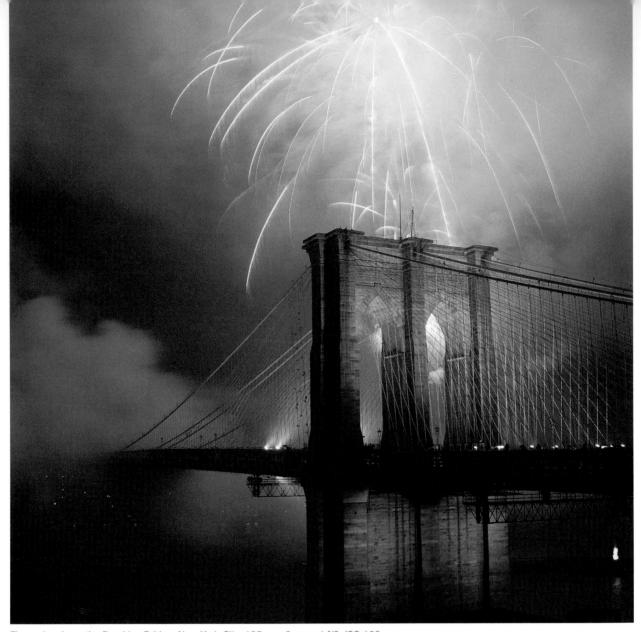

Fireworks above the Brooklyn Bridge, New York City, 135mm, 8 sec. at f/8, ISO 100

Over time, you will find which settings work for you. (I used to take notes at the end of a fireworks job, just to keep myself tuned up for next year. There's no real need for that anymore because the metadata attached to digital images tells you what works and what doesn't.)

Set the shutter to bulb. Bulb, or B, mode keeps the shutter open as long as the release button is pushed. But you are not physically pushing that button, are you?! No!

This is absolutely a job for a cable release. Punch the button on the cable release and the shutter is at your command; it will stay open as long as you want it to. And, because you are using a cable release, you are not touching the camera or the tripod. This is important because at f/8 the shutter will remain open for a while, meaning anywhere from 4 to 15 seconds. (Remember, if you have a foreground element in the picture, such as a

monument, you have to make sure that the lit-up monument is exposed properly. In many ways, that foreground object will determine the length of your exposure.)

Again, the brightness of fireworks allows you to work at a reasonable or even low ISO; something in the neighborhood of 100 to 200 will do fine. The faster your ISO, the shorter your shutter speeds, which will make it impossible to capture those wonderful tracers of light shooting into the sky.

Some photographers time the launch of the rockets and open their shutter accordingly, keeping it open for, say, 8 to 10 seconds, and then closing down. This ensures that they will record the path of the pyrotechnics into the night sky as well as the explosions. This is a fine approach. Give it a try.

Other photogs use a black card. A black card is just that: a black card. Nothing mysterious or fancy. It can be a piece of black cardboard or foam board, or it can just be an index card covered with black tape. (Be sure it is not shiny tape. Shiny material might pick up slivers of light and reflect them back into the lens. Use a matte-black gaffer tape.)

With a black card, you can keep your shutter open for very lengthy periods and record multiple starbursts. You open the shutter and shoot one explosion, then cover the lens with the card and wait for the next. You can experiment with this trick and produce really terrific results, layering multiple fireworks into one picture.

An example of manipulating a black card would be, say, if you have the Brooklyn Bridge as an architectural element in the foreground of your fireworks shots, and the proper exposure for it is f/8 at 10 seconds. This limits your fireworks shooting range, right? You have to get the bridge, so that exposure can't be compromised. But, with the black card, if you are quick enough, you can uncover just the upper portion of the sky while blocking the area of the lens that is recording the bridge. This procedure is dicey. You have to move the card quickly, hovering it around where the bridge ends and the sky begins. If you have ever made a black-and-white print in the darkroom, think of this as burning and dodging right at the camera lens. You can't keep the card static or it will create a hard line of obvious exposure change.

It has to hover, quickly jiggling around that sky-bridge borderline. If you correctly pull this off, you can keep your lens open for several batches of fireworks, extending over 20 to 30 seconds, filling the sky with color. But—this is an experiment! A fun one, but an experiment. Back yourself up by shooting some "straight" frames.

At the beginnings of the digital age—the digital rage—this technique was problematic; seriously lengthy exposures produced a lot of digital noise. The longer the shutter was open, the longer the chip was "on," building up heat with every passing second. That sensor heat, caused by lengthy exposure times, would really fray the quality of the digital file. Long exposures were the Achilles' heel of early digital cameras.

Predictably, advances in digital camera technology have smoothed over a lot of those problems. Still, it is wise to experiment with your particular model and see what it can tolerate. As you may suspect, the higher-end models handle long exposure well, while the more basic cameras have limitations. Also, those high-end machines will have an in-camera high-ISO noise reduction option in the menu. When you engage this, the camera actually reprocesses the file to eliminate bad digital noise. (Note: The camera literally reprocesses the file for the same duration as the original exposure, thus turning a 10-second shot into a 20-second interval where you can't fire another picture. This isn't a disaster but is something to be aware of. While high-ISO noise reduction is operating, you cannot fire the camera.)

Other bits and pieces: Don't shoot all night long at one exposure. (If you are shooting in bulb setting, your exposures will most likely vary a bit anyway, even if you are trying to time yourself.) This is an occasion for bracketing and shooting as many frames as possible. Also, shoot right away when the fireworks start. Pyrotechnic displays can build up a fog of smoke over a series of explosions, and if you are in a wind pattern blowing that smoke toward your lens, you can end up feeling as if you're shooting in a war zone. So shoot immediately, and shoot fast.

Have a good Fourth of July. Try some of this out, and have a hot dog on me.

# FLASH!

HANG ON TO YOUR HATS—we are about to set off a light explosion. That's what you are doing when using a flash, small or big: You are letting loose photons that go screaming everywhere, hitting all sorts of stuff you don't want them to, in addition to stuff you do want them to hit, like your subject. Your DSLR viewfinder has been turned into a bomb sight and you want to shout, "Fire in the hole!"

## FLASH IS YOUR FRIEND

That blinding explosion of light makes many folks afraid of flash. It seems random and uncontrollable, at least at first. The photog announces his presence, then startles his subject with a hard barrage of flashed light—about the unkindest thing you can do to someone. (Ever get pulled over by a police cruiser at night? The flashlight in the eyes? Not good.) The first results with flash are often so discouraging—appalling, even—that people give up. *Never doing that again! I'm a landscape photographer anyway! Why bother with a flash?*

Because, dear reader, if you pursue this craft/hobby/avocation/passion with serious enough intent, you will need to shoot a flash picture now and then—probably more frequently than now and then. You will not have the luxury of simply saying,

DSLR with flash popped up and ready to shoot

"Oh, I only shoot available light." And although some of the high-end cameras nowadays deal very effectively with superhigh ISOs, that capability deals only with one thing: the quantity of light, not its quality. Go ahead and jack your ISO into the stratosphere, which enables you to shoot something. That something may be standing in the worst light imaginable. Always remember the big three of light—quality, color and direction. You need to account for all three.

So, if you want a clean, reproducible digital file, one that has contrast, detail and a "look," you must make flash your friend. Flash affects everything—the quality, color and direction of light—and when used well, it affects them all for the better.

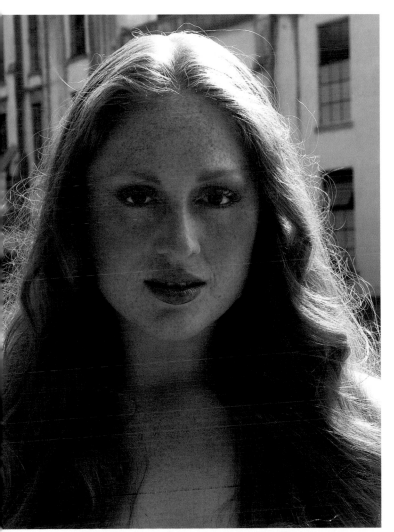

Backlit shot without flash, 44mm, 1/125th at f/11, ISO 200

## ON-CAMERA FLASH

Let's take this in pieces. Many, many camera models, both amateur and more advanced "prosumer" models, come with an onboard flash, generally referred to as a built-in, or pop-up, flash. It is a tiny light source, located right smack at the point of view of the camera. This is wonderful and awful at the same time. That little pop-up can admittedly save your neck at those desperate moments when the light goes away and you have to shoot nevertheless. In fully automatic modes, if the camera senses darkness—*Pop!*—up comes the light, and you just blast away. In other modes, you need to be proactive and purposely engage the built-in flash. Check the manual for specifics about your camera.

Take a look at this lovely, backlit face at left. All the light is behind Vanessa, the subject. That can sometimes work out fine, and you can simply overexpose the scene (plus EV) and use ambient light, with no harm and no foul. But here, we are figuring out what to do with flash. How to get light into lovely Vanessa's face? I'm working close, so I pop up the flash and start figuring things out.

Yikes! In the small photo on the next page, you can see that she is all lit up now, thoroughly recognizable and snappy, but is the light pretty? Hardly. I might as well have asked Vanessa to put her face down on the glass of a photocopier. An additional problem is the shadow in the lower part of the picture. I made that, or, rather, the pop-up did. The light from the flash is so small

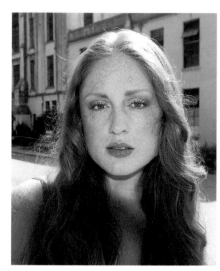

Shot with built-in flash, showing lens shadow across her body, 35mm, 1/60th at f/8, ISO 200

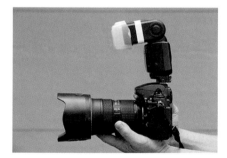

Speed-light flash mounted on DSLR

Shot with speed-light flash, showing no lens shadow, 38mm, 1/250th at f/8, ISO 200

and so low and tight to the camera lens, it flies right over the lens and the lens shade and throws a shadow straight onto my subject. So, although this is a "properly exposed" picture of Vanessa, it falls far short of being expressive, interpretive, nice, beautiful or lovely—all of those things we want our pictures to be.

Next step? A hot-shoe flash or, as it is often called, a speed light. There are lots of speed lights out there, ranging in cost from very reasonable to relatively pricey. The higher-end models are bigger, more powerful and more versatile. Take a look at the options available within your own camera system; all systems have controls, electronics and technology that are specific to their lines.

For the next shot, below, I attach a speed light to the hot shoe and take a picture. This is still not the best light, but look what went away: the shadow. The higher elevation of the hot-shoe model eliminates the annoying shadow caused by the pop-up. This is perhaps a good indication that when it comes to flash photography, small details can make a big difference to the look of the picture. It is a game of inches.

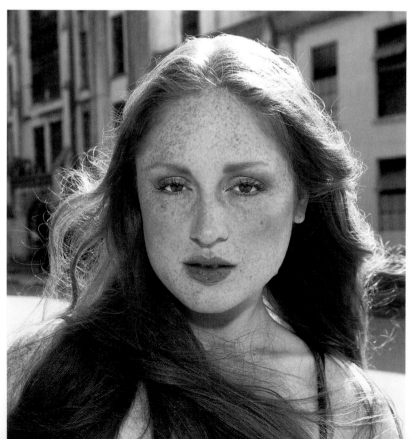

## USING FLASH INDOORS

Now, let's bring the flash indoors. We've already seen the pop-up, or built-in, flash in action, and know it's not a great quality of light. Hence, I bypass that option and go straight to a speed light, this time off the camera. As you can see in the image below, a wire connects the flash to the camera. It is via this connector that the flash and the camera continue to talk to each other, working out the exposure.

Moving the light off of the camera is a crucial element of flash photography. A hard flash emanating from the exact angle and orientation as the lens renders unsatisfactory results. It is not a "kind" light: It is flat and unforgiving. It is more a record of the subject than it is an interpretation. The difference between hard-core, on-camera flash and well-handled, expressive, off-camera flash is the difference between a news report about the subject and an in-depth interview. The first is just the facts, and the second contains the substance and meaning of the story.

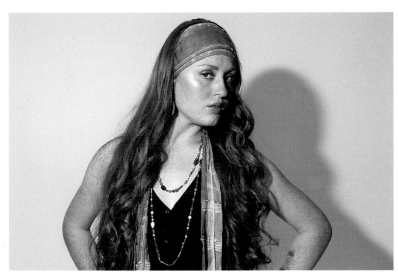

Shot with off-camera speed-light flash, showing shadow on background, 38mm, 1/250th at f/5.6, ISO 200

But I still have a problem, even with the speed light. The flash throws Vanessa's shadow against the wall, as you can see above. Again: a

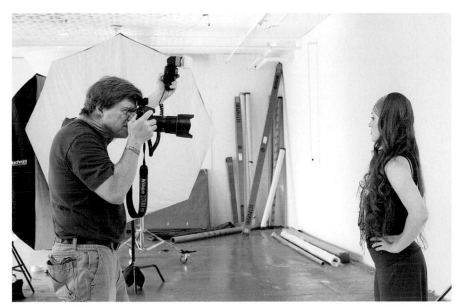

Setup for shot with off-camera speed-light flash

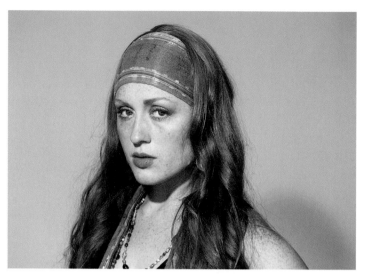

Shot with model moved forward, resulting in less shadow on background, 62mm, 1/250th at f/5.6, ISO 200

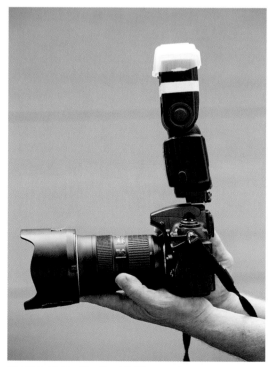

Speed light tilted to direct light upward

dead-bang giveaway about the hard nature of the light and its direction. It results from placing Vanessa too close to the background.

The solution? (Hit forehead here.) Move Vanessa forward. I always try to pull my subjects away from whatever background I am shooting them against. It gives me a measure of control over two vital zones in the photo—what's up front and what's in back.

Now, at left, Vanessa is standing away from the wall. There is still the barest hint of a shadow from the flash, but the photo is vastly improved. What's the next building block for achieving a pleasing, flattering light pattern for her?

Bounce. Most speed lights have a movable flash head that you can click upward toward the ceiling. (The ceiling can't be Sistine Chapel height—it has to be a reasonable distance, within, say, 5 to 10 feet above the flash. It should also be white, or at least a very neutral, pale color. Light reflects the color it hits, so if the ceiling is red, you'll have, if not a tomato face, one that appears ruddy, approximating somebody's complexion after a day at the beach.)

Now, as you can see in the picture opposite, I am finally doing Vanessa's expressive face some justice. Soft, easygoing light results from the bounce tactic. Why? Here is a never-changing rule of light: The smaller the source, the harder, more spectral and shadowy the light will appear. The built-in flash is harsh and hard, right? Those characteristics are directly related to the tiny size of that light source. What happened when I bounced my speed light? I took that relatively small light source and turned it into a big source, in this case, the ceiling. The light flies from the camera upward and hits this big swatch of white reflector board. (Photographers don't think of ceilings as ceilings but as overhead fill cards.)

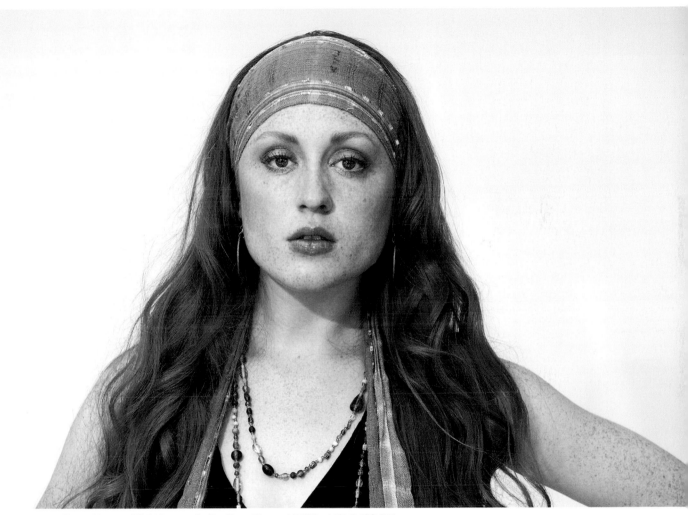

Shot with speed light bounced off ceiling, 38mm, 1/250th at f/5.6, ISO 200

So now this big canopy of light descends on Vanessa, softly gracing her face, and yields the far preferable result. This illustrates in real terms that axiom of light (and flash): The bigger the source of light, the softer and more pleasing the light will be. Think of window light on a cloudy day: It's soft light coming through clouds, then filtering further through a screen or diffuser. It is light as gentle as a falling rose petal; it makes no noise when it hits, and it is very easy on your subject.

When you make it easy on your subject, your subject will make it easy on you, simply by looking good in the pictures you both produce.

# THE HOME STUDIO

WHAT DO YOU NEED TO SET UP A HOME STUDIO? Basically, you're looking at it: a room, a backdrop, a stool for your subjects. Even the stool is optional. A high ceiling is good, and the more space you have to place your subject away from the background, and your camera away from the subject, the better.

## THE STUFF

And then, of course, there's the stuff.

The lights, the cameras, the stands . . . Where do you start? There is a multitude of options, each of them designed for a particular need, vision, approach, subject matter and budget.

When building a small home studio, my advice is to use the KISS method: Keep It Simple, Stupid. It's a plan of action I often apply to myself.

Remember when I bounced light for the closeup of Vanessa? A simple upward tilt of the on-camera flash head and nice light was the result. Let's take it a step further. With this shot of Vanessa perched on the stool, opposite, I'm practicing what I preach, which is to get the light off of the camera. Here, I chose to detach the flash from the hot shoe (that U-shaped piece of metal on top of your camera that you attach the flash unit to) and put it behind an umbrella. Simple and soft is a good description of an umbrella light. Although it is not the only solution for studio lighting, it is certainly a time-honored one— and one that works. Do you need an umbrella light? Do you need half the equipment that's in the picture on the opposite page? When people think about a photography studio, they tend to envision big power packs, large flash heads, cords and wiring everywhere. If they imagine traditional studio lighting, they picture heavy, complex and expensive gear.

Basic studio setup

Now, there certainly are massive studio systems out there, designed to shoot everything from new cars for print ads to spreads for fashion catalogs. Yet, a simple one-room home operation can get by on small camera-bag flashes that easily double as portrait lights. Advances in speed light and battery technology, as well as the introduction of a multitude of light shapers designed specifically for the small-flash user, have opened up a world of possibilities. Even the beginner photog can experiment with controlled, eloquent portraiture right at home.

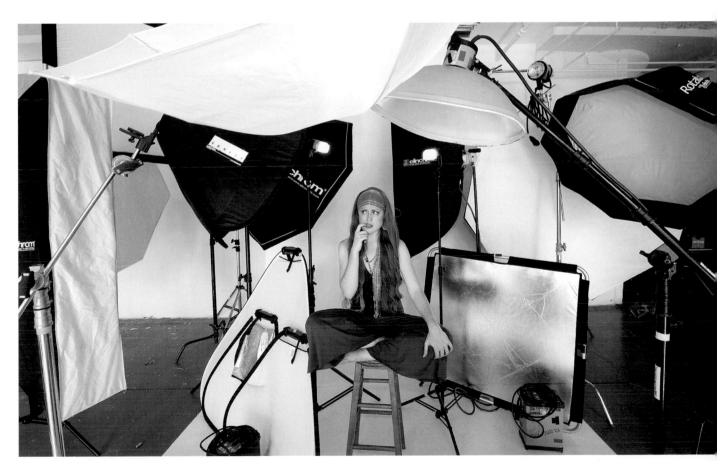

The choices for studio equipment can be daunting.

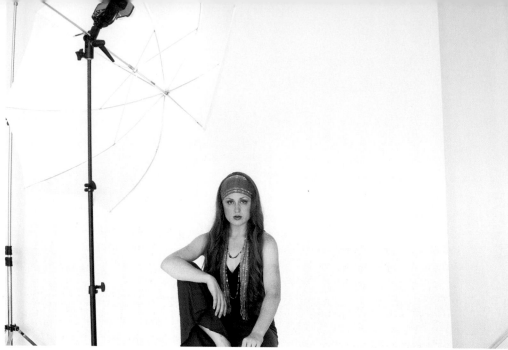

Portrait setup using one speed light, 50mm, 1/50th at f/5.6, ISO 200

## A SIMPLE SETUP

Take a look at the umbrella portrait of Vanessa, above. I shot it with one speed light, an umbrella on a stand and a piece of white cardboard. The result is very pretty, very simple.

So how do you start, and what do you get? Far be it from me to tell you how to spend your money, but I will tell you what *I* would buy if I were assembling a home studio from scratch.

- A room spacious enough to use a portrait-length lens (roughly 85mm to 150mm) without placing you on top of the subject or jamming the subject against the wall.
- A relatively high ceiling. You don't need cathedral heights, but 10 feet or higher is great.
- A table. The table should be large enough to provide a surface for a computer, card readers, battery chargers and the like.
- Background paper (also called seamless paper, or no seam). Standard rolls come in widths of eight feet, but there are half rolls available for simple head shots.
- Background paper supports. This can be really simple stuff: a pair of lightweight stands and a piece of aluminum pipe or a wooden dowel,

with a way to connect the supports to the stands. There are simple, cheap kits available that have the stands, the couplers and collapsible crosspieces in a fairly light duffel bag.
- Roll of gaffer tape. This is for everything from securing wires and cables to taping down paper edges to anything that becomes a problem. Note: Remember, this isn't duct tape; duct tape leaves a residue and pulls plaster and paint off walls. Gaffer tape is strong but easily removed.
- Tripod. It doesn't have to be a huge and hugely expensive model, but it must be sturdy.
- Pieces of white and black foam board or cardboard. These will play multiple roles: They can serve as fill cards for your subject, blockers or "flags" to prevent lens flare, or "cutters" that shape the throw of light. With a matte knife, you can shape them into whatever you need them to be.
- A-clamps. Standard-issue out-of-the-hardware-store items. You'll use these to clip things such as cutter boards or flags to light stands.
- A set of light stands. You should probably have at least two or three for lights and fill cards. The

stands can be as light or as heavy-duty as you wish, depending on your lighting equipment. If you use small speed lights, the stands don't need to be gigantic.

• A sand bag. This will stabilize a stand that is supporting a light. You can purchase one from a major camera store or grip house, or you can use a simple bag of sand, homemade or straight from the nursery. (Be careful: Homemade bags tend to leak contents. It's best to rebag them in plastic.)

That's really about it, in terms of basics.

Go back and look at the photo on page 75 that shows Vanessa hemmed in on all sides by lights and light shapers of all sizes and configurations. That shot would terrify many a neophyte photog, and it is certainly true that a camera store will keep selling you "must have" gear for your home studio as long as you're willing to keep writing checks. On the other hand, the basic kit I've described here can probably be had for under $1,000.

In all this talk of equipment, I have avoided talking about the lights themselves. Again, so many possibilities exist. But, if you think you want to go the speed light route, I would suggest getting two. That way, you have a main and a fill, or a main and a background light. Two lights more than doubles your versatility.

Beyond the items on the above list, well, as many a long-suffering spouse or mate of a photo enthusiast has repeatedly pointed out, "Honey, there's want, and then there's need."

Sophisticated results on a limited budget,
102mm, 1/250th at f/5.6, ISO 200

# [THE STUDIO GOES WITH YOU]

What is a photo studio, anyway? A studio is an empty box you fill with your imagination. That box can exist anywhere. I have made studios in the most unlikely of places, including washrooms, electrical closets, hotel rooms, backstage loading docks, parking garages and the grungy netherworld beneath a grandstand.

One of the most dangerous places I've ever set up a studio was just over the left-field wall at the old Yankee Stadium. I was shooting a cover for an issue of *Golf Digest* featuring famous golfing buddies. Then Yankee manager Joe Torre and former New York City mayor Rudy Giuliani were a pair of very well-known links companions.

We set up early, well before the game, which meant we had to drag a whole studio kit out to the field, run lines to power outlets, set up white seamless paper, poles, stands, soft boxes—the whole nine yards, all while dodging batting practice home runs, which were

## DO THIS FIRST

Even if you're new to the game, you can build or find a studio-on-the-go. Bring your lights, however minimal they may be (it could simply be the one attached to your camera), and a tripod. If you've got a portable backdrop, sure, bring that too. If you haven't, well, I've shot several magazine cover images against a plain white wall.

Impromptu studio behind Yankee Stadium

**"A studio is an empty box you fill with your imagination. That box can exist anywhere."**

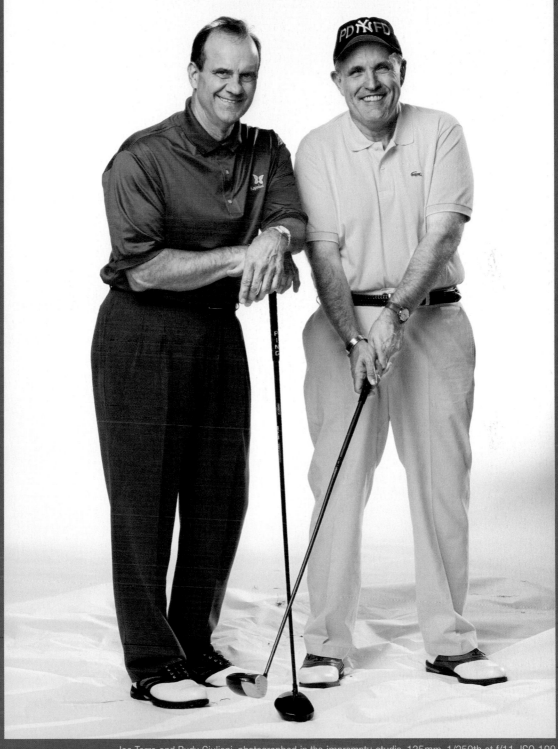

Joe Torre and Rudy Giuliani, photographed in the impromptu studio, 135mm, 1/250th at f/11, ISO 100

Cowgirl at The Futurity, 50mm, 1/15th at f/8, ISO 50

frequent. (I think some of the guys were having sport with us and tagging them into our area just to see if they could fly a baseball through our seamless.) But that's often what you do as either a pro or an avocational shooter: You improvise and make accommodations for situations as they present themselves.

I traveled to Fort Worth, Texas, to shoot The Futurity, which is the Super Bowl of cutting horse competitions. (Cowboys use cutting horses to separate, or cut, cows from the herd. That's harder than it sounds, seeing as cows are comfortable in the herd and want to stay there.)

It was an interesting event—for about three days. Being a people photog, watching horses and cows race back and forth in an arena eventually became for me, well, old. I went to the administrative offices of the Will Rogers Coliseum and asked the folks there if I could commandeer a men's room off the main floor, and they said fine. So in between the stalls and the sinks, I set up a painted backdrop and a couple of lights and started asking cowboys and cowgirls to come by. To me, these folks were fascinating and iconic subjects, and thus more interesting than what was happening out in the arena. Right there in the loo I made what became some of my favorite-ever portraits.

It doesn't really matter where you are. The main ingredients, as always, are your subject and the bits and pieces needed to turn your photo musings into a real picture.

Yes, sometimes things can get hectic. Onboard the aircraft carrier USS *Harry S. Truman*, I was mostly shooting flight-deck action. But I had a couple of small flashes with me, so I borrowed a swatch of gray paper, taped it to a wall and grabbed a light stand from the ship's photo department, setting up an makeshift photo studio on the

## JOE'S TIP

To get ready for an improv-style photo shoot, remember to do the following:

CHECKLIST ☑:
☐ When you're doing this kind of shooting, which is typically portraiture (of which we will learn more in our Composition section), you don't often need your wide lenses but rather, "portrait length" lenses, which generally run from about 85mm to 150mm—normal and normal-range zoom lenses.

☐ When doing a portrait, control of your light is very important. What I tell people is: The human face is like terrain and, as with landscapes, different faces are effectively rendered by different kinds of light. Try to match your light to your subject. You hardly ever want harsh or head-on light for a portrait, and though there's no strict guide for this, it can be said that good portrait light is often diffused—softer, coming from the side of the camera.

Firefighter from the USS *Harry S. Truman*,
42mm, 1/250th at f/14, ISO 100

hangar bay level. Sailors came by, and I encouraged them to bring "the tools of their trade," props that would identify them and their jobs on the ship. The crew got into it and came by with tailhooks, headsets, flight gear . . . you name it. Instantly, thanks to my "studio in a box," I was able to add another layer to the story I was telling of this floating city at sea.

LIFE magazine assigned me to photograph the supremely busy tenor Placido Domingo. I finally corralled him for brief moments prior to a concert in Houston. I set up a background in an unused dressing room and began imploring him to give me five minutes, two minutes, one minute in front of my lens. After being made up as Othello, with the curtain about to rise, he agreed. I was in such a sweat to get this assignment done, I literally pushed him into the room, inadvertently stepping on his cape and snapping his head backward. He simply looked at me in very imposing fashion—he was wearing armor and a sword to boot—and then settled in for his portrait.

Still, my favorite frame of the night wasn't made in my little studio. After all the angst and hustle, the frame of the night for me was Placido becoming Othello, lit only by makeup mirror lights. His studio—his dressing room—yielded far better results than mine.

You never know.

Placido Domingo, 150mm,
1/60th at f/4, ISO 200

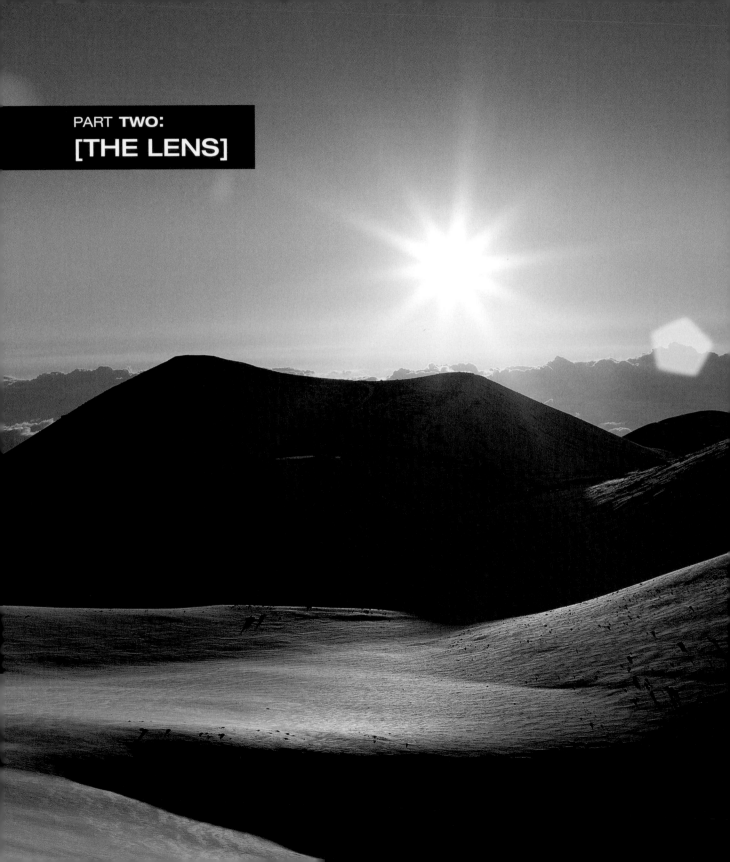

PART **TWO:**
[THE LENS]

# THE EYE OF THE CAMERA

THE LENS IS THE EYE OF THE CAMERA. Yet, the human eye is a tough act to follow. It is audacious, ridiculous even, to think that a collection of glass elements, coatings, metal rings and aperture blades could substitute for the incredibly supple instrument that supplies us with all of the visual information we will receive in our lifetimes.

Macro shot of a human eye, 105mm, 1/60th at f/16, ISO 100

The human eye is nothing short of amazing. It has mechanics, sensitivity and wiring that even the best of digital cameras can only dream about. Linking with the brain, the eye can sweep a dark alley, pulling out detail from the dimmest corners and depths, and then swing out to a brightly lit street scene exploding with highlights and backlights, making the adjustment to those extremes in nanoseconds. Sensitive and responsive, it deals with and even thrives in a world of darks, lights, exuberant colors and subtle monochromes.

The lens on a digital camera, directed by the eye of the photog, embraces all that cool-looking stuff out there, too. Yet it funnels it, not to the supercomputer known as the human brain, but to a very limited sensor, or chip. Think of taking a gallon jug of milk and trying to pour it into an eight-ounce glass. That's kind of what the lens is doing. Digital cameras, when faced with the amazing extremes of color and light in the world, shrug. They can't possibly cope with all of it. TMI—too much information—big time.

The human eye can effectively see detail in dark, dark shadows, and bright, bright highlights. This spectrum from darks to lights is referred to as dynamic range. Digital cameras can't handle nearly the dynamic range of the human eye. Think of it this way: The diaphragm of the lens opens and closes in increments, called f-stops. The eye can see and process the equivalent of about 12 to 14 f-stops of light, which is a vast range. The fanciest digital camera out there can only handle about 5 stops. So, how do you make your lens and camera behave even just a bit more like your eye and brain?

Use lenses well. Understand what they do and how they function. Handle and hold them properly. Make sure the lens you choose is the right tool for that job or that moment. The lens is your point of view, your window to the world or the mirror you use to look at your own life and the lives of those around you. If you can understand how to choose and use lenses well, you have a crack at making this machine in your hands look at things the way your eye does.

The lens you use defines how and what you see, and photography is all about seeing.

## WHAT, AGAIN, IS APERTURE?

Aperture, as I've mentioned, is a hole in your lens through which light travels. Bigger hole, more light. Smaller hole, less light. In this age of fancy-pants digital cameras that have a gazillion menu items and just about cook your breakfast for you, that description sounds absurdly simple, prehistoric even.

But at the end of the day, in simplest terms, that's the aperture. It is somewhat refreshing to see that this crucial element of the photographic process has not really changed much over the years. The hole, as I indicated, can range from big, which is often referred to in photo lingo as "wide open," to small, referred to as "closed down." It is adjustable along the way from big to small in clicks, or f-stops.

Sounds simple—and it is. But, as with all things photographic, there are other issues that present themselves with every click of an f-stop. F-stops can be adjusted manually, if you have the camera set in manual mode. Or if you're using that popular exposure mode known as aperture priority, you, the photographer, designate the f-stop you wish to work at, and the camera automatically shifts the shutter speed to keep exposure pace with whatever f-stop you've choosen.

It's important to remember that the higher your f-stop number, the smaller the opening in the lens and the less light you are allowing to transit the lens to the sensor. The lower the number, the bigger the opening— meaning lots of light is pouring onto the sensor. Hence, at f/16 (high number), your hole in the lens is quite small.

Lens aperture closed down to f/16

At f/2.8 (low number), it is very large. Welcome to the mildly illogical world of picture-taking.

As I mentioned previously, each full f-stop click along the way represents either twice as much or half as much light as the previous f-stop, depending on which direction you are heading. So—stick with me here—when you go from f/16 to f/11, you are doubling your light. Click from f/11 to f/8 and again you are doubling the amount of light. Clicking from a higher to a lower number is referred to as "opening up" the lens, or the f-stop. Moving in the other direction, say from f/4 to f/5.6, halves the light with each full f-stop click. This is called "closing down" the lens or f-stop.

The best way to get your head around all of this talk of f-stops and aperture is to point your camera at a simple nondescript subject, such as an evenly lit wall. Fill the frame with the wall, and click up and down through the f-stop range. You will get a feel for how aperture behaves and how much light there is in one f-stop.

Lens aperture opened up to f/4

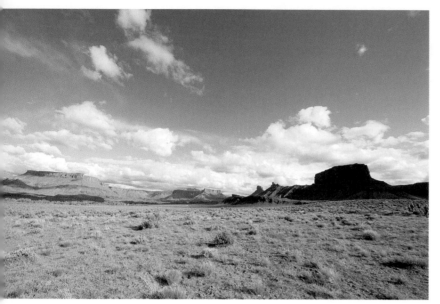

19mm

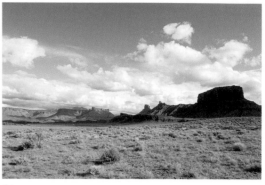

24mm

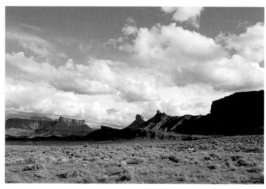

35mm

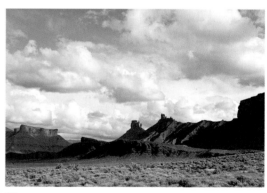

50mm

## FIELD OF VIEW

When I say "field of view," I am referring to what you see through the lens. Shorter, wide lenses embrace the whole scene, while longer lenses parcel it out in smaller bits. Lenses are referred to by numbers, such as 70mm or 200mm, that are based upon the lens's focal length, which is the distance from point of focus in the center of the lens to the sensor, or chip. (This used to be called a film plane, back when we ran rolls of acetate through the backs of cameras.)

Pretty dry stuff, huh? But here's the thing: Lenses are very exciting. Lenses provide the size of the window our cameras use to peer at the world. Get a group of photogs together talking tech, and lenses invariably come up. "You get that new 300 f/2.8? Sweet!" Or, "How about that 14? Gorgeous!"

Superlatives fly around like crazy. *Sweet, smooth, incredible, sharp, beautiful, fast, great, super*—you might think those photogs are talking about a fashion model driving a Ferrari. No, nothing that exotic or scintillating. Just some glass stuffed into a metal tube that we look through. But the reasons chests heave, passions ignite and words gush is that the lens is incredibly important to what photographers do; it defines what we see.

Take a look at these pictures, all shot from the same vantage point, with the same camera and the same camera settings. The choice of lens allows you to take a trip without moving. You throw the door wide open to the full magnificence of mountains, clouds and sky with a 19mm, and then you slowly close in while traveling through a series of lenses all the way to a

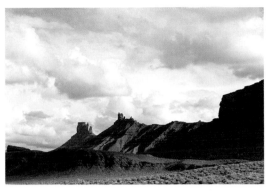

70mm

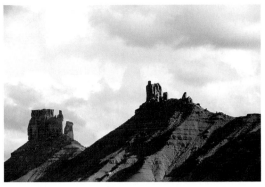

200mm

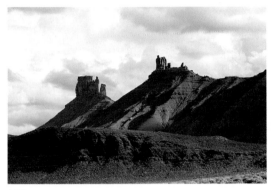

135mm

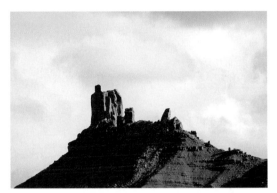

400mm

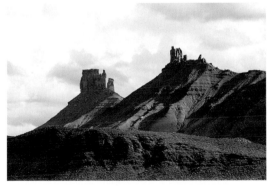

150mm

600mm, which yields a very narrow slice of the scene. The overall result? Different pictures emphasizing different elements and telling very different stories.

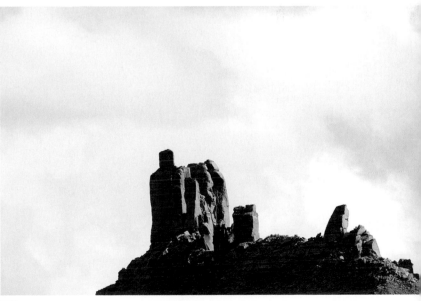

600mm

# [DEPTH OF FIELD]

As with aperture, depth of field, or DOF, is, at its core, a very simple thing. DOF refers to what is sharp in the picture. Now, there's critically sharp and acceptably sharp—and there's a crucial difference between the two. Critical sharpness should be achieved on the key element of your picture. What is around that absolutely sharp point should be acceptably sharp, or within depth of field. DOF generally divides itself this way: One-third of it leads up to the point of critical sharpness, and two-thirds leads away from it. In other words, there is more sharpness in the background than the foreground.

Do an eyeball exercise in DOF. Focus on an object very close to you. You should be vaguely aware that objects in the distance are blurry. Now shift your eyes to the blurry background material. This now gets sharp, while your original foreground point of focus gets fuzzy. It's impossible to focus on both subjects simultaneously. Even the eye can't do it, though sometimes we think it can because the eye-brain combo is so fast and seamless while it makes adjustments.

You've just done a DOF exercise, using your eye. A camera does the same thing: Put something close to the lens, focus on it and the background goes soft, or out of focus. Push the focus ring past that close object, and select a focal point in the background. The object in front of the lens that you originally focused on is now an out-of-focus blob. Depth of field at work.

Your eye-brain team operates automatically and at such lightning speed that you're not really aware of the constantly changing pattern of what's in focus and what's out. This process is instinctive, just part of the day. But you must be aware of DOF when you are shooting pictures. As opposed to just letting your eyeballs do their thing, you can actually step in to manage and direct the camera to produce greater or shallower depth of field.

Remember when an object really close to the lens was sharp and pretty much everything else was a blur? Keep that quickie lesson in mind. The closer the subject, the shallower the depth of field. In other

## DO THIS FIRST

When you're looking to gauge your depth of field, choose an appropriate aperture before shooting. Remember that there are three principal things to pay attention to: how long the lens is, the size of the aperture and how close you are to the subject. The longer the lens, and the closer you are to the subject, the shorter the DOF. If you want to compensate and get greater depth of field in such a situation, then you have to close down your aperture.

**"The key element in your picture should be critically sharp. What is around that element should be acceptably sharp."**

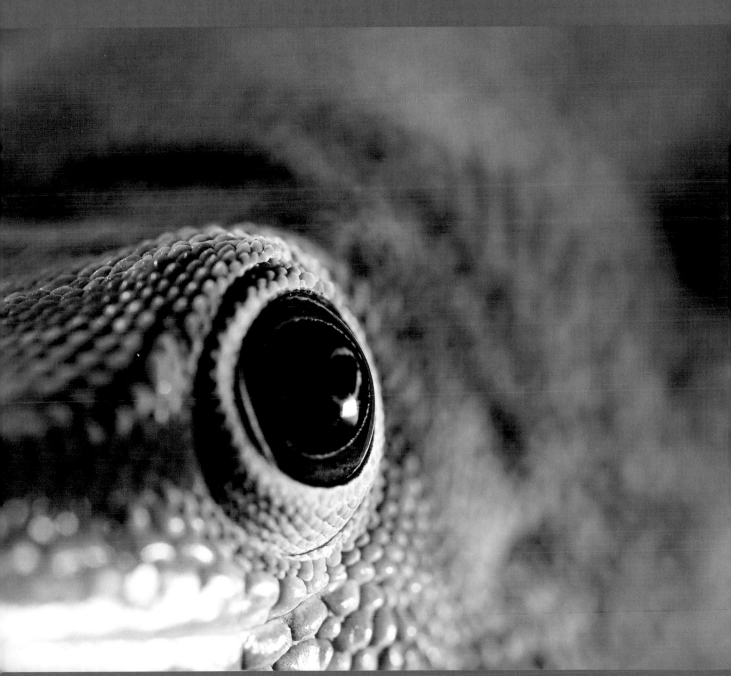

Macro shot of a reptile with limited depth of field, 300mm, 1/125th at f/11, ISO 100

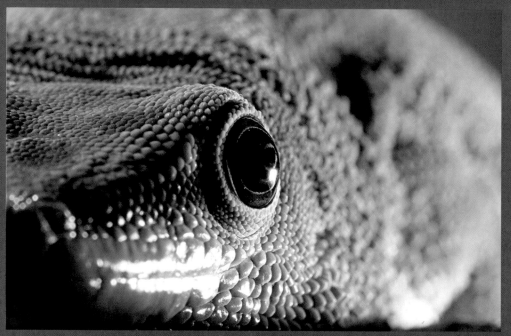

Macro shot of that reptile with greater depth of field, 300mm, 1/125th at f/32, ISO

words, the range or distance between things that are sharp to the things that aren't gets much shorter. By contrast, if your subject is in the middle distance or far away—in other words, not particularly close to the lens—your depth of field gets much greater.

How much? Tough to say because DOF is dependent on another crucial factor, and that is aperture. Remember I said there are other issues besides exposure control that moving the f-stop ring will affect? DOF is the big one.

The smaller your f-stop (high number), the greater the depth of field. At wider aperture settings, the depth of field gets very limited. Lens choice affects DOF as well. The longer the lens, the shorter the depth of field. Wider glass will stretch out depth of field. For example, a 20mm lens at f/22 will yield tremendous DOF, but a 300mm lens at f/4 will have relatively shallow DOF.

That's a lot of numbers, right? Sounds like math, not picture-taking. So what do they mean to you in the field?

A lot . . . and nothing. Here's the thing: Picture-taking requires prac-tice. Shoot, and shoot again, and again. And then shoot some more. The numbers, laborious to figure out at first, give way to intuition—so much so that when you hunker down on the ground to shoot the foreground clump of daisies with the purple mountains majesty in the

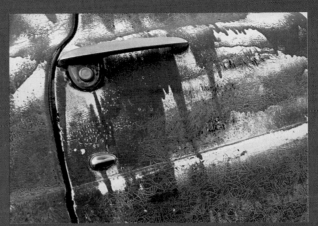

Car door with shallower depth of field, 24mm, 1/2,500th at f/1.4, ISO 200     Car door with greater depth of field, 24mm, 1/50th at f/11, ISO 200

distance, you instinctively move your f-stop into the higher numbers to get greater depth of field. You remember the one-third/two-thirds rule of DOF, so you know a bit of the foreground grass will get sharper, but the real benefit is extending the sharpness into the background. Because of your quick, simple f-stop adjustment, the distant mountains are discernible, and not just vague, out-of-focus lumps.

Likewise, when you shoot a portrait of your kid at the local street fair, and there are wires, cords, clowns, pedestrians and other distracting junk in the background, you push the camera in closer and open the f-stop to around f/2.8 or f/4. Your child stays sharp, and the background softens up but still retains the sense of a busy celebration.

There's lots to talk about with depth of field. It's, well, deep.

## JOE'S TIP

Depth of field is pretty simple once you get used to it. These things will become instinctive, but for now, commit them to memory if you can, or make a crib sheet of this checklist:

CHECKLIST ☑:

☐ The closer you are to your subject, the shallower the DOF (less of your image is in focus).

☐ To shoot a picture with the shallowest DOF, set your aperture as wide as possible, such as f/1.4, 2.8 or 3.5.

☐ The farther you are from your subject, the greater the DOF (more of your image is in focus).

☐ To shoot a picture with the greatest DOF, set your aperture as small as possible, such as f/16, 22 or 32.

# WIDE GLASS

IT'S A WIDE, WILD, WOOLLY, WACKY, WONDERFUL WORLD OUT THERE. But let's just stick with wide for now. Wide-angle lenses, or *wide glass* as they are known, give you the ability to include in a picture elements we are only somewhat aware of when we are staring straight ahead at a scene. These elements live on the edges of our eyesight, in peripheral vision.

Whereas a telephoto lens, which we will learn about later, allows us to eliminate distance and zoom in on a subject, a wide-angle lens does pretty much the opposite: It throws its arms out to the sides and embraces an entire scene. A good wide-angle lens is a must for any shooter's equipment bag. It is an effective, necessary tool for setting a scene, snapping a group portrait, shooting in tight quarters or doing landscape photography and environmental portraiture. What wide glass does is establish context. It answers questions. What does the scene look like? How far away is it? How close is that thing to the other thing?

Wide glass tells stories. Consider for a moment a tight portrait shot with a longish lens. Done well, this portrait can tell you a bit about the subject's life, to be sure. The lines on a face may speak

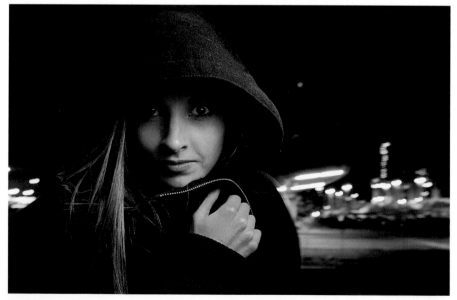

Portrait shot with a wide lens, 24mm, 0.6 sec. at f/2.8, ISO 400

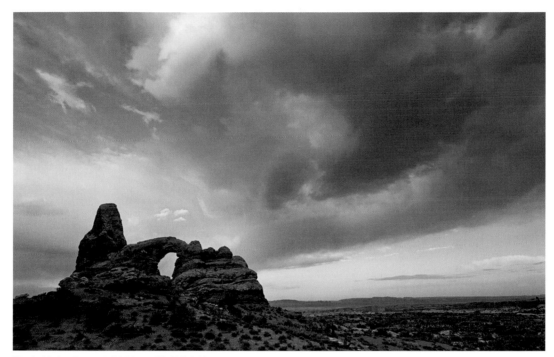

Moab, Utah, 17mm, 1/160th at f/8, ISO 200

volumes. The eyes might be weary or bright. The roughness of skin might imply a hard life. You can tell a lot from the close look a telephoto creates. But you can't tell where the subject is or what the subject is doing.

Wide lenses locate people and places. They show relationships. Switch from a long lens to a wide lens, and a face becomes a face in a place. There's more information. You give your viewer other things to chew on, more to think about. Pulling back from a tight view to a wide view allows the shooter to bring in items the viewer will tune in to. Business suit, overalls, military uniform? Bank lobby, fishing dock, fourth-grade classroom? Showing context can often complete the story you began to tell when you became intrigued with someone's face.

Wide lenses are the answer for landscapes. They are essential for showing the depth and breadth of either the natural or man-made world. I wouldn't tackle either the canyons of Manhattan or those of Arizona without one. One workhorse wide-angle zoom that is always in my bag is the 24–70mm. It is just wide enough to grab very horizontal scenes, and it gives me room to push in closer and distill things a bit. It's very handy as a walk-around lens.

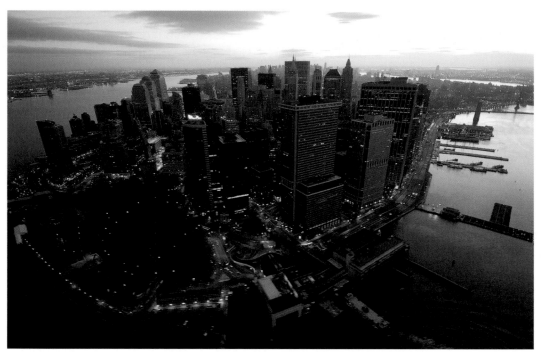

Lower Manhattan at dawn shot with wide-angle lens, 18mm, 1/10th at f/4, ISO 400

shooters inevitably succumb to when they first get one of these puppies in their hands. "This is really wide! Cool! I can get *everything* in my picture!"

Yes, you can. And, as I have cautioned already and will again, you can easily get nothing in your picture. Really wide glass should come packaged with hazard warnings, as far as I'm concerned. First-timers with wide-angle fever tend to show lots of pictures that have subjects of interest that are very, very tiny and in the back of the frame. Up front is a really, really wide expanse of . . . emptiness.

I view a 24mm lens as civilized, controlled. Just wide enough, thank you. Proper. Fairly easy to control. But, have you ever been at an ice cream parlor and ordered a vanilla cone with one scoop, and the guy next to you is slurping the double chocolate banana whammy with the extra whipped cream and an avalanche of cherries? You look on with longing. I believe the expression is "wistful."

That's how I feel about serious wide-angle lenses. A 24mm or so will suffice, but the real tasty adventure of wide glass is in the smaller numbers, down around 20, 18, 16 and (yikes!) even 14mm. There are a multitude of wide-angle zoom lenses that traffic in these numbers; such ranges as 14–24 and 16–35 are commonly available. These smaller numbers get you a really wide view of the world.

Taking a wide view is wonderful, but, as with any adventure, there can be pitfalls. The biggest, to my mind, is the sheer childlike enthusiasm

Be careful of introducing your viewers to a vast void in the foreground of your picture. You are asking them, quite frankly, to work too hard to involve themselves in a scene that you thought was so magnificent, you just had to squeeze all of it into one picture. The human eye is easily bored. This is eminently understandable. Just think of how many pictures are being made out there, all of them screaming for attention. It becomes visual white noise, and the eye goes to sleep. It needs something that causes it to snap to attention. If your picture can do that, you win.

When working wide glass, a great way to create interest is to anchor the foreground of the photograph. Out there in the wild, try to find elements close in that complement the scene, give good information, provide compositional pizzazz and add color. *And then put these things in the foreground.* A blasted tree, a marvelously intricate

rock formation or even a single dandelion, placed strategically in close to the lens, can make or break a landscape. In the big city, a stoplight, a lone pedestrian or a colorful awning can humanize and scale the concrete jungle. Compose your overall scene so that these foreground elements spark interest, captivate your viewers and stimulate a visual journey through the photo. In other words, you have to find this thing, this anchor, and once you do, you must handle it well in the frame. For a story on the long history of London's River Thames, I used a wide lens to frame the scene, but made sure there was foreground interest by showing the ancient artifacts treasure hunters find in the river. In the photograph at right, we see various elements working together to tell the river's tale.

When you're using wide glass, stay active; a wide picture shot from eye level and middle distance can be a real yawner—a one-way ticket to Boringville. If you want to shoot that flower, get down there with it. Push the wide-angle lens in close. (Remember to click to a high f-stop to close down your aperture. You most likely want a lot of DOF in a photo like this.)

Climb something! Find an elevated view that gets you a better look at that red rock formation you wish to put in the foreground.

Get off the beaten track! Wander!

The wide-angle lens covers a lot of ground. So must you.

Artifacts from the River Thames shot with wide-angle lens, 24mm, 1/30th at f/11, ISO 64

# [YOU DID WHAT?]

Classic, tight-framed portrait,
112mm, 1/60th at f/8, ISO 100

You shot a portrait with a wide-angle lens? They say you're not supposed to do that!

Well, I guess that's me: Authority issues from day one.

One of the larger lessons that can be drilled into you about shooting pictures of people is that there are portrait-length lenses (generally about 85mm to 200mm) and then there are, I don't know, call them street lenses. Wider glass. Scene-setter devices. Landscape lenses. Not typically thought of as people lenses.

I understand the mandate—and the caution. You don't want to push wide glass in on a subject to the point that his nose looks like it needs landing gear and his head looks like the Great Pyramid.

But you do want information about this person, information that goes beyond what you could glean from a driver's license pic. The difference being discussed here is that between a portrait and an environmental portrait. Or, a studio head shot and a street portrait. Or the difference between using a portrait lens and a wide lens.

There are studies: pictures, generally made with portrait-length lenses, that trap the human face, hem it in on all sides and make the viewer confront that face. Study it. Respond to it emotionally. Make guesses about who he really is and what his life is like. What is his age? How much has he seen in his life?

Many times, a person's face is the road map to that life and at least a bit of the soul. Done well, rendered simply, without distraction, a portrait like this speaks volumes about the person without showing anything else but the person's features. Here is where portrait glass is your friend. Longer than a normal lens, what is generally considered to be about 50mm (a 50mm lens supposedly sees a field of view roughly akin to "normal" eyesight), a portrait-length lens produces a slight bit of compression in the 85 to 200 range, with more of it obviously occurring in the higher numbers. That compression, and the straight-on approach generally dictated by these kind of lenses, gives a sort of rectitude, or properness, to the frame. Clean, simple, dignified. No distortion, no "I shot it from my hip without looking" feel to it.

Perhaps when you work like this, with this type of lens, you are unconsciously connecting with the portraits of long ago, when portrait-taking was a more arduous process, and the subject had to come in and stand or sit in formal fashion for literally minutes at a time for a single image. There was no motor-driven mayhem back then. You had one chance to get it right. Now there's a prospect that would truly terrify today's shooters: All you get is one frame!

Filled well, though, that one frame may be all you need. In the studio portrait on black, opposite, there are volumes of information offered about the subject. The woman commands the lens with her beautiful combination of smile and gesture. Hers is an interesting, wonderful face, a face that encourages study, curiosity and interest.

But what about some more info? Like, what does this person do? Where does she work? Why are we supposed to be interested?

Ah, that's the job of an environmental portrait. This approach allows you to meet the face in a place. Location, location, location, can be established with settings and souvenirs, either personal or professional.

Tricia Wright, a studio neighbor down the hall, is a terrific painter. In a typical portrait, you see an artist with a finished piece behind him or her, but when I walked into Trish's studio, I saw that the floor, coated with years' worth of splashed paint, had been transformed into its own work of art. To me, it spoke powerfully of the labor of being a painter. I asked Trish to lie down and reach her hand and brush out, à la Michelangelo's Adam . . . the act of creation, which is the act of any artist.

**DO THIS FIRST**

To shoot an environmental portrait, you have to think story. Think "face in a place." Locate the person in an environment that tells about who the individual is and what he or she does.

Painter on the floor of her studio, 28mm, 1/60th at f/11, ISO 125

Drum workshop, 21mm, 1/60th at f/9, ISO 100

For Bob, left, well, he repairs drums for a living. So what do you do to express who he is? Pose him with the drums, in a pleasing and artful way. Bob leans in the foreground, dominating the frame, but all the busy stuff of the background helps tell his story. Drums everywhere, with an honest-to-goodness character up front! It's a fun picture to look at, giving the viewer's eye a lot to ramble though.

Both the classic and the environmental approach can work for the same subject. Come in close, then pull back. For example, I photographed conductor and composer Leonard Bernstein numerous times. Lenny was a wonder—a difficult wonder, occasionally, but still, a genius and a tremendous source of contagious energy.

On one occasion, I chose to come in close and study Lenny's face. No background here: Just the intensity of a man filled with grit, edges and pain, who turned those aspects of himself into art that lifted us all. That face has lines of love and sadness. The eyes have a weary intelligence. This is a face that has seen life.

In the shot opposite, Lenny's workplace was filled with the stuff of a creative life. And there he is at the piano, still creating, still involved. It is a picture that calls to viewers, affording them a glimpse of a normally private place that is teeming with information and personality. We are looking up the sleeve of the magician. This is where imagination and intelligence became musical notes.

## JOE'S TIP

To shoot an environmental portrait, remember the following:

CHECKLIST ☑:
☐ Use a lens that will show what you have decided is pertinent in the environment, while retaining some depth (could be a wide lens).
☐ Close down the aperture a bit (maybe to as much as f/11) to get some DOF and show the environment in focus.

Leonard Bernstein, 200mm, 1/125th at f/8, ISO 100

Bernstein at work, 24mm, 1/30th at f/11, ISO 100

"Both the classic and the environmental approach can work for the same subject. Come in close, then pull back."

# [TIGHT SPACES, WIDE GLASS]

Superwide lenses, up to and including fish-eye lenses, which produce extremely wide, hemispherical images, should be wrapped in caution tape with the warning: GO HERE WHEN YOU NEED TO, AND BE CAREFUL WHEN YOU DO. A fair amount of distortion is a possibility—make that a certainty—unless you handle the lens really well. And even if you do, if there's a foreground element, it's going to look a little weird.

But when your back is literally against the wall, go for it. Use the superwide and risk the distortion. It might be fun and impart to your picture a certain unique quality.

I shot this photo with a 14mm onboard a Navy sub. There isn't a lot of room on a nuclear hunter attack sub, that's for sure. In fact, it is a marvel of using limited space well. In this environment, your back is *always* against the wall—which, when I made this picture, was the only way I could keep myself from slipping down the hallway. I kept pushing backward against the nearest surface and hanging on. A 30-degree dive onboard one of these submerged contraptions is an event; the submariners call the exercise "angles and dangles," for obvious reasons. But to get the intensity of the guys running the dive planes and executing the maneuver, and the effects of that maneuver (check out the guy tilted over in the aisle), I had to go wide. Really wide.

There's a touch of distortion, to be sure. But worth it in terms of telling the story of that moment? You bet.

Fish-eye lenses are notorious for being overused, mostly because some shooters use them to get their giggles for the day. Distortion is a given with these superwide lenses; their construction turns the world into a bowed, curved place, giving rise to a lot of less-than-serious

## DO THIS FIRST

If you think you're going to shoot in any kind of tight space—and remember, an office or classroom can be plenty tight—remember to pack a wide or superwide lens, if you have one, or even a fish-eye. It can be a lifesaver for capturing what you want because it expands your view and brings in all the information.

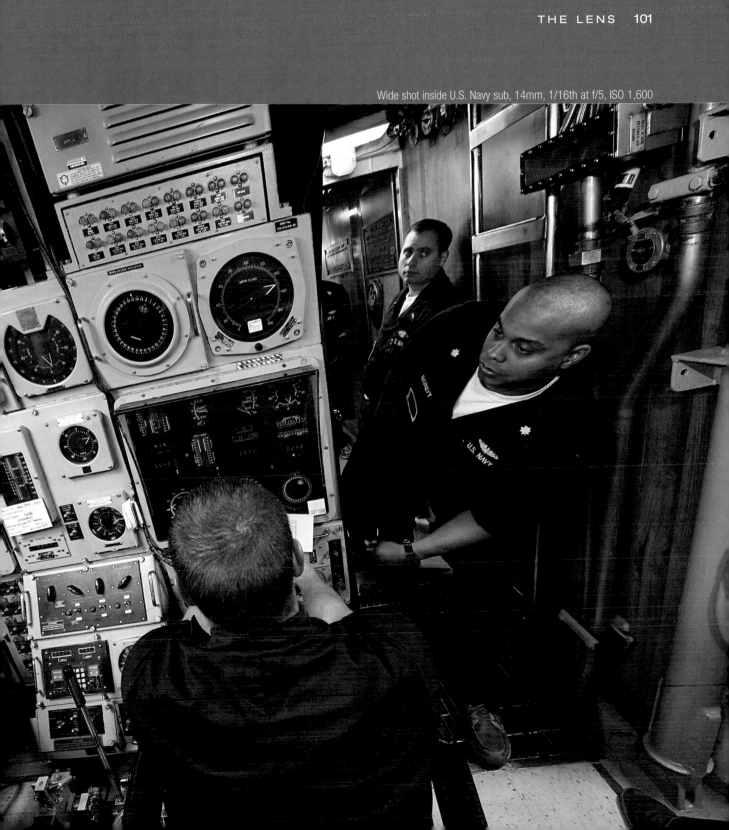

Wide shot inside U.S. Navy sub, 14mm, 1/16th at f/5, ISO 1,600

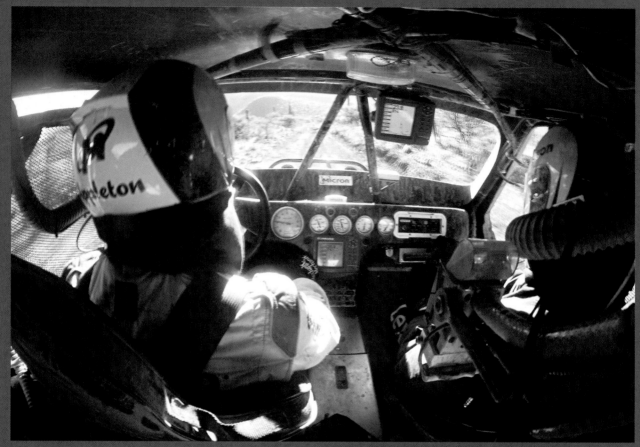

Inside Baja 1000 dune buggy, 15mm fish-eye, 1/30th at f/8, ISO 100

imagery. But they are handy because they are not only wide but also usually quite small. Fish-eye lenses have great appeal if you want to get pictures from, say, inside one of the dune buggies during the wild running of the Baja 1000 off-road race, as I once did. I hung a camera in back of one such desert vehicle, and it stayed there the entire 1,000 miles, returning with the picture above. (The camera was set on aperture priority mode, and the co-driver just periodically pushed a remote

**"But when your back is literally against the wall, go for it. Use the superwide and risk the distortion. It might be fun and impart to your picture a certain unique quality."**

button that fired bursts of exposures. A lot of rigging, safety wiring and luck needs to attend an attempt such as this.)

But it worked, at least for a limited time. At the end of the race, the whole rig was frosted with dirt and sand. Thank goodness I had borrowed the camera from the Nikon loaner department!

The camera after the Baja 1000 race

## JOE'S TIP

To shoot with superwide lenses, remember the following:

CHECKLIST ☑:

☐ Think about what the lens is going to do. It is going to give you a bit of distortion (a fish-eye will yield an image that can look positively weird), so plan accordingly. Maybe you want the weirdness or maybe you want to temper it. One thing you can do to exaggerate or soften it is to situate the lens differently: If you tip it or angle it, the distortion in the resulting image is increased. (A building shot at an angle with a fish-eye becomes surreal beyond Gaudi's imagining.) If you aim it straight and zoom in, you can mitigate the distortion. Use your lens for what you want it to offer you, and then outthink your lens for the final result.

☐ A wide lens naturally retains more depth of field. Close down the aperture to get enough depth to show the scene effectively (maybe f/5 to f/8).

# TELEPHOTO

ONE THING THE HUMAN EYE CANNOT DO IS GET BIGGER. It cannot magnify objects or go telephoto all on its own. This is one huge, cool thing the right camera-lens combo can do that the eye cannot do. As you stand on the sidelines of a football game watching with your naked peepers, unless the action comes in your direction, the scrum out there on the field is going to be occurring roughly in the same register and dimension all day long. You can't enter the action unless you want to get trampled by huge, fast-moving players wearing the equivalent of gladiators' armor. And your eyes simply can't grow legs on their own and trot out for a closer look.

With a telephoto lens, however, you can do just that—get your eyes on the field. Via the mechanics of a telephoto lens, you can "fill the frame" with magnified action that your sideline-bound eyeballs perceive as only a small part of a generally observed scene. Instead of just seeing a messy collection of well-muscled combatants flinging one another about, with a good telephoto you are right there, in the mix of the blood and sweat, the grunting, the heaving—the emotions. Think of it as a transporter that just beamed your point of view right into the middle of the huddle.

(While we're talking sidelines, here's a sideline comment about shooting action with a telephoto: Keep your wits about you. If those behemoths out there suddenly get very, very large in the frame, they are coming toward you, probably very rapidly. You can dive so far into a telephoto that you lose a sense of where you are. Giddy with excitement at the play coming your way, you're recording popped eyes, flared nostrils and flying sweat. You're there! So close you can see the laces on the old pigskin! And that's your last conscious thought as the person carrying aforementioned pigskin runs right over you and your new, remarkable telephoto lens. Cleat marks on the front element of a lens are not recommended, unless you're striving for a special effect.)

Telephoto lenses, simply put, bring us close to what we are observing from afar. Referred to as "long" lenses or "long glass," telephotos are important tools when a situation demands to be rendered with magnification and impact. Imagine you're at your kid's soccer game and she scores the winning goal. You shoot it with a 50mm normal lens. Then you have to keep explaining to anyone looking at the picture (and proud parent that you are, that would be everyone you meet) that there's Susie, right there, kicking the ball. You need to explain, see, because little Susie is about 7 or 8 of the 30 million pixels churned out by your fancy digital camera, which means the ball she's kicking is about 2 pixels big.

Microscopic, in other words. Inconsequential. This kind of situation is where a telephoto rules. With a long lens, as you develop the skills of holding it properly and instinctively tracking action (no silver bullet stuff here, just practice—and a few tips later in this book, beginning on page 124), you would be right on Susie, following her path down the field as she avoids defenders, kicks the game-winner and jumps for joy when her teammates mob her. The telephoto lens tells that kind of story. With the magic of magnification, you are right there with little Susie, recording a moment she will remember forever, at least partly because Mom or Dad shot it well.

Mark McGwire, 200mm, 1/250th at f/8, ISO 100

## HOW TO SHOOT WITH TELEPHOTO

So, how do you "shoot it well" with a telephoto lens? The first thing to do is choose wisely. Big is good, with telephotos, but bigger, or really, really big is not necessarily best. Consider what you like to shoot. Is it in fact soccer or other sports? Or is it landscapes and wildlife? Or are you a street shooter who travels and wants to record the interesting faces of a foreign (or familiar) culture naturally, without being intrusive? All of these might call for a different focal length of lens.

Runners, 300mm, 1/15th at f/11, ISO 400

After 30 years in the field, I can say with assurance that one of the most useful (and used) lenses I tote is a 70–200mm telephoto. The millimeter range on this lens is very versatile, and it is capable of embracing many of the diverse situations all photographers find themselves in. The 70mm, or wider end of things, is very useful for faces and small groups. It is just a bit longer than a 50mm normal lens. A touch of telephoto can go a long way.

Let's go back to the soccer game, shall we? You are hovering around the sidelines. Your kid has rounded up some teammates and wants a quick snap. A buddy portrait. Two, three or four kids, all goofing for your (roughly) 70mm lens. Perfect. Nice shot. Then they charge back onto the field for the second half. Slide that puppy to 200mm, and you've got a good working perspective on the action.

A handy lens, indeed. A 70–200mm telephoto can reach into the middle of a sports field and also across an Istanbul street into a spice market. At its long end, it can bring you in tight to the human face, rendering a beautiful, detailed portrait while minimizing background. In its wider settings, it is excellent for general scenes where storytelling is important.

The "go-to" 70-200 in my camera bag has a maximum aperture of f/2.8, which classifies it as a "fast" lens in photo lingo. As discussed in the aperture section, the lower the number, the wider the lens opening. In the world of telephoto lenses, *fast* and *fixed* are generally positive terms. "Fast" means the lens opens wide relative to its length; "fixed" means that the aperture doesn't change as you zoom in. In other words, if my lens is set at f/2.8, and I have to quickly zoom from 70mm to 200mm,

the lens will stay at f/2.8. My exposure and my shutter speed will also stay put, right where I set them. (Unless the camera is set to P mode: Then it will make automatic adjustments. If set to A mode, my f-stop stays the same, but the shutter speed might adjust, depending on the scene.) I value that constancy. It's one less thing to worry about in the midst of all the other stuff out there waiting to jump me.

Fast and fixed aperture telephotos tend to be expensive. There are now, however, a variety of telephotos on the market in the 70–200, 70–300mm ranges that are quite good and a bit cheaper; they are referred to as "variable f-stop zooms." A popular range of f-stops for these lenses is f/3.5 to f/4.5 or f/5.6. When you zoom a variable f-stop lens from wider to longer, the f-stop will change. The lens will get "slower."

Why is this important? As you zoom to telephoto, and the lens closes the aperture down, your shutter speed needs adjustment to maintain the same exposure. In manual mode, you have to be conscious of doing this yourself, but if you are in one of the autoexposure modes, the camera does it automatically. With the aperture closing down (letting in less light), the shutter speed requires more time to compensate for that loss of light. A slower shutter speed combined with a long lens can make for shaky, out-of-focus pictures.

So be careful! Remember what I said about choosing wisely: If your mission, once again, is to shoot kiddie soccer and the games occur mostly in daylight hours, a variable f-stop telephoto could suit you just fine. There's lots of light outdoors in the daytime, generally speaking. But if the games are at night or your student athlete is, say, a basketball player running around in poorly lit gymnasiums, you may want to consider the more expensive, fixed, fast glass.

A tremendously useful lens like a fixed and fast long glass is not a specialty item. A 70–200mm does

Gymnast, 200mm, 1/500th at f/2.8, ISO 1,600

Wind farm, 400mm, 1/1,600th at f/4, 1,600 ISO

a lot for you, and it is all-purpose. Because of its midrange lengths, it is neither too heavy nor too bulky for a typical camera bag. But, despite its applicability to so many situations, it will fall short (literally) if you are going after more exotic and elusive subjects, such as wildlife.

Depending on your quarry, this very rewarding but arduous (and sometimes frustrating) kind of photographic endeavor can require something beyond 70–200mm. There are 300s, 400s, 500s, 600s and more. These very large conglomerations of glass in a tube may be essential should you embark on that once-in-a-lifetime African safari or wilderness trip to Alaska with the intent of

getting great lion or polar bear pictures. Gigantic lenses such as these are weighty and extremely challenging to hold by hand. Therefore, other things have to come along to provide stability, like monopods and tripods.

In short, this gets to be a lot of work. I advise venturing into these big-number lenses only if you are absolutely committed to a subject matter that demands their use. But yes: If, for example, birds are what make your heart take flight, then big lenses with a bunch of zeroes attached to both their millimeter lengths and their price tags are pretty much requirements. Beware as you enter this market. In the telephoto world, there are lenses (and companies that make them) that promise to do it all. One-stop shopping: "Yep, the Grand Master Zoomer! This here 65 to 892 millimeter variable f-stop son-of-a-gun with the hydraulically assisted autofocus and a built-in level is just the ticket! Leave your other glass home. This lens is all you need!"

Very seductive. And very untrue. Remember: The longer a lens zooms, the more distance those glass elements inside the barrel travel, with potential degradation of quality, sharpness, brightness and speed. At the camera store counter, play with the lens. Does it feel comfortable in your hands? Is the autofocus quick to respond? How heavy is the lens? Is it dark to look through? Is it a brand name? All of these factors affect how much use and enjoyment you will get out of your new lens in the field.

And, with lenses, the phrase "you get what you pay for" is very, very true.

Sea lions on a submarine, 135mm, 1/125th at f/6.3, ISO 125

# [DOS AND DON'TS]

There are those who would have you subscribe to the "rules" of photography: "Always have the sun at your back!" "A 50mm lens is best because it approximates 'normal' vision!" Then there are those, like yours truly, who say: "Hooey! Rules are meant to be broken."

Yet one of these rules is actually rooted in common sense *and* the laws of physics: Never use a shutter speed slower (lower in number) than the length of your lens. So, if you are shooting with a 200mm lens, then your shutter speed should be about 1/250th of a second. The smaller the focal length of the lens, the physically smaller the lens gets, and the easier it becomes to hand hold for sharp results. Hence, with a 50mm lens, you could get away with, roughly, 1/60th of a second.

This is pretty logical, actually, and in the early stages of shooting and using various lenses, it is a wise rule to observe. The faster your shutter speed, the sharper your results, because the speed of the shutter will help you avoid camera shake, and it will also freeze your subjects if they move. All good stuff.

But photography, that very situational, unpredictable art and craft, refuses to be constrained by logic or rules. You'll find yourself in situations where improvisation and quick thinking trump the manual. And, if you push yourself and work at it, you can produce surprising results, even from scenes in which you thought the best move would be to just leave the camera in the bag and go have a latte.

In 2000, with the Olympic Games in Sydney, Australia, coming up, I shot a story for *National Geographic* on the limits of human performance. It was all about how high, fast and far the body can go. I spent time with U.S. Navy SEALs, shot Olympians in training, and covered the New York City Marathon, a yearly grind through the five boroughs of the city that, amazingly, draws close to 40,000 participants.

My mission here was simple: Emphasize numbers. Show the readers how many people had taken to running as a way of staying in shape. The obvious picture to get was near the start, as thousands of participants began their 26.2-mile journey by crossing the Verrazano-Narrows Bridge. (It's amazing to watch. On a suspension bridge designed for the smooth horizontal flow of traffic, you can see the cables shaking as this teeming horde of leg-pumping, arm-churning runners bounces its way across the span.)

The cleanest vantage for seeing the massed runners is from the air, meaning via a helicopter, a pricey piece of equipment to rent in New York. On marathon mornings, I have counted no fewer than 15 helicopters circling the bridge like a small swarm of bees.

## DO THIS FIRST

Hold steady! When shooting with a telephoto lens, you have to work at keeping it stable. It will magnify any vibration, and your picture might look blurry. Tripods will steady the camera, and there are postures, too, that help the shooter keep the camera still. General tips in the last chapter of our book will discuss some of these.

**"Photography, that very situational, unpredictable art and craft, refuses to be constrained by logic or rules."**

New York City Marathon on the Verrazano-Narrows Bridge, 200mm, 1/500th at f/8, ISO 100

I wanted to work with the lines of the bridge and "stack" the runners, or create a frame that was so chockablock with bodies it looked like they might extend forever. This is a mission for a long lens, the longer the better. "Stacking" refers to the ability of a long lens to compress a scene, in this case, the moving mass, which, shot with a 600mm lens, looks as if it's made of bodies running on top of one another.

Hand holding a 600 from the open door of a helicopter on a blustery fall day isn't logical—and certainly doesn't conform to anybody's rules. Shooting on ISO 100 transparency film (this millennium marathon occurred just prior to my conversion to full-time digital shooting), I had to perform a delicate but strenuous dance among the three tent poles of proper exposure: ISO, aperture and shutter speed.

- ISO: I wanted to keep it as low as possible for sharpness and detail. At high ISO, the runners would look like bits of film grain, which nowadays would be called digital noise.
- Aperture: I needed at least a little depth of field, so I kept the lens between f/5.6 and f/8. Thankfully, greater depth of field lives out there at the distance I was shooting.
- Shutter speed: It had to be fast, but not too fast. That would have required jacking up the ISO to unacceptable levels. But it couldn't be slowish, given the size of the lens and the fact that my shooting platform was a wind-buffeted, vibrating bucket of blades and bolts.

I ended up shooting 1/500th of a second, bouncing between f/8 and f/5.6. I leaned back into the chopper, using my body to buffer the camera and lens from the vibration and shot like mad one frame after another. The field of view of a 600mm, as we have seen, is very narrow, so with the wind conditions corkscrewing the bird around in the air, it was difficult to line up the graphics of the bridge cleanly. Out of several rolls, only one or two frames really sang.

But that was enough. I knew I couldn't go back to my editors, and say, "Well, it was just too hard to shoot the big lens." This is difficult work, sometimes. At those times you just have to grit your teeth, take a chance and break the rules. Here it worked out. The marathon shot ran as a two-page spread in the magazine. But behind the shot was a plan, and the risk of the telephoto proved worth it. The wider shots had dimension and depth and certainly were easier to shoot, but the editors bypassed them. The big lens ruled that day, and to use it, I had to break the rules.

**JOE'S TIP**

When shooting with a telephoto lens, remember the following:

CHECKLIST ☑:
- ☐ Keep the lens stable, perhaps using a tripod, or at least brace yourself well.
- ☐ Remember to keep your shutter speed high, so that you can shoot these bigger lenses sharp.
- ☐ If you want to retain some DOF, set your aperture to about f/5.6 to f/8.
- ☐ Practice holding long lenses! As in archery, it's all about stillness and muscle memory. As you get more comfortable, you'll be able to shoot with telephoto lenses at slower shutter speeds than you thought possible.

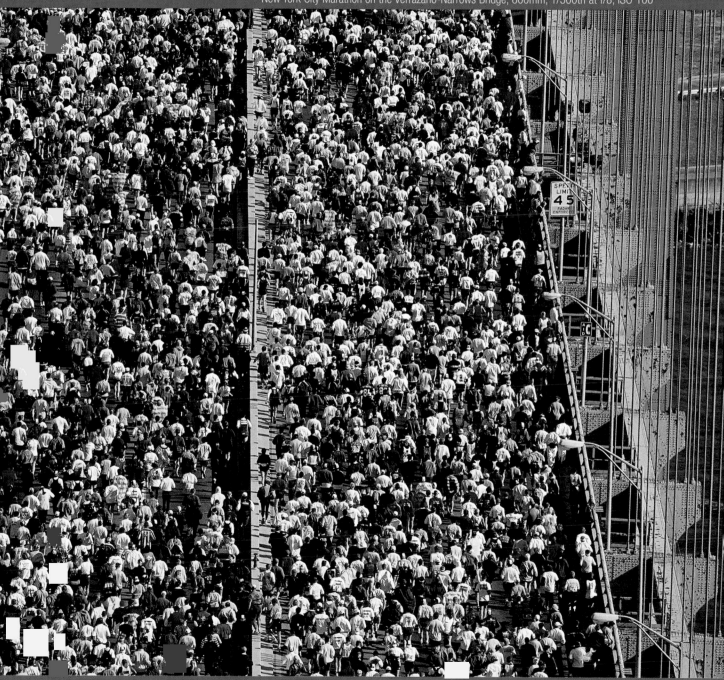

New York City Marathon on the Verrazano-Narrows Bridge, 600mm, 1/500th at f/8, ISO 100

# [PORTRAITS AND DOF]

There are lots of buttons, dials, clicks and wheels on today's versatile and powerful digital picture-making machines. They all have their own functions and sets of numbers: 1/125th! Half a stop! Plus one EV! And f/6.3! Different from f/3.5!

It would be easy to face this onslaught of calculations and just surrender. Give up, dial the camera back to P and let it do the math. This is understandable. Picture-taking is supposed to be great, passionate fun. Factoring, say, exposure relative to DOF in a backlit situation can be pretty tiresome. But here's the thing: Every single one of those buttons and numbers means something to your photograph. And although they are just numbers, they have enormous impact on the aesthetic of the picture, determining whether it's any good or not.

Let's take a look at a couple of portraits to see if depth of field has anything to with whether each image works or not. I made the first picture of this lovely Hawaiian dancer with a lens set at 86mm, at 1/125th of a second at f/14. It is a solid exposure across the board. The foreground and background are well exposed; the sky is a rich blue. From a technical standpoint, I did well. But is it successful creatively? Hmmm . . .

It's not my favorite frame, to be sure. One of the problems is the choice of f/14 and its resultant huge depth of field. Front to back, there is tremendous detail and sharpness, and this works against the success of the photo.

*Hey, wait a minute! I thought pictures were supposed to be sharp!* True enough, but in portraiture, most times, you strive for selective sharpness. What's sharp and what's not send a powerful message to the viewer. You are saying "Look here! Not there!" You drive attention to your subject's eyes and face. The rest of the frame is supporting cast. Those other elements contribute information and are the staging. They are not supposed to overwhelm.

## DO THIS FIRST

Be aware of how much DOF you have in your image and, equally important, what is contributing to that DOF and what can be adjusted. Do you have too much or too little for the desired effect? If so, focus on the three things that govern the outcome: length of lens, size of aperture and closeness of the camera to the subject. If you're not where you want to be, change lenses, adjust your aperture or move up or back.

**"In portraiture, most times, you strive for selective sharpness. What's sharp and what's not send a powerful message: 'Look here! Not there!'"**

Hawaiian dancer, 86mm, 1/125th at f/14, ISO 100

Hawaiian dancer, 200mm, 1/5,000th at f/2, ISO 100

In the 86mm shot on the previous page, those elements do overwhelm by virtue of their dead-bang crispness. You can barely discern where the leafy headdress the dancer is wearing stops and the tree behind her starts. She looks like she's standing in front of that big plant in *Little Shop of Horrors*, and that sucker is about to swallow her.

But in the midst of this relative failure (not *total* failure—maybe the Maui Chamber of Commerce would like this for a brochure), I did notice something: The dancer had a luminous smile and a real twinkle in her eyes. Immediately, I knew that's where I wanted to go. I needed to isolate those elements.

That would be tough to do with this midrange lens and all those f-stops. So I switched up and went telephoto, to 200mm. Remember I said that telephotos reach in to parcel out a scene? They get the details of the face—and little else—used close in this way. Near the greenery was a pool with a waterfall, so I asked the dancer to get in the water, and I got wet, too, lowering the lens right at water level. The waterfall splashes directly behind her, but it is just lively texture and patterns. The focus is on her face, specifically her eyes, which are sparkling.

Only the face is sharp because I shot the lens at f/2, as wide open as possible: Small number, big hole in the lens. Minimal depth of field—razor thin, in fact. You still know you are in the islands, with the leaves and the water. And you are engaged by her wonderful expression and directness. You look nowhere else because there's just the hint of atmosphere, not a cacophony of it, screaming for attention.

All those numbers add up.

## JOE'S TIP

When you are taking this kind of portrait, and you decide that shallower DOF is what you want, remember the following:

CHECKLIST ☑:

☐ Visualize the portrait. Decide what crucial elements you want sharp. People ask me all the time, "What's the key thing to make sharp?" My answer, when dealing with portraits, is, "The near eye." This doesn't matter so much with the dancer here—both eyes are in the same plane of focus—but it has proved a useful strategy for me over the years. You'll come up with your own rules of thumb, and I hope some of them are derived from these pages. As you go forward and gain experience, trust them. Rely on them. Lean on them. They will be the foundation for the shooter you become.

☐ Open up your aperture as far as you can, to f/1.4, f/2.0 or f/2.8.

☐ If you want truly minimal depth of field, go with a longer lens and fill the frame with your subject: Push the lens in close.

# MACRO SHOOTING

I GUESS IT CAN BE CALLED SHOOTING. I mean, pictures are being made, right? But it's not in any way freewheeling, the way the term *shooting* implies. It's not chasing light or action or trying to capture that nuance of expression that defines a portrait subject.

Colorful feathers, 123mm, 1/125th at f/5.3, ISO 100

I have generally avoided closeup photo work. For me, this falls into the life's-too-short category. *Excruciatingly slow, tedious* and *painstaking* are all adjectives that come to mind.

But also, then: *Beautiful, intricate, fascinating.*

Macro shooting is applied photography. It is not firing off frames for a lark. It is taking a camera and lens on a narrowly defined mission. There are parameters and concerns that make this exercise

more of a study than "a shoot." Shooting small stuff can create big photographic headaches, to be sure, but venturing into the world of the very small can yield very large rewards.

Using a closeup, or macro, lens opens up an unseen universe to the photographer. From tiny flowers to minuscule bugs, there is much that is hidden, explosively colorful and dreamlike. Macros reveal texture and patterns that can be observed only as the camera moves relentlessly inward.

Concerns abound, as mentioned, many of them involving the issue of focus. Depth of field is razor thin when working close. Exactly how thin depends on the chosen f-stop and how near the lens is to the subject. Closing down the aperture to extremely

Laser light through a diamond, 105mm, 1/125th at f/4, ISO 100

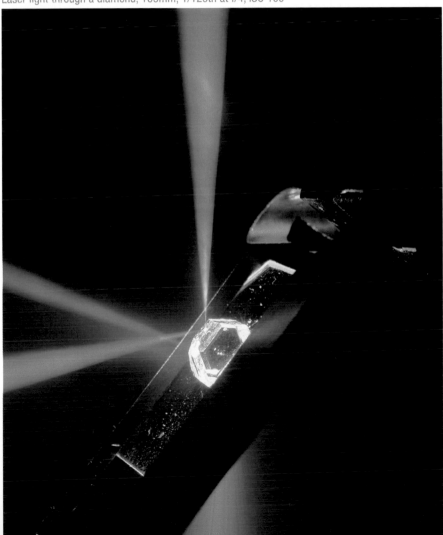

small openings, such as f/22, f/32 and the like will increase depth, but it will also require longer and longer shutter speeds, which in turn mandate a tripod. No worries when the object is fixed, but for, say, a flower in a field, even the slightest of breezes will cause movement that a slow shutter speed will not stop. The result? A blurred flower.

A strategy for the above scenario is to go to "consecutive high" on the motor drive, or frame rate, of whatever camera you're using. Blasting through lots of pictures of a flower that does not change attitude or expression may seem excessive, but the fast-moving camera can, with luck, catch the posy just at that split second it is absolutely still. Sheer volume here can help accomplish the mission at hand. But then of course there is the issue of "mirror bounce." The interior workings of the camera as it swings the mirror up and out of the way of the sensor may in and of itself cause vibration at super-slow shutter speeds. Experienced still-life and closeup photographers often lock the mirror up after framing and focusing the shot.

Another way to increase depth of field without dangerously slow shutter speeds is to raise the ISO—and live with the resultant loss of quality (sometimes minimal with minor increases, but if you

Frog closeup, 300mm, 1/200th at f/40, ISO 100

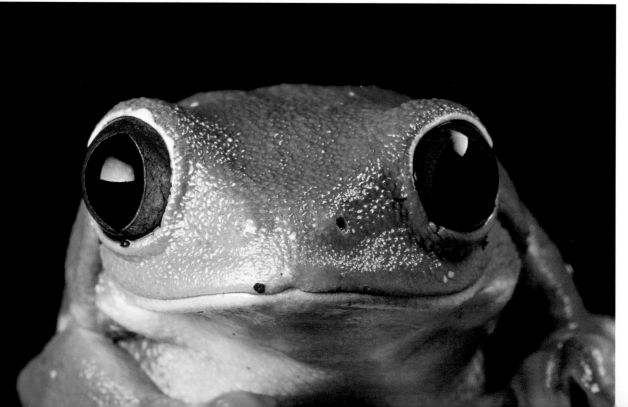

push ISO too high, image quality may seriously degrade). Yet another approach is to light whatever detail you're shooting with flash.

One thing I hope you are picking up on as this book progresses is the "horse trading" that goes on in almost every photographic strategy or equation. Want more depth of field? Okay, that means slower shutter speeds. Don't want that? Okay, jack up your ISO, and if you go really high ISO-wise, the picture will lose vibrancy. Want minimal depth of field for a portrait? Okay, but then part of the face might be a little soft, and the background will be completely out of focus, thus eliminating the sense of place. If that happens, you don't know where your subject is. No good, you say? I *need* to know where the subject is and what the environment is like. Okay, once again, close down your aperture, and lengthen your shutter speed. Oh, but a person might not be able to hold steady for that long a shutter. Well then, better use a flash. Or get a tripod. Or . . .

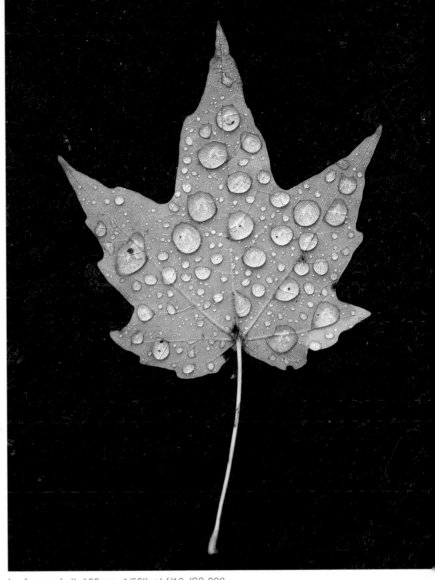

Leaf on asphalt, 105mm, 1/50th at f/10, ISO 200

There are myriad minute calculations that need to be made as you approach any shot. As you shoot more and more frequently, these calculations will become not only more and more accurate, but also intuitive. One area where the calculations will forever be a bit more consuming and precise is in the world of closeup photography. The closer you are, the more unforgiving the tolerances that impose themselves.

With macro lenses and closeup techniques, it is a small world, after all, with smaller margins for error.

# [SHALLOW DEPTH, DEEP DEPTH]

There is no better way to see depth of field disappear than to use a lens in close. The closer you get to your subject, the more and more minimal the depth of field.

Many of the new cameras, both pro and "prosumer," have lenses in their lines that will go to closeup, or macro mode. Some are all-purpose lenses that can be shifted for close work with the flip of a button or switch. Others are simply called macro lenses, and they will seamlessly focus from normal working distances to really, really up close and personal.

Again, one characteristic all of these lenses share is increasingly limited DOF the closer they get to the subject. One way to compensate, of course, is to click the f-stop to a larger number, which represents the smaller aperture openings. Many of these closeup lenses have smaller-than-normal aperture options and will close down to f/32, or even f/45.

Closing down the lens, as already discussed, gains you back some of the depth you lost when you pushed in close. Take a look at this series of pictures, and watch, as they go from f/3.3 to f/40, the range of what is sharp increase in each sequential frame. Shallow depth of field to deep depth of field, with just a few clicks.

## DO THIS FIRST

If you have a lens that can go closeup or macro, a useful exercise is to shoot a subject throughout the aperture range. Then you know the depth of field the lens can give you at certain settings and distances. You can then select the setting you want for your desired effect.

> **"Closing down the lens gains you back some of the depth you lost when you pushed in close."**

## JOE'S TIP

For closeup shooting:

CHECKLIST ☑:
☐ Use a tripod. Shooting handheld closeups is tricky.
☐ This is an opportunity to use a cable release, which keeps your hands off the camera and eliminates any possibility of shake. I discussed this device and its use more fully on page 48.

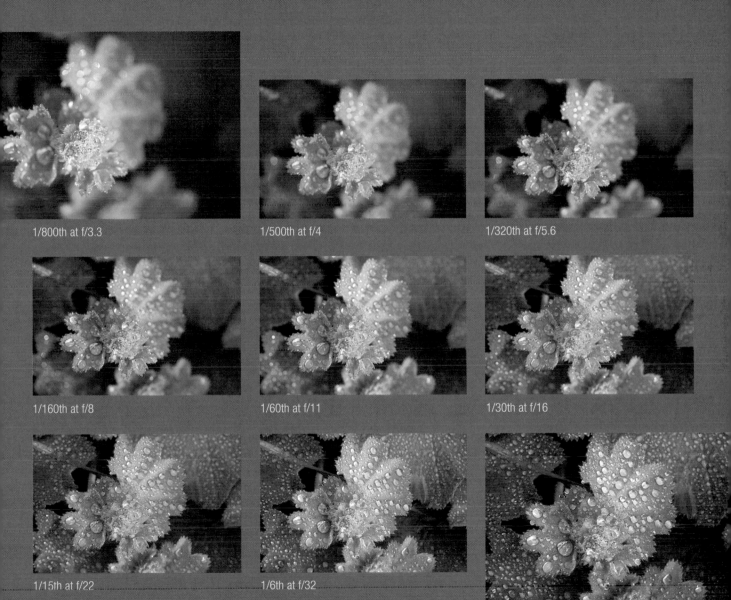

1/800th at f/3.3

1/500th at f/4

1/320th at f/5.6

1/160th at f/8

1/60th at f/11

1/30th at f/16

1/15th at f/22

1/6th at f/32

1/6th at f/40

# MOTION

WE BECOME DESPERATE, ON OCCASION, TO STOP THE WORLD. The great strength of photography is its ability to slice time and preserve moments. At many of the great news events of our era, there have been still cameras shooting side by side with video or motion film cameras. What do we, the general public, generally remember? The still image. My sense of history, and my memory, is written in still images. So how do you show motion when the camera in your hands is called a "still" camera?

Hmmm . . . Another one of those photographic paradoxes. Remember that when the aperture numbers get big, the opening gets small? This is another one of those.

Panning with an Olympic runner, 600mm, 1/30th at f/4, ISO 400

There certainly will come times when you'll want to show motion or, as I often put it, "the notion of motion" in a still frame. You'll want the viewer to know that this subject is on the go. Fast movement is a powerful thing to convey. It can signify importance (this person has to be somewhere in a hurry), a sense of emergency (even life-and-death situations) or effort and competition (runners charging, legs and arms pinwheeling into a frenetic blur).

Confronting a fast-paced world, we hold a camera designed to stop things dead in their tracks. What to do? Well, we can redirect the instrument, via the mechanism of shutter speed. As I've mentioned, shutter speed goes hand in hand with aperture. Together, working in concert, they produce a proper exposure.

Remember when I said that each full f-stop click represented either twice or half the light, depending on which direction you were clicking? Same thing with shutter speeds. The speed of 1/250th of a second is twice as fast as 1/125th of a second, meaning it lets in half as much light as 1/125th. Go in the other direction, and the next full stop on the shutter speed dial is 1/60th of a second, which allows in twice as much light as 1/125th. It is a slower shutter speed than 1/125th.

(Please note that I am referring to the traditional full clicks on the dial, both for aperture and shutter speed. Most digital cameras now available have options in between the traditional full clicks of either the shutter speed or aperture dials. On the way to f/8 from f/5.6, for example, you can stop at f/6.3 or f/7.1. In between 1/125th and 1/250th live 1/160th and 1/200th of a second. These numbers may vary among camera systems.)

By adjusting your shutter speed, you can dictate whether you freeze a fast-moving object or let it blur through your frame to indicate motion. Obviously, faster shutter speeds stop things. Generally, it is accepted that to stop reasonably

fast motion, your shutter must be no slower than 1/250th of a second. But, of course, there is fast—and there is *fast*. A basketball player at the top of his jump? A 1/250th setting will handle that pretty well. The overhand serving stroke of a top tennis player? No way. At 1/250th, most of the subject will appear sharp with a bit of trailing motion in the extremities, such as arms, hands, legs and feet, which almost always move faster than the core of the body.

Experiment! Your camera is likely to feature shutter speeds as fast as 1/4,000th or even 1/8,000th of a second. Click around the dial. See what works. Remember as a general rule of thumb: The closer the action is to you, the faster it will move through your frame, relative to your position.

Freezing an Olympic swimmer, 600mm, 1/500th at f/4, ISO 800

## PANNING AND BLURRING

There is a difference between "panning" and "blurring." Blurring of your subjects may occur when you use a slow shutter speed (just what counts as "slow" will vary relative to the speed of your subjects). Hold the camera steady, then let the subjects just flow through the frame, creating their own patterns and swirls. With blurring, a workable range of shutter speeds could vary from 1/15th to about 1/60th of a second. Obviously, a slower shutter produces greater blur, creating more of an impressionistic look for the subjects while, because you are holding the camera still, the world around them remains sharp and discernible.

Panning is different. Again, you need to choose a shutter speed that will produce the hint of motion for the subject. A ballerina at Lincoln Center will require a different set of shutter speeds than, say, a toddler at her dance recital. But the technique here, different from simple blurring, involves moving your camera and lens along with the subject. That way, the world dissolves into a blur, and the subject, if you do it right, will stay approximately sharp. Panning takes practice! It can be a wonderful technique at a horse race, a car race or, as you see opposite, a foot race.

Quick note: When I pan the camera with a moving subject, I don't generally like to use a

tripod, even though there are shooters who would insist that it is essential for this technique. I find it gets in the way, actually impeding the fluidity of the movement I need to make as the action crosses my view. One good thing that happens as you slow your shutter in order to pan with action is that, correspondingly, your f-stop has to close down to maintain proper exposure. That means you pick up depth of field. The extra range of potential sharpness is very handy when everything, including the camera, is in motion.

Panning a leaping dancer, 87mm, 1/125th at f/6.3, ISO 200

# [TIMING]

The fanciest camera in the world won't be able to follow action and stop it at its peak. Only you can do that. Timing, when it comes to capturing a moment, especially if that moment involves a fast-moving object, is everything. Practice is key.

Also key? Research. Know the sport, the ballet piece or the road race. Do a little reading. Review the program and know just when the trumpets will sound and the cheerleaders will execute their amazing flying pyramid move. Anticipate. Keep your eye in the lens. Put the camera on consecutive high frame rate, and put it into its most efficient autofocus mode. At most events, especially sporting events, there are always distractions and noise. Block it all out. Don't get caught (as I have) watching slack-jawed, camera down at your side, as the touchdown you were supposed to photograph is being made.

Go for the high moments. Stay ready. The highest moments usually come around only once.

Olympic gymnast in midair,
400mm, 1/500th at f2.8, ISO 800

## DO THIS FIRST

Locate yourself well. You child will start the race only once. Be prepared and in position to freeze that moment in time and to get the shot that you already see in your head. You know what she looks like when the beeper goes off. Put yourself in a confident position to render what you already see. This means asking questions—of spectators, officials, coaches. Can I stand here? When's her heat? Is it "Ready, set, go!" or "Swimmers, take your mark. *Beep!*" You're dealing in a world of split seconds. You must be ready.

## JOE'S TIP

To get ready for a shot like this, remember to do the following:

CHECKLIST ☑:

☐ Set your camera to consecutive shooting. (When you press the shutter, it'll just keep shooting until you let up or until the "buffer" gets filled after a certain designated number of frames, at which point the camera shuts down.) Depending on the camera model, you may have "consecutive low" and "consecutive high." Go to consecutive high. This will give you the most frames per second (FPS) that the camera is capable of.

☐ Set your camera to the best autofocus for action (you may want to check your instructional manual for this).

☐ Set a high shutter speed to freeze the action, at least 1/500th or even higher.

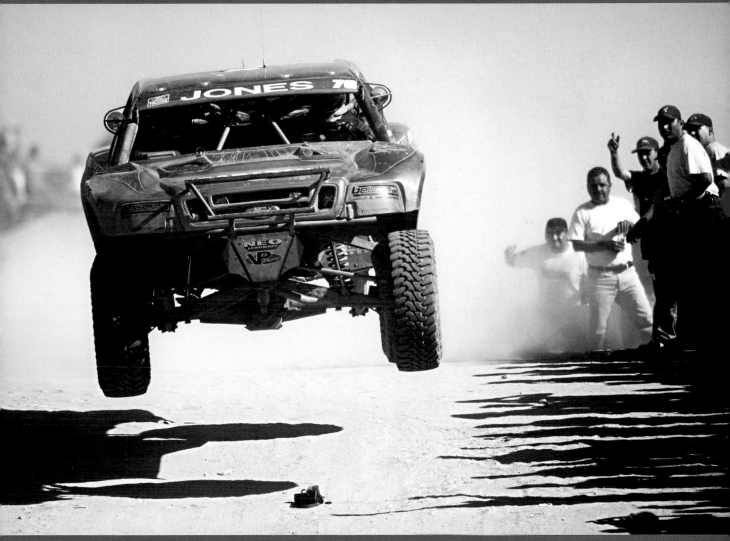

Baja racing car takes flight, 600mm, 1/5,000th at f/2.8, ISO 200

"Practice is key.
Also key?
Research."

PART **THREE:**
# [DESIGN ELEMENTS]

# TEXTURE

EVER SEE A PICTURE YOU COULD SMELL? Or one that made you itch, at least subconsciously? Chances are it is a picture filled with texture. Pictures that sum up phrases like "smooth as silk" or "hard as a rock" are generally studies of textures that both the natural and man-made world have to offer. When you hold your camera to your eye, remember to think about not only how a texture looks but also how it feels.

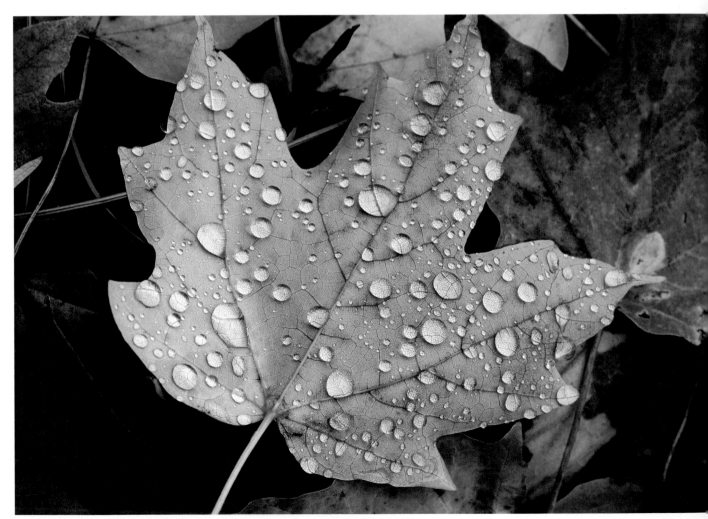

Drops of water on a blanket of autumn leaves, 105mm, 1/100th at f/10, ISO 200

Grooves in the bark of a tree, 300mm, 1/6th at f/5.6, ISO 200

Redwoods and moss, 30mm, 3 sec. at f/22, ISO 100

Purple blossoms among tangled vines, 60mm, 1/40th at f/8, ISO 200

## QUALITY OF LIGHT

The ever-important photographic constant, quality of light, has to be right there with you in an adventure with texture. Soft light drapes itself on silk, for instance, the same way silk drapes itself on our bodies. Hard sidelight thrown on sand, for example, creates the minute, endlessly repetitive shadow and light pattern that reminds us of how scratchy it is. This is very powerful because you engage not only the viewer's eyes but also the gut and the memory.

If you can make a person flinch with a picture of the shiny, metallic edge of a razor or shudder with cold at a picture of snow crystals, you're cooking. You've hit them not only between the eyes, but also in the heart.

Peeling paint on a fence, 15mm, 1/60th at f/5.6, ISO 200

## SENSORY AND TACTILE TEXTURE

Texture abounds. It is everywhere, in both the natural and manufactured worlds. Texture is a measure of how closely all of our senses are interconnected. Texture, which is about touch, constantly beckons the camera, which is about a visual sensation. When you combine the appearance and details of a surface with the right light, the resulting picture engages not just the viewer's eyes but also his or her nose, fingers, tongue.

Flaking paint on the back of a boat, 22mm, 1/20th at f/6.3, ISO 100

Coiled rope aboard a ship, 157mm, 1/10th at f/10, ISO 200

You can wrap yourself up in a good picture rife with texture in the same way you wrap yourself in a soft blanket. There's virtually no end to the reactions you can produce by shooting texture effectively. You can make somebody go "Yuck!" or make a viewer put the photo down, go immediately to the fridge and grab a bucket of ice cream, then add cherries and chocolate sauce.

Rusting ship, 200mm, 1/5th at f/8, ISO 400

# [TELLING A STORY WITH TEXTURE]

Vaulted ceiling, 200mm,
1/30th at f/5.6, ISO 64

I'm a people shooter. Give me a person and I can make a picture of him or her. Occasionally, it might even be a good picture. People are what fire my imagination and drive me when I'm working behind the camera. People are unpredictable, nuanced, weird, beautiful, awkward, shape-shifting creatures. That's why when I do a portrait session, and it's the same light, the same camera and the same lens for dozens of photos, I am still looking and hoping to find that one moment that defines that person, or at least the person at that moment. That one, impossible-to-force moment when my subject just owns the camera, and I can't help but hit the shutter.

When *National Geographic* came calling and asked me to do a story on a largely deserted island in the middle of New York Harbor, I of course said yes; you usually say yes to *Nat Geo*. But then I spent the better part of a couple of months puzzled and terrified about telling virtually an entire story without a single photo of a person.

Ellis Island, once the busiest immigration center in the United States, was then in the process of reconstruction and development as a museum and tourist draw. I had to show that process in rough terms and what the main museum building was going to look like. But also, very important, I had to show the "feel" of this island, long left derelict, and somehow convey what it might have been like when it was filled with a swirling mass of humanity.

For so many people, this landfall represented their first steps into a new world. But those people were long since gone. The clamor, bustle and desperation of Ellis in its heyday were now just echoes down long, deserted hallways. It was empty, achingly so. How to conjure the feel of all that ancient angst? How do you photograph a bunch of ghosts?

Texture. Show the age and decrepitude. Make the viewers feel what it was like. Make them hear the voices. Transport them, via their memory and perception, right there to those rotting rooms. Take a picture of a dusty doorknob that beckons them to turn it. Show a wall so shabby—cracked, its paint peeling—it appears to weep from all that it witnessed.

To do this effectively, you have to speak in the language of light. While not an absolute, the most evocative light of the day occurs at sunrise and sunset. So, for about a month, my life revolved around this tiny island, at those times of day. Talk about ghosts. Wandering in the predawn gloom through halls, medical wards and even the crematorium was downright unsettling. Armed with my tripod, I would

## DO THIS FIRST

A great photo exercise is to take a word that describes a sensory perception—*soft, hard, rough, smooth*—and take a picture that expresses that feeling. This often involves the rendering of textures. When shooting texture, fill the frame. This is not about "the big picture," and it's certainly not about panoramic shooting or "busy" photographs. It's about detail, intimacy and connecting with the viewer's emotions and senses, which means that, when you have a camera in your hands, you have to connect with your own. By now, you know how to use your settings to move toward a lush rendering, and also how to capture detail. Use what you know to capture—to create—texture.

Abandoned corridor, 24mm, 1/15th at f/11, ISO 64

**"When the light hit the patina and texture of the place, the walls did seem to talk."**

poke open a door that led to blackness, hearing the fluttering and scurrying of pigeons and lord knows what else. Being possessed of a brain more than slightly bent from countless bad movies, I would call out, "Freddy? Jason? You guys in here?" (Photographers, many of whom spend extraordinary amounts of time alone and in foreign or strange places, tend to develop their own mechanisms for survival and amusement.)

But then! The light would come up, hard, warm and slanted, and grace a chair, a door, a wall. In the play of highlight and shadow on human artifacts, I found a way to tell the story. And even though I shot this series on film, a long time ago, it remains one of my favorites. The principles I worked on here

with a film camera in my hands remain true to this day, as I continue to tell stories with ones, zeroes and pixels.

When working in spaces such as this, you basically have to follow the light. And, as they say in Photoshop, black conceals, white (light) reveals. As the sun would come up, this dark, creepy place would begin to glow. It was like watching the cover of an old, leather-bound book slowly being opened. Under that cover lay the richly detailed pages, an account of what happened here. That which is left behind is often just as telling as that which gets taken, so I concentrated on those relics of humanity that remained.

When the light hit the patina and texture of the place, the walls did seem to talk.

Deserted hallway, 35mm,
1/60th at f/8, ISO 64

Abandoned file drawers, 35mm, 1/15th at f/11, ISO 64     Scale in a medical office, 50mm, 1/60th at f/8, ISO 64

## JOE'S TIP

In the midst of all this poetic photographic reverie, you still have to remember why you are in a particular location: to tell a story, concisely and effectively. You're not there to chant, pray to the sunrise or play shadow games. The light moves fast, and what is beautiful right now will lose its charm in a matter of minutes as the sun travels. So you have to work fast, and it is important to observe good photo basics.

First off, stay calm. That wonderful wash of early or late light can make you lose your mind. Do not allow whatever striking environment you find yourself in to overwhelm you. You look everywhere, and everything—every single thing—looks great. So you try to shoot everything, and when you get back to your laptop and launch the images, it turns out you've shot . . . nothing.

Be disciplined. Make sure to fill the frame with texture and detail.

Pay attention to the quality of light. Does it complement or enhance the texture of what you are shooting?

If you are shooting wide, it is a very good idea to anchor the foreground of the photo with a lead or important element.

But, once you have the foreground locked, don't get cocky. Remember that the middle and background of the photo, if not handled properly, will absolutely torpedo your carefully crafted foreground.

To capture texture, presuming the subject is static and doesn't have a time schedule or an appointment, shoot multiple frames and bracket. As I've explained previously, this means making several exposures on either side of the scale, over and under, as well as the presumed "correct" exposure. I generally discourage bracketing when shooting people because you could lose the crucial moment in one of your incorrect or poorly exposed brackets. But when you're looking at a texture that is unchanging for the next little while, have a go at it. Shoot a bunch of frames while varying your f-stops and shutter speeds.

Speaking of f-stops, when shooting texture, you may want a touch more depth of field (what's sharp in the photo) than usual. Front to back, you could well want all that crinkly, gnarly, interesting stuff you are shooting to retain sharpness and depth (perhaps more so than if you are shooting a portrait). So crank the f-stop dial to the higher numbers (smaller lens opening). More of the subject matter will be sharp.

CHECKLIST ☑:
☐ Remember to fill the frame.
☐ Anchor the foreground.
☐ Observe the quality of light.
☐ Consider bracketing.
☐ Set your f-stop higher.

# PATTERN

OBSERVING PATTERNS IS one of the most arresting and intriguing things you can do with a camera. Patterns can be rhythmic and smooth, luring and lulling the eye as they roll out in endless fashion. Or they can be as sharp and loud as a drumbeat, stopping you cold with their jagged pace and color.

Lobster buoys, Cape Cod, 28mm, 1/640th at f/8, ISO 200

Weathered chains, Oregon,
300mm, 1/20th at f/2, ISO 100

Jet fighters flying in formation, 900mm, 1/800th at f/7.1, ISO 100

The head of an elk above the grass, Yellowstone National Park, Wyoming, 600mm, 1/250th at f/7.1, ISO 100

## THE PATTERN GAME

As a photographer you play a game when your eye confronts a pattern: How much of it to show? How little? Do you embrace the entire pattern as the sole drama of the photo you are about to take, or do you truncate it, using the lens as a scalpel to slice only a piece of it? Yes, a pattern is interesting—but a pattern interrupted can prove even more interesting.

Rain in a forest of lodgepole pines at Yellowstone, 255mm, 1/20th at f/13, ISO 100

Test chamber in the National Ignition Facility, California, 24mm, 1/60th at f/5.6, ISO 100

Water beading on metal, Bar Harbor, Maine
157mm, 1/200th at f/16, ISO 100

# [BREAKING YOUR PATTERN]

One of my first successful, even exhilarating, moments behind the lens yielded a picture of a pattern. That day I made a photograph of a grid of windows in a dormitory in Syracuse, New York. Now, attaching the word *exhilarating* to the experience I just described may sound a bit over the top. But I don't get out much, so just the tiniest bit of excitement often suffices.

I remember distinctly that the feeling I had that day, at that moment, with my father's Beauty Lite III range finder camera in my hands, is the exact same feeling I get today when I make a good frame with my turbocharged, computer-driven digital camera. And describing the feeling as exhilaration is, frankly, pretty accurate.

A couple of things happened that gray day in Syracuse. I was pursuing a pattern, and that which draws your eye when you first start taking pictures is a good indicator of what will forever elicit your interest. To get this particular picture, I had to walk into hedges and climb over a couple of bushes. No big deal, but technically, I was standing where I was not supposed to be. It felt subversively good. I might have intuited right then and there that to do their jobs, to get the best photos, to tell a true story, photographers often have to go where they are not wanted or where they are not supposed to be. They have to stand apart from the crowd, find a way, find a spot and become the eyes of all those folks who cannot be there at that moment.

Sticking with patterns: Whether it's the rolling dunes of the Sahara or the repetitive steel and glass of Manhattan or the side of a Syracuse dorm, patterns abound and are rich fodder for a lens. Some patterns shout and grab your eyes so thoroughly that they are the visual equivalent of a Marine drill sergeant getting in a recruit's face. "Can you hear me, son! Are you going to use that camera or just stand there?" Others present themselves much more subtly, and whisper. Still others live inside that which is large and ugly. An intersection in a big city might be an absolute zero as picture material, but the manhole cover in the middle of the road, with 20 years of tire marks on its weather-beaten exterior, might be stunningly beautiful.

Light can create the pattern. You'll pass up a grassy field in flat light—there's simply nothing to see. But in late, hard daylight, that same field explodes into a world of patterns, created and shaped

## DO THIS FIRST

Hunt for patterns. Do this even without your camera. Train your eye to notice the patterns that exist just about everywhere. They are so ubiquitous and constant, we often just walk right by, never distinguishing them as patterns. Get to the point where it's natural for you to identify them—the spread of a tree's branches; the rhythms of birds in flight; the poetic repetition of columns in a decrepit building; in short, the patterned world around you. Then when you're walking with your camera, it will be natural to employ these designs— to factor them into your image and make them work for you.

Group of swimmers, shot from below, 50mm, 1/60th at f/5.6, ISO 100

**"I might have intuited right then and there that to do their jobs, to get the best photos, to tell a true story, photographers often have to go where they are not wanted or supposed to be."**

Tufts of grass, Bar Harbor, Maine, 202mm, 1/100th at f/5, ISO 200

by the quality of light. To successfully pursue patterns, you have to remember to look big—and look small. The sweeping majesty of the ancient rocks of the high desert may pull your eye, immediately and understandably. But the spiky, scruffy desert grass growing out of the sides of the rock may be equally beautiful and deserving of attention.

A photographically well-observed pattern can be just that: a picture of a continuous, repetitive, graphically intriguing series of shapes, colors, lines, shadows and highlights that pulls the viewer along and allows that person to get wrapped up in the continuity of it all. In other words, a complete pattern. All pattern and nothing but pattern. The elements thereof can be playful and lively and so intricate that they engage the eye in a game of visual Ping-Pong. Or, they can be languid and serene, presenting shapes that melt into other shapes—a visual lullaby of a photograph.

But do you really want people going to sleep as they look at your picture? Most likely not. This is where the hand of the photographer

## JOE'S TIP

We live in a world of broken, incomplete patterns—bits and pieces of stuff everywhere. The rush of modern life offers a visual hodgepodge out there that rarely presents itself to the lens in pristine, orderly fashion. Power lines everywhere, crisscrossing what would otherwise be a pastoral scene. Billboards engulfing what was once a simple, sinuous ribbon of asphalt through the countryside. Boxlike buildings, ugly and efficient, replacing the grace and style of older architecture.

In other words, crapola everywhere you look. That doesn't mean beautiful, attractive patterns don't exist. They do. But to escape all the clutter, with a camera in your hands, one has to (to borrow a phrase from my teenage daughter) chill.

Step back from the cacophony and really look. That may seem like superfluous advice, I know. When you are out taking pictures, you're supposed to look. That's what we do, right? We look.

Well, there's looking and there's *really* looking. I remember walking up to a fellow photog out in the field during a workshop and asking him, "Hey, whatcha shootin'?" He smiled and shook his head. "You're standing on it," he said.

He had found this amazingly intricate, delicate pattern of small flowers and buds, lying low in the grass, and had been shooting it like mad. Thankfully, he was done, because I had just big-footed his subject matter into rubble. But the point is: He had been looking. I had been walking and not looking.

So walk slowly when you have a camera. Where are you rushing to? You are out there to see, breathe and feel. You really can't do all of those things during a forced march. All shooters are guilty of this, of course, charging about like possessed people, convinced that something stunningly beautiful is just around the corner, and we better get there, and quickly, lest it disappear.

comes in. Do you let the pattern play, ad infinitum, uninterrupted? Or as a shooter, do you purposefully step into the mix of things and look for what might break that pattern? It could be as simple as a pedestrian passing along a long brick wall, or something more majestic—a brightly painted tractor churning its way through an endless field of Kansas wheat.

The pedestrian or the tractor might be quite small in the overall context of the bricks and the wheat, but the point is, you have given the viewer a visual anchor, a pinprick of difference in a sea of repetition and sameness—something for the eye to hang on to, or even be irritated by, and thus return to. A tear in the fabric of a pattern. An interruption. Like any interruption, it calls attention to itself. And that interruption, no matter how small, just like counterpoint in music, can cause an emotional shift for the viewer. It can elevate the pattern photograph from being lovely to being alive.

Take it easy. Let the patterns of the world creep up on you, or vice versa. Let the changing light whisper in your ear. Slow down. Be curious. See within things. With patterns, less is often more. Look at all the craziness out there and find simplicity. Distill.

To do this, proper lens choice looms large. What you are taking is a slice of the world, and you must, must choose a millimeter length wisely. At various times, the observed scene may call for wide glass; at other times, it may call for the biggest telephoto in your bag. But the mantra of lens choice for patterns is absolutely and completely this—fill the frame.

An effective photo of a pattern thrives on being singular and complete. When shooting this type of graphic subject matter, the stray tree branch, the overly hot sky or the out-of-focus clump of mud in the foreground will kill the impact of the picture. So shoot it clean. Look around the edges of the frame.

Make sure that there are no unwanted intrusions. If there are—*move your feet*.

Get closer, move back, get high, get low. Look carefully at how the light is playing with the pattern. Remember that super-duper zoom lens you are looking through is not the only thing that zooms. If you move 180 degrees from where you are standing, the whole deal might be even more interesting. So move around. Zoom with your feet. Don't figure the gear is going to do all the work for you. Stay nimble, physically and mentally.

To photograph patterns effectively, you may have to break some patterns of your own.

CHECKLIST ☑:
☐ Walk slowly; look carefully.
☐ Pick your lens to fill the frame.
☐ Remove anything extraneous
   from the scene.

# LIGHT AND FORM

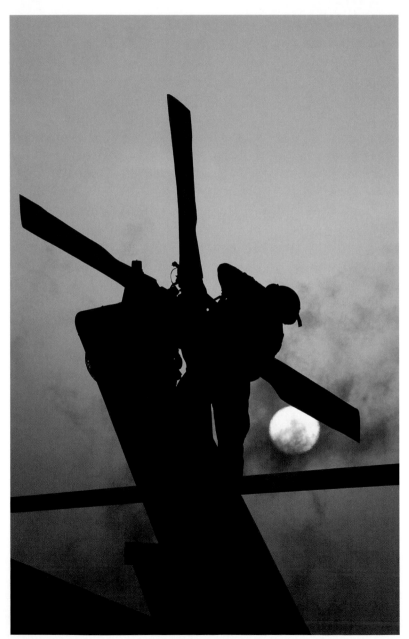

WHEN YOU TALK about light and form, you are talking about the DNA of photography. Light and form dictate how something looks, and how something looks is what calls to us as photographers. Light, as we discussed in Part One, either reveals or hides form from us. (And trust me, many times what we don't see in a photo is just as important as what we do see.) Light causes shadows, and the way in which light and dark play together determines if the form you are looking at will be interesting or not—and if it will be deserving of a photograph. On a flat, gray day, a majestic mountain range might be dull and barely worth the expenditure of pixels. But go back the next day during a gorgeous sunrise, and those same mountains come alive in the ruddy wash of early light. One day, no pictures; the next, you can't stop taking pictures.

## LIGHT OBSCURES FORM

Light is the variable here. Forms are forms. They will be the same tomorrow as they are today. But they will look different, depending on the light. As photographers, we follow light as surely as musicians in an orchestra follow the baton in the conductor's hand. Light hits things and defines them as being interesting or not.

Hard light on surfaces, for example, illuminates those surfaces but causes other areas to go black. That play of light and shadow will draw the eye, which is programmed to seek light areas and is attracted by contrast. The edge of a highlight as it suddenly, sharply falls into shadow is a moment of high contrast that compels at least a glance. Don't be afraid of shadows! They are your friends.

Silhouette of a helicopter and a technician, 300mm, 1/1200th at f/5.6, ISO 125

Bryce Canyon, Utah, just before sunrise, 180mm, 1/15th at f/11, ISO 100

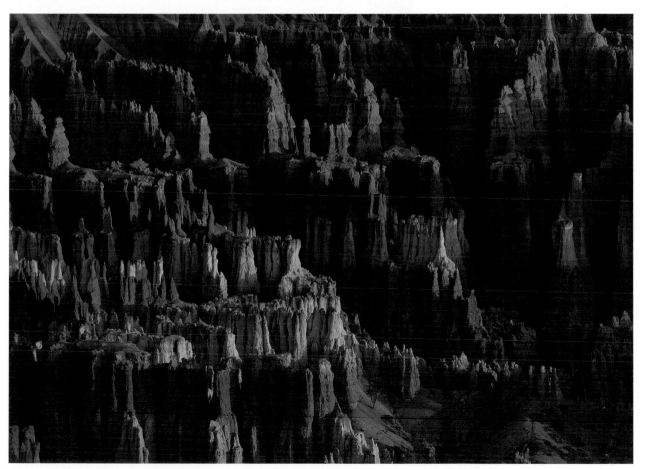

The sun highlighting rock formations at Bryce, 300mm, 1/10th at f/11, ISO 100

Light illuminating the structure of a leaf,
157mm, 1/60th at f/22, ISO 200

## LIGHT REVEALS FORM

If shadow obscures form, soft light can reveal
form in wondrous ways. While some forms
call for that hard edge of darkness and bright
light, others thrive in soft, diffuse illumination.
Smooth, round shapes can often look best on a
cloudy day. In this subdued light, details that
would be hidden by hard, bitter daylight come
forward and dominate. No shadow games here:
The picture is filled with light, and the eye of
the viewer is allowed to feast on nuance, detail,
shapes and color. I don't want to talk about
f-stops and ISOs here—we've already done that,
and you understand the mechanics—I want
you to look at the light. Drink it in. Decide
what to do with it.

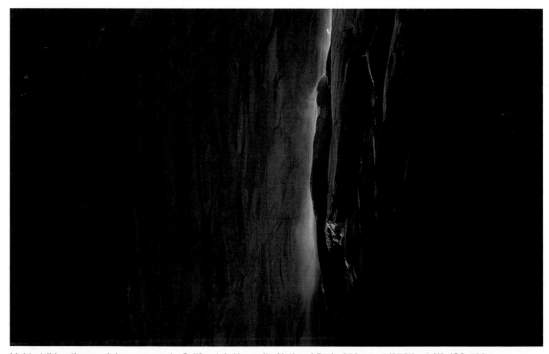

Light striking the crack in a canyon in California's Yosemite National Park, 300mm, 1/250th at f/2, ISO 100

Hercules C-130J turboprop propellers, 450mm, 1/30th at f/10, ISO 125

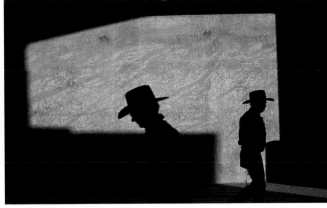

Silhouettes of cowboys, 85mm, 1/125th at f/8, ISO 50

# [FROM THE FUTURE]

*National Geographic* assigned me to shoot planes. The project was, of course, more grand than that—the official title of the story was "100 Years of Flight: The Future of Aviation." It was to be a forward-looking story: the planes of today and what they might look like tomorrow. I had to show these marvelous machines, the people who design and fly them and how important flying is to human mobility. My pictures had to put the reader right there in the cockpit with me. And in the cockpit of tomorrow.

My subjects were these sleek, soulless bundles of angles, metal, wiring and horsepower. People took a backseat; my dominant mission was to make these flying machines look cool. It was a story that was all about light and form.

Light and form are joined at the hip. Throwing light on an object allows us to look at it. There is no form in a black room. Switch the light on, and we encounter the shapes of whatever is there.

But simply throwing light on something does not guarantee that you'll wind up with an expressive photograph. Flipping that wall switch doesn't make life interesting or beautiful. Ever spend the day in nothing but overhead fluorescence—that charming institutional light of choice? Greenish, flat and uninviting, it allows us to function, nothing more. We can work, but we don't thrive. We go flat—along with everything else.

Now go outside and encounter daylight in its myriad forms. Our eyes come alive, adjusting in a nanosecond to the endless play of light and dark, squinting for brightness, reaching for detail in soft shadows. We become engaged.

Which is what anyone with a camera has to be. He or she must be engaged if the pictures are to engage the viewer, even if it's only to show how the family trip to the lake went, or what Johnny's graduation looked like. When shooting for a big picture magazine, the stakes are a bit higher: You don't know the people who are looking at your photos. You aren't narrating for family and friends. The snaps have to work, all on their own. They need to grab the eyeballs of a bunch of strangers who have pretty much seen it all already, or the story you are trying to tell won't work.

So it was with the planes. Flying bits of light and form. They were singular, to be sure, but also: They were much seen and very familiar. I needed to make pictures of planes (wings on wheels) with different forms, and I decided I needed to render them with different light that gave each its own power and distinction.

The F-22, called a Raptor, is a bird of prey, designed to strike so fast and unexpectedly that the battle is over before the foe even knows it's joined. It is a collection of hard angles, shadows and menace. The plane, left, is gray and the high noon sun in which I was shooting had no color.

F-22 Raptor, 600mm, 1/640th at f/8, ISO 125

B-2 bomber, 180mm 1/1000th at f/8, ISO 125

In the photograph, the light is hard and unforgiving. The camera angle is low, making the craft ominous and emphasizing its lethal potential. The lens is a 600mm, which has power and compression, and makes the plane seem bigger than it really is. Light and form combine to tell the story of this machine.

The soft sky light for the B-2 bomber, above, is not what you might have chosen, thinking ahead. This aircraft is the batwing, the flying wedge, one of the coolest planes ever made. Anticipating shooting this, you would just about sell your soul for colorful light, sunset glow and beautiful clouds tinged with blood red. (That, actually, would be pretty good. If I were to go back and do this over, I'd once again be bartering with the light gods for exactly such a condition.)

I didn't get it. But a photographer plays the hand he's dealt. I was sitting backseat in a T-38 trainer, dogging the B-2, which was flying racetracks around its home facility at Whiteman Air Force Base in Missouri. I stopped short of saying I was

bored up there, but the light did have a certain sameness to it. I kept shooting furiously of course, having been given only an hour of flight time with this puppy. I wanted to show the batwing, the essence of the very distinctive form of this airplane.

Then we settled in next to it, and I looked out the window. The soft light combined with the sinister profile of the plane to reveal . . . something new. An unanticipated angle. I scrambled to attach a longer lens and get the camera to my eye. Forget the batwing. Lots of shooters had been there, done that. What I had flying next to me was a fortuitous combo of light and form that revealed a different look and could impart new information to the reader, something that might be different enough to grab the eye. Hit this plane with hard light from this angle, and the crucial details of the profile would disappear, and so would the picture.

The colors I wished for during my B-2 adventure finally showed up for the picture of the X-47A, an experimental drone

## DO THIS FIRST

Before you put the camera to your eye, assess the light and shadows. Look for light that reveals form and shows dimension. Where is the light coming from? Is it hard, soft, reflected? Might your subject matter profit from hard light or soft? Think: How am I going to shoot this? What light does this form require? This can be an interesting exercise: translating what your eye sees in terms of light and form into what your camera can actually capture (more on how to do that in the tip on page 153). As a photographer, you are, in fact, a translator. You start with the language of light and shapes in the real world and assess how to render them best in a still image produced with the help of a machine. You're translating for your ultimate viewer, who wasn't lucky enough to be there by your side, what you actually saw *before* you took the picture.

X-47A drone, 39mm, 0.5 sec. at f/5.6, ISO 125

"Blessedly, the plane had a reflective skin, and I could see the stunning morning sky mirrored on its wings."

type of aircraft that I shot at Naval Air Weapons Station, in China Lake, California. This plane was Martian-looking. Pilotless, it was dropped in utter blackness at the end of a runway for its photo shoot. No people. Just me and a weird-looking piece of flying metal, staring at each other in the desert dawn.

Again, light and form tell the story. Blessedly, the plane had a reflective skin, and I could see the stunning morning sky mirrored on its wings. That sunrise, though, pretty as it was, couldn't do all the heavy lifting. I had to separate the sleekness of the aircraft from the blackness of the surrounding asphalt. So, I applied my own light, a series of small flashes, all pointed toward the ground. I didn't really light the plane, I lit the ground.

The wash of low light defined the form. Now, with light from above and below, the craft leaps out of the darkness and arrests the eye. The light and the form, this time spiced with color, make an announcement: This plane is from the future.

## JOE'S TIP

Okay: Light and form are important. How to make the best use of them when you are out there shooting?

Lens choice plays a big part. Do you go wide and show the whole shape, maybe even distorting it a bit? Or go middle of the road, lens-wise, and just let this interesting shape be interesting? Or do you bring out the big guns and go telephoto, which will compress the subject matter and make it feel overlarge and powerful?

How about all three? Some objects are so interesting, they're going to look dynamic through an 18mm or a 300mm. And, although those middling lens lengths can do the job as well, when dealing with form, it might be best to leave them in the camera bag and try the extremes of whatever glass you've got.

Shooting form is about graphics. Middle, or normal, lenses can make your form go to sleep. To get graphic in a powerful way, wide and long lenses are often your allies.

So are your feet. When shooting the polished, candy-apple-red '57 Chevy, you become utterly entranced with your 20mm lens in close because it is making that tail fin look so big it belongs on a great white shark. But don't forget the 70–200mm zoom sitting in your bag. Take a walk, lie down on the ground. Rack out to 200mm. Fill the frame with all that chrome and candy-apple coolness. Different look, different power, different form, even though it is the same object.

The other thing is light. This whole section is called light and form for a reason. Throughout this book, we talk light. It is—yes, again—the language of photography. It is how we speak and how we describe our subjects. So choose your words wisely! Light in early and late daytime has angle and a warm color. High-noon sunlight blasts and bleaches everything in sight. Cloudy, soft light lets details speak. These different qualities of light set the tone of the conversation. What do you want to say?

CHECKLIST ☑:

☐ Choose the right lens. Wide shows all and telephoto just a slice. Both approaches can be interesting and effective.

☐ Move your camera position around. Look at the form from top to bottom, high and low, left and right.

☐ The right light is essential. If it's not there, you may have to make your own with flash.

# TALKING COLOR

WE'VE TALKED ABOUT TEXTURE, pattern, light and form. There are pictures on these pages that show all of the above, from dead leaves to supersonic aircraft. What else was present in those photos? Color! You simply can't discuss pictures without talking about color, or lack thereof.

Take a trip back to—what was it?—fourth grade? Back when we first got acquainted with that notoriously colorful character, Roy G. Biv: red, orange, yellow, green, blue, indigo and violet. The colors of the rainbow. The color wheel. (There will be a test in tomorrow's class!)

## THE COLOR WHEEL

There are folks out there who have spent their whole careers writing learned textbooks on color and how it interacts with our eyes. Do you need to do the same in order to pick up a digital camera? Blessedly, no. I mean, there's lots of color out there—an unfathomable amount of color. In our digital world, there are 16.7 million possible colors in an 8-bit image.

*Sixteen point seven million.* Has anybody seen them all? No. But to get a handle on their vast variety, we generally organize colors using one of the two major systems: additive and subtractive. Digital cameras and computers use the additive system with red, green and blue as the primary colors. Most printers and other methods of reproduction use the subtractive system with cyan, magenta and yellow (mixed with black) as the primary colors. The traditional subtractive color system, which painters and other visual artists (like photographers) have relied on for centuries, uses red, yellow and blue as the primary colors. Mixing together two of these colors produces the secondary colors:

- Blue + Red = Violet
- Red + Yellow = Orange
- Yellow + Blue = Green

Add these six to what are called the six "tertiary" colors (red-violet, blue-violet, blue-green, yellow-green, yellow-orange and red-orange) and you have the basic color wheel known to anyone who ever picked up a crayon.

Color relationships are easy to understand when illustrated on a wheel. The color wheel at left shows the six basic colors: the three primaries and the three secondaries. Colors that lie opposite of each other on the wheel (blue and orange, red and green, yellow and violet) are known as "complements." Colors that lie adjacent to each other are called "analogous" colors. This wheel also depicts two other key attributes of color: hue and brightness. Hue is how you describe the color on the spectrum—in other words, "red" or "blue" or "yellow" or "green" or "violet" or "orange" (and on and on . . . ). "Brightness" refers to a color's tone, whether it is light or dark. A third key attribute, saturation, refers to the intensity of the hue. A fully saturated hue is pure and undiluted. A desaturated hue moves toward gray, as if mixed with its complementary color (for example, red in shadow will appear greener). Note that one half of the wheel, from yellow to red, is marked "warm," and the

**Warm**

**Cool**

other, from violet to green, is marked "cool." Colors have many attributes, including temperature.

As photographers, we seek to use the primary and secondary colors in strong, rich ways; they can be the tent poles that your picture hangs on. They have power. Why do you think pictures of the American flag grab your eye? Those saturated reds and blues command attention. You can use the same colors with more muted effect, too. Desaturated reds and blues can turn into dusty roses and slate blues that create an aura of melancholy or nostalgia.

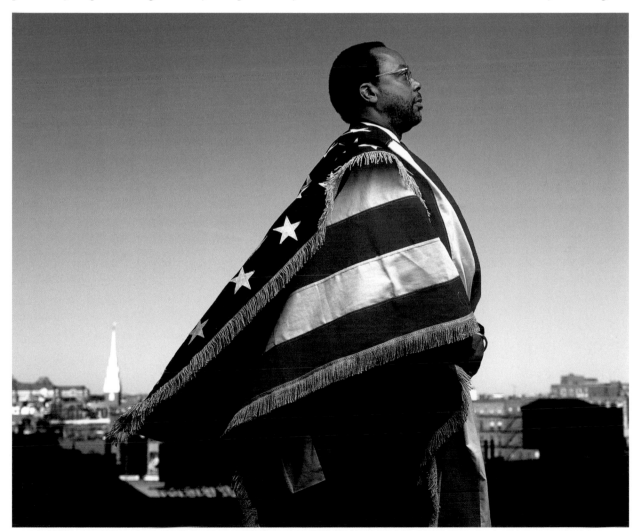

Red, white and blue of the American flag, 28mm, 1/1250th at f/8, ISO 100

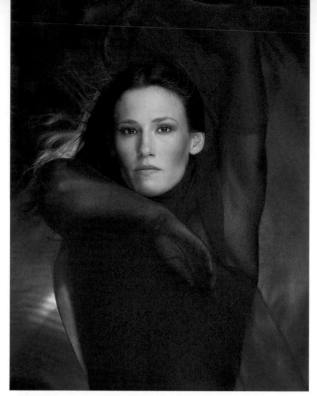

## TEMPERATURE AND SCHEMES

Take another look at the color wheel. Is it necessary to spin this wheel in your head while your eye is to the lens? Not really. Most of the time, your brain is either consciously or unconsciously aware of the color palette in the frame. One thing to remember is the notion of "cool" and "warm" colors. Take a look at the wheel yet again—note the zones of color temperature there. Using a monochromatic, or one-color, palette, can convey a particular mood, such as a swirl of red that screams, "Passion!" Cool green can evoke a rich—think "color of money"—vibe.

Playing colors off one another can be very powerful. For example, focusing on the bright yellow overalls of a park employee as he strolls through the lush green grass of a golf course is making an analogous color scheme work for you.

Red catches the eye and creates an intense mood, 190mm, 1/25th at f/5.6, ISO 400

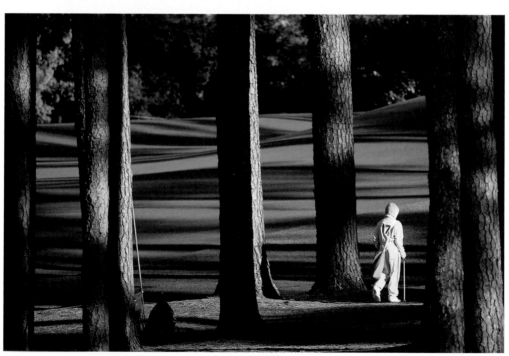

Golf course with cool greens, warm browns and a highlight of yellow, 600mm, 1/250th at f/4, ISO 100

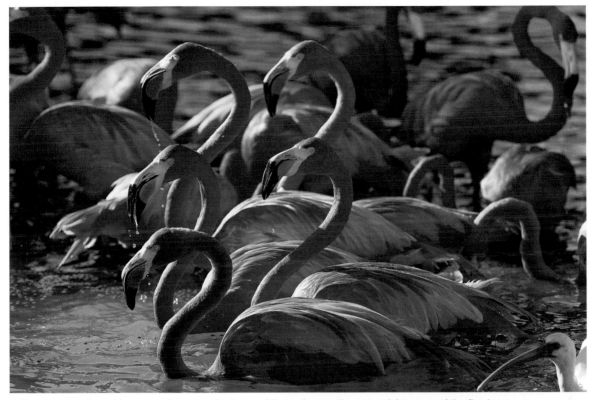

A blue-green pool provides a complementary background that enhances the warm pink-orange of the flamingos, 200mm, 1/1000th at f/4.8, ISO 200

Or note, above, the deep blue-green water against which the vibrant pink-orange of a flock of flamingos comes alive, the cool color complementing the warmth of the birds' feathers. Complementary colors can work for you; hues opposite each other on the color wheel play well together, creating a vibration that attracts the human eye.

Calming blue water allows the subject to pop with a sliver of orangey yellow, 85mm, 2 sec. at f/4, ISO 100

# [POW! ZAP! WHAM!]

I've got a strong color palette. Some folks in the photo world would be embarrassed to admit such a thing these days, when so much emphasis is placed on lack of color. There are a lot of looks popular today that are marked by desaturated colors—very hip, very cool. Very now.

I say, fine. Photography's a big room, and there's space for everybody. Lots of styles, approaches and attitudes can sit together and casually jostle one another.

But as said, there are millions of colors out there, and me, I like 'em all. Color is so powerful when it is used well. It can beckon seductively or demand that somebody take notice. It can be as brutal as a bludgeon or as delicate as a scalpel. Soft as a kiss, hard as a slap. Color pours through our lenses and fills our eyes.

Breakfast in Copper Canyon, Mexico, 180mm, 1/30th at f/2.8, ISO 200

I went to five different grammar schools. And on top of that I had older sisters. Oftentimes I had to make my own fun. Early reading material ran to the comics, super-heroes, epic adventures, tall tales and stirring battles. In other words, the fantasyland of my head. (Think Spiderman meets Gandalf, and you get an idea of where my young mind was wandering.)

Comic books contain stories told with vibrant, saturated color—smack-you-between-the-eyes, primary, slam-dunk color. The panels of a well-done comic are their own color wheel, with vibrating colors, harmonic colors. Certain colors that recede and then rush back in, like a powerful tide. For better or worse, strong colors have stayed with me.

That's not to say I'm out there shooting my own version of a comic book, though I have had some editors think this when I brought back my pictures. It's more about seeing in color and, over time, becoming aware of which colors play well together. It's also about being mindful of how powerful lack of color—or, certainly, selective color—can be.

Take a look at this early-morning scene in the Copper Canyon of Mexico, opposite. Members of the Tarahumara Indian tribe still live a secluded life, deep in the canyon, as far removed from cities and tourists as possible. Simplicity of life, simplicity of scene, simplicity of color. The fog is like a gauze over the lens, draining hue and vibrancy—a perfect situation to shoot in color.

Really? Yes. Lack of color often makes as powerful a statement as a picture chockablock with reds, yellows and blues. Here, the pinprick of the orange fire in the midst of the pale morning brings home the feel of the start of the day. Early morning, cooking breakfast, hungry kid, dog running about—the same dawn-of-day ritual occurs in Chicago, albeit in a different way. By showing the rural location, and showing it with effectively selective color, I involve the readers, make them look and feel. Breakfast in the Copper Canyon—not like breakfast in Paris or Wichita, but breakfast nonetheless. That story is universal and very human.

Be careful, though. Color, marching in lockstep with the advance and migration of light, moves. It's like dealing

Copper Canyon, Mexico, 200mm, 1/250th at f/4, ISO 200

with the ocean: You don't want to turn your back on it for very long. Keep attuned to changes in color palette and direction of light. Early-morning (and late-afternoon) light is often called "golden hour" because the light is warm in tone and, as has been mentioned, angular, low to the horizon. It's got a distinctive color temperature. Remember the color wheel? Golden hour lives in the warm section of the wheel.

That morning in the canyon, the fog evaporated, as fog does, opening the door for early, yellowish morning sun. Minutes after I saw that pale breakfast scene, I turned and saw these two boys, above, awash in warm sunrise glow.

# DO THIS FIRST

Make the decision that the subject deserves color—and then decide what kind of color. There is color, and then there is *color*: There's the bright red of a fire truck at high noon and the soft greens of a still pond at daybreak. Color relates more to exposure than to most other adjustable elements. You can make color appear more lush or saturated by a subtle underexposure, and that image will have a different aesthetic and emotional power than one that might be bleached out or overexposed. With color, there's no right and no wrong, but there is *what you want*. So I urge you to develop a strategy. Do you want to further soften that pond or strongly brighten that truck? You can do this with your exposure setting before you click.

It was like someone had peeled back a sheer curtain to unveil the true colors of the scene. Minutes apart, yet completely different color palettes. Stay on your toes!

Color is powerful because it commands attention. Color can represent the signposts you place in the wilds of your photograph. If you view color as part of the language of photography, imagine sparks of color to be exclamation points. They say, "Look here now!"

Ballerina, 60mm, 1/25th at f/5, ISO 400

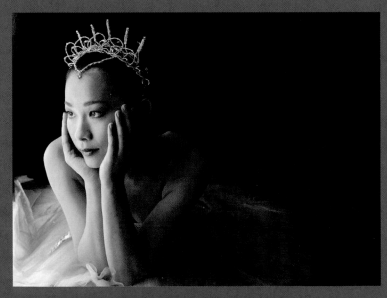

Instead of shouting and pointing, though, equally powerful statements can be made with muted, hushed color. Color that permeates but does not dominate. Color that creates a mood that is so pleasing or involving that the viewer surrenders to it. Soft color. Color without edges. Describing color like this really means describing the light that produces such a thing. Here is where clouds are your friends. When the sun is high in the sky, unrelenting and raw, color vacates. It surrenders, really. The strong sun blasts color, making it tinny and hard and rendering the shadows so black they are impenetrable. High noon, with its harsh daylight, is, as I've mentioned in the lighting section, the worst of times to shoot pictures, especially color pictures.

But lush color is a gift of cloudy weather. The clouds run between us and the sun, acting as a giant diffuser, and the light beneath the clouds falls as softly as a leaf. Here rich, saturated colors step forward and dominate. Take a look at the ballerina at left, looking through a window on a cloudy day. The light embraces her face in a lovely fashion and slowly fades as it runs over her pink tutu. It gives the garment a richness that pleases the eye but doesn't overtake her lovely expression. It fits the quiet contemplation in the dancer's face.

Now bring a pink tutu outside into cloudy weather. As you can see on the opposite page, it plays well with the complementary greenery. Neither color shouts, but each speaks strongly. There's a difference.

I've been discussing selective color, accents of color and quiet color. What about a color riot? That can be fun, too—in fact, unbelievable fun, if you can find the right scene or subject. LIFE assigned me to do just that—have fun with color—when they sent me across the river from Manhattan to the Hoboken, New Jersey, warehouse where Macy's keeps all

En pointe, 300mm, 1/350th at f/2, ISO 200

"Color, marching in lockstep with the advance and migration of light, moves. It's like the ocean. You don't want to turn your back on it for very long. Keep attuned to changes in color palette and in direction of light."

## JOE'S TIP

We've talked about color theory and the color wheel—all well and good. But when you have a camera in your hands, how do you actually shoot color?

Remember the time of day and the atmospheric conditions will directly affect color. I have often said a perfect day for a shooter involves a stunning sunrise-sunset combo, with soft clouds in between those colorful bookends of the day.

The day I just described means that "golden hour" —that early and late time for light when it is warm, angled and beautiful—will be absolutely killer (worth getting up for!) but in between, there will be the soft light that comes through clouds and ensures rich, textured color, as well as easygoing, workable light for portraits. One thing the day described above has no room for is that screamingly hard quality of overhead, bright, high noon sun, generally the enemy of color and the photographer, out there on hot tarmac, trying to manage a few million overheated pixels. High, hard sunlight is generally to be avoided—bad light, bad shadows, bad results.

Now there might be shooters who will disagree with the above. Lord knows, photographers will disagree about anything. I have seen, and will continue to see, excellent pictures made at that time of day. And anyone who does take a camera in hand with serious intent will, despite his or her best efforts and intentions, occasionally be hooked into shooting pictures in that kind of light. Let me offer some survival strategies for finding good light and reasonable color in these conditions.

First, get out of the sun. Find open shade from a tree or a building. Most likely, you can manage that light. Look for reflected light. Glass and metal buildings can often make for huge "bounce cards" that reflect hard light in interesting or pleasing ways. In shade or reflected conditions, color often comes back to life, and you can see details in shadows. (Buildings painted white, obviously, are great "fill cards." Buildings painted different colors, or perhaps made of brick, will also reflect hard sun. But take note: Light bouncing off a structure painted, say, green, will cast, yes, green light on your subject. Which might be interesting-looking in the sense of being different, but it could also produce odd, sickly results. It is important to remember that light picks up the color of its reflector, so it may be best to seek neutral surfaces when looking for reflected light.)

Or just go inside. It's hot out anyway. Maybe that little coffee shop or that old bar down the street has a vintage wooden floor that will take nasty, unworkable sunlight and bounce it upward into the rest of the room to jam it with a golden glow. (Because light picks up the color of what it hits, old wood floors punt back warm, yellowish light, which is often very pleasing.) Buy a latte and sit by the window. The harsh light that was trashing everything in the street might meet a lace curtain or a set of blinds that shapes and bends it into something nifty-looking.

Remember, your fancy-pants digital camera has limits to what it can see. The eye, amazing instrument that it is, can make minute, constant adjustments, and thus rotate from a bright, squinty-eyed street scene to looking into shade and pulling out detail. Even the best of digital cameras fail at this. So you have to give this tool an assist by being smart in these conditions. Move. Follow the light. That's where the color is.

CHECKLIST ☑:

- ☐ Light reveals color, so follow the light.
- ☐ Golden hour is great light, but it often lasts less than an hour; it can be more like 10 minutes. When you see it, shoot it! Now!
- ☐ High, hard sun is tough but not impossible to shoot in. Look for bounce surfaces and diffusers, such as curtains, to help you.

Macy's Thanksgiving Day Parade, 28mm, 1/125th at f/11, ISO 64

kitchen sink of fantasyland. There were brilliant colors everywhere. Each frame was just brimming over with it. Here, I was not really looking for that delicate color accent to entice my viewer's eye. I was opening the floodgates, filling the scene and the eyes with a full spin of the color wheel.

Out on the street, when it was time to go marching, the clown revved up the primary-color engine with this multihued smile, left. The brassy quality of light at about eight in the morning, with no clouds to baffle the sun, was a perfect comple-

of its Thanksgiving Day floats. My job? Make a wide, wide picture, below, that showed the playful parade that rolls downtown from the Upper West Side to 34th Street every year on Turkey Day, delighting millions.

Fun doesn't even begin to say it. I was like a kid in a candy store, asking the mildly exasperated Macy's technicians for a smoking dragon, Humpty Dumpty, giant eggs, dwarves, flowers, reindeer, you name it—the

ment. Any later and the higher sun would have bleached these colors (and also cast my subject's eyes in deep shadow). I asked the clown to turn in the direction of the light, to work with it and not away from it. For snappy, contrasty color like this, the sun has to be with you, at your shoulder, and not behind your subject.

The result is like an explosion in a paint store. Color splashing everywhere and over everything—celebratory, riotous, glorious color.

Macy's Thanksgiving Day Parade preparations, 18mm, 1/4th at f/11, ISO 200

# COMPOSITION AND COLOR

I'VE ALREADY SAID that light is the language of photography. There are some who would say color is a second language, and indeed it is. So what are we talking about when we speak of photography's particular brand of colorful language?

## THE LANGUAGE OF COLOR

Before breaking down the specific color components of light, let's get this on the table right away: The human eye is programmed—genetically, biologically, every which way from Sunday—to seek, be attracted to and thus look at light areas. The eye gets pulled by brightness. It's fact.

That is why it is so crucial to manage the tonalities of your picture. Don't expect someone to stay with that delicate little rose you found so attractive on your last photo walkabout if you place it against a big expanse of bright white sky. The viewer's eye will run right over that flower,

A young girl finds shade in an abandoned building, Mumbai, India, 180mm, 1/125th at f/4, ISO 100

Panorama of New York Harbor showing Ellis Island, the Statue of Liberty and Lower Manhattan, 20mm, 1/125th at f/5.6, ISO 200

Satellite dishes at sunset, 20mm, 1/15th at f/5.6, ISO 100

hit that sky and keep going. It can't help it. If you carelessly include blown-out, dead-white areas in the edges of your frame, you are creating an exit ramp for someone to get out of your picture. And they aren't coming back.

   That's the general rule of thumb for managing bright areas: Be careful! Small bits and pieces of extreme highlights are often fine. White, after all, is white. But if you need to put on sunglasses to look at your camera's LCD because a whole bunch of the pixels in there have died and gone to highlight heaven, you have a problem.

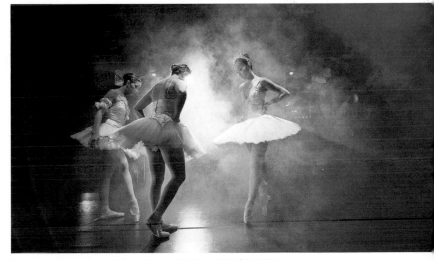

Ballerinas under stage lights, 23mm, 1/60th at f/4, ISO 6400

## COLOR ALCHEMY

When dealing with the specifics of color, it is good to remember three key attributes: hue, saturation and brightness. Hue is the color, plain and simple. Saturation deals with the intensity of that color. Desaturated colors are weaker, paler. Saturated colors are strong, powerful. Again, think of the American flag: It is a statement about saturated color. Brightness is about tone. If the tone runs toward darkness, it is called a "shade." If it leans toward white, it is a "tint.'

These terms are nice to know and drop during the meet-up of the local camera club, but by my

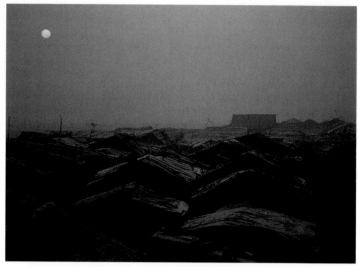

The sun rises over New Delhi, India, 80mm, 1/30th at f/2.8, ISO 200

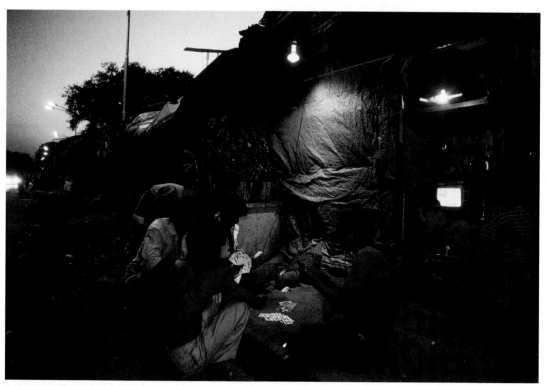

Card game at dusk, Mumbai, India, 24mm, 1/30th at f/4, ISO 200

Dr. Andrew Weil in color, 105mm, 1/250th at f/5.6, ISO 100

lights they do little for you in the field. Color is a gut call. You feel it in your head and your heart. Colors have harmonies, vibrations. They call to your eye. Experiment with your camera and find out which colors, and combinations of colors, move you. Work on choosing the right hues, saturations and levels of brightness you need to tell your story, set your mood.

For an extreme example, look at the photos on this page of alternative medicine guru Andrew Weil, naturally exposed in color and rendered in infrared. Both work, albeit quite differently. Which do you prefer? What are you after?

Dr. Andrew Weil in infrared, 105mm, 1/125th at f/5.6, ISO 100

# [HOW ABOUT NO COLOR?]

I've been a magazine photographer for a long time, and for the most part, I have been sent into the world to bring back color photographs. Most editors, especially the editors at LIFE, view color as an essential tool when telling stories about this amazing, multihued world. But there was a time when I was consistently called on to tell stories in black-and-white. In my early days as a newspaper–wire service shooter, B&W was the coin of the realm. The hot-type papers of that day could only manage whites, grays and blacks—and not particularly well at that.

My imagination and my nose for color led me to magazines, and Kodachrome quickly replaced the Tri-X in my bag—except when shooting for one particular journal: *People* magazine. It was one of the first magazines I started shooting for back in the roaring '80s. Started as the brainchild of Dick Stolley, *People* has been a juggernaut of magazine publishing for years, though I gather now it faces stiff competition from the likes of *US, Them, We, He, She* and *It*. (Whatever would they all do without the comings and goings of Hollywood?)

Anyway, the story used to go around (and it might have been apocryphal for all I know)

that readers surveyed by *People* always cited the stirring color photography that dominated the magazine. Which was odd because there wasn't a thing in color in the magazine— except the ads and the cover. This I'm sure was one of the great coups of magazine publishing, to produce a black-and-white weekly that somehow convinced a whole community of readers that it was in color. Amazing.

Regardless of what the people who read *People* thought, as a shooter on assignment for the magazine, you went out without one very powerful thing in your camera bag—color. Seeing the world in monochrome might at first seem to be a one-way ticket to Dullsville, but when you make that adjustment and dial your retinas to the gray scale, wonderful things can occur. Simplicity becomes paramount. Peeling away the veneer and artifice of color can take your viewer immediately to the core of the story you are telling. Backgrounds that might scream in color become just tones, framing the foreground instead of competing with it.

Take a look at this window-lit portrait of the singer Carly Simon. She is, by any judgment, a lovely woman, and the soft light combines with the scene to give her a dreamlike, quiet

## DO THIS FIRST

We know that, these days, you can just push a button and see your color shot rendered in black-and-white—and you can decide then which you like better. But for most of photography's history, shooters had to decide beforehand whether a subject was better rendered in color or B&W. Try this exercise: Put your camera in black-and-white mode for 24 hours, and then go out and shoot what you think are "black-and-white subjects" or "black-and-white moods." Then take a look. Did you see differently—did you shoot differently—than you usually do? If so, file this knowledge away. When confronting any future subject, ask yourself first: "How would this look, that way? How would it look if I shot it the way I shot on my black-and-white day?" These are the kinds of good learning experiences that, on graduation day, have constituted the education of a true shooter.

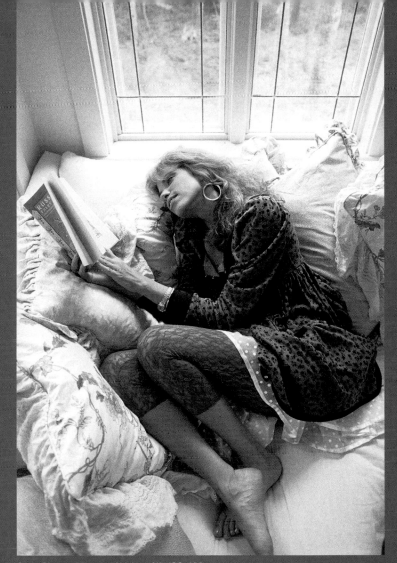

Carly Simon, 28mm, 1/60th at f/8, ISO 400

power. This is the behind-the-scenes Carly, the at-home Carly, not the rock star belting out "You're So Vain" with her considerable voice.

Now, I was shooting for *People*, and black-and-white was the rule. But, as a photographer, you don't get to stand next to—actually over—Carly Simon lying back on a bunch of pillows too often. (At least I don't. For the celeb shooters in L.A., the "livin' the dream" crowd, this kind of thing is most likely an everyday occurrence. But for me, a grunt shooter from New York City . . . Well, this was a day to remember.)

So I shot some color, too. Carly, being hip to the magazine, actually asked me if I was shooting B&W, and at that moment, I did have Tri-X in the camera, and I replied truthfully. She was concerned about her red lacy stockings. As she said, rendered in color, they would be "naughty." But before we left that window box, those stockings were duly documented in their vibrant, naughty redness.

The color was a smart move for me, being at that time a magazine freelancer. Most magazines that purchase pictures, especially those trafficking in celebrity, look to publish

color, so it was a good thing to have for the archive. The color picture's pretty snazzy, but does it work? This is a matter of taste, of course. (There is no right or wrong in photography, really; as I've said, it simply comes down to whether a picture speaks to the person viewing it.) Which Carly? Hmmm . . .

For me, the black-and-white conveyed the essence of the scene. The quiet light, the sense of relaxing in a safe place, reading by a window, all work in good old monochrome. In color, the stockings, although not scandalous, surely do dominate and draw attention away from Carly's dreamy expression. Rendered in black-and-white, you want to stay with her and immerse yourself in this idyllic scene. In color, the stockings are jarring, a garish stoplight in a visually peaceful, country vista. The color hijacks the picture.

I felt the gravity of black-and-white was right for the picture of Joe Biden, opposite. Cloudy day and a thoughtful moment on a train, rendered in monochrome.

Then Senator Biden was just returning to Congress after a series of life-threatening aneurysms and other medical complications. I met him at the station in Wilmington, Delaware, simple and easy, and just sat down across from him and went to work with a Leica M4, quietly observing his introspective mood as he contemplated his first days back at work, the train speeding toward Capitol Hill. I didn't even consider color here. Stayed simple, just like the picture.

Carly Simon, 28mm, 1/60th at f/5.6, ISO 200

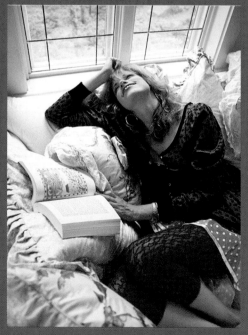

(A tangent: Always treat people well—family, friends, presidents. Stories of intemperate, ego-driven fools with cameras are legion and legend. I strive to avoid the "temperamental artiste" mode, and meet people directly, honestly and sincerely. I also remain resolutely curious about my fellow human beings. It is not false. A photographer, amateur on day one or pro on day 1,000, must possess genuine curiosity and empathy for the human condition, in whatever shape or form it presents itself in front of the lens; these qualities are among the most important things you carry with you. Plus—and here's the self-preservation side—you don't want to be a complete jerk to somebody who might well end up being the vice president of the United States, and whom you might want to shoot once more.)

More on that later. Back to color, or the lack thereof. By virtue of having a camera in your hand, you can choose some of the world's color, all of it or none of it. It's like the biggest, most sumptuous buffet you have ever feasted at.

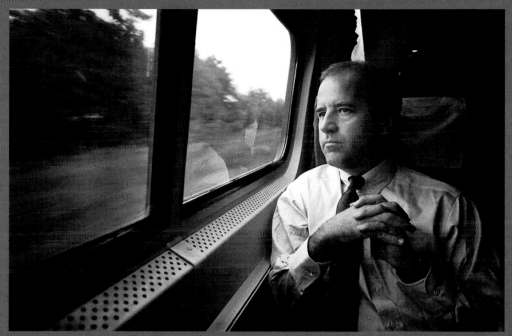

Joseph Biden, 28mm, 1/60th at f/5.6, ISO 400

So, let's go to the circus (with which I hope to surprise you on the
following page). A veritable color salad, to continue the banquet anal-
ogy. Especially when dealing with clowns, those princes of tomfoolery,
garishly painted and clad as outlandish caricatures, all gussied up just
to make us laugh. The last thing one might think of is to shoot them in
black-and-white.

But when telling stories with a camera, sometimes you have to look
under the makeup. The circus is selling something—fun under the big
top. You can see that for the price of admission. But what about a life
in the circus? Backstage, outside those famous three rings? Let's get
past the laughter and the spotlights and look at the life.

Here's where, as a photographer, you enter the realm of interpreting
a scene instead of simply recording it. This is where the head, the heart
and the humanity of the photographer take over the digital machine,
and we use it to tell stories. It may be the effort your daughter is putting
into swimming as easily as it is the back story of a clown.

I was blessed to get to know and tell a story about Prince Paul, a
legendary clown with Ringling Bros. circus. He was, as he preferred to
say, "a little person." An older man, a bit misshapen from life's knocks, he
nevertheless answered the ringmaster's call, sometimes several times a
day. He made legions of children look, laugh and, occasionally, cry.

Prince Paul, top left, 35mm, 1/60th at f/8, ISO 400; top right, 35mm, 1/500th at f/8, ISO 400; bottom right, 55mm, 1/60th at f/4, ISO 400; bottom left, 24mm, 1/30th at f/2.8, ISO 400

The picture of him putting on white makeup powder stays with me. It was one of legendary LIFE shooter and picture editor John Loengard's favorites of my early, mostly woebegone archive. As he said to me, "There's pain there. This isn't easy." An apt description of Prince Paul's life. Life isn't kind to most performers as they age, especially if the performer is a little person in a traveling road show. I chose black-and-white to tell that part of the story, the one outside the spotlight. Shades of gray helped do that. In that sea of vivid color known as the circus, the simple story I was trying to tell might have drowned.

Color is powerful. So is the lack of it. In digital photography we can choose, with the flick of a button, to simply record it or emphasize it or eliminate it altogether. The choice is important and, as said, always available. Remember that: It is *your* choice, not the camera's. These digital devices are often so high-tech and high-powered that when you first take them in your hands you can feel like a city slicker on a bucking bronco, desperately hanging on to the saddle horn as the bronc runs away with you. Yet, don't forget that when you have a camera in your hands, you stand in service to your subject matter, trying your best to explain and interpret it. All those millions of pixels can sometimes get in the way. Look. Feel. Hear the heartbeat of the story. Then put your camera to your eye and tell it what to do.

## JOE'S TIP

We've talked about bright colors, saturated colors, lush color, lack of color, selective color, vibrating colors. What works? When?

There are important things to remember and review in your head. The primary colors tend to be strong and get noticed right away. Complementary colors play off one another well. Warm tones contrast or vibrate against cool tones, pleasing and intriguing the eye.

Adjectives routinely used to describe color are: *intense, vibrant, wild, subtle, pale, faint, muted, deep, rich, hot, cold*—one could go on just about endlessly. But if you notice, many of those descriptors could apply to, say, human moods or to qualities of light (or to a hospital patient with a fever or to the behavior of your kids). When hunting for color, remember it has emotion and provokes emotion in those who see it. Match the emotion of your subject to the emotion of the color.

CHECKLIST ☑:

☐ Notice the light and color in the scene, and think about what it says to you and what you want to say.

☐ After you take stock of the light and color, decide if you want to modify anything—for example, bounce light or change the color (if you can).

☐ If you are working with natural light, remember that it will change. You have limited time to capture it.

PART **FIVE:**
**[COMPOSITION]**

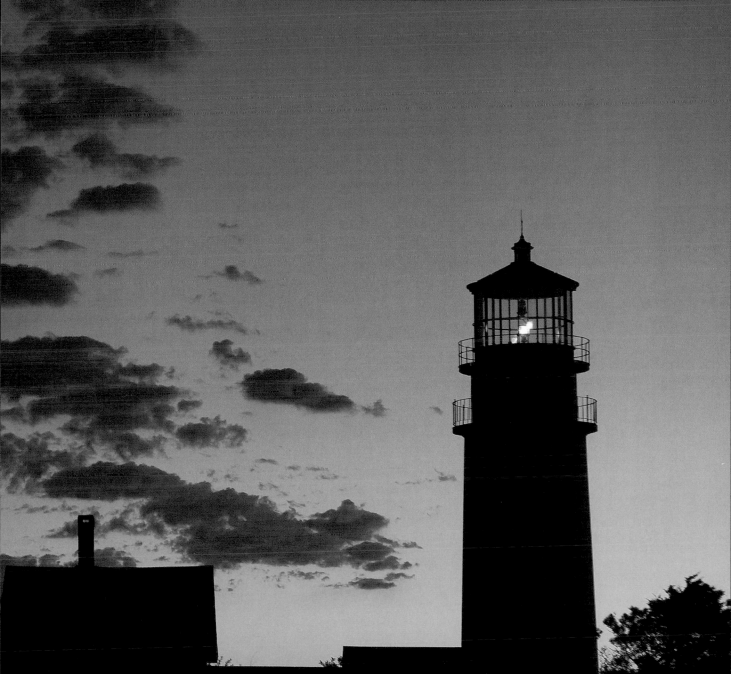

# BASICS OF COMPOSITION

"COMPOSITION" DOES NOT APPEAR on a pull-down menu. It is not a checkoff. It's not a "maybe sometimes you might want to shoot in 'vivid' color mode if the light is flat" type of thing. It is with you all the time, every picture. Even for those of you who use a point-and-shoot or a cell phone and never ever resort to a setting, composition still pertains. There are tips to come for you, too, because any time you put the camera to your eye—in good light or bad light, at sunrise or sunset, framing people or landscapes—you are going to compose. Yes, you can crop post-click in Photoshop, but cropping is not delicate. It's a meat-cleaver technique; you're amputating part of your picture. It is better to see the picture whole when you are composing it.

## THE FRAME

In my opinion, composition is everything. It first refers to what is in your frame and what is not. Composition derives from where you put the camera, and everything flows from where you put the camera. It is point of view. It is the best barometer of how you see the world and also what kinds of pictures you choose to make.

Parasailing, Hudson River, New York City, 35mm, 1/250th at f/11, ISO 100

Man on a bike, Shanghai, China, 85mm, 1/125th at f/4, ISO 200

## THE CONTACT SHEET

As I grew up in photography, I would routinely seek out editors, looking for work, asking for reactions, information, counsel, guidance. The top editors spent precious few minutes with your portfolio, your "greatest hits" if you will. They knew those snaps were your finest and had been edited, toned, tweaked, sequenced and printed to create impact and make an impression. That "best of" album could represent the salient images you shot in a day, or a week, or a year. They could be the product of an incisive, economical mind at work behind the lens, a skillful storyteller who observed well. Or they could be the happy accidents of a scatter shooter who ran through jobs with finger continuously depressing "consecutive high" on the motor drive. The editors wanted to know which one you were if they were going to give you a job.

Man with a cart of mannequins, Shanghai, China, 200mm, 1/125th at f/2.8, ISO 200

To find that out, they went to your black-and-white contact sheets. These were the road maps to the way you saw as a photog: the telltale MRI of your photographic brain. These were all of your clicks. Did you zig when you should have zagged? Did you run out of steam at a certain juncture? Or did you see it through and construct a compelling document with a beginning, middle and end? Were most of your shots well composed? If you looked at my contact sheet from this street in Shanghai, you'll see that these two pictures indicate that I varied how I used the light and my lenses. I kept moving and thinking. Take a look at your pictures from your last family outing. Is there variety of angles, lenses and light? Did you get in close for details and then move out to set the scene? Did you tell the story of the day? Think, constantly, about composition.

Winding path in an autumn forest, 200mm, 1/15th at f/11, ISO 400

## THE NEW CONTACT SHEET

The contact sheet of today is the grid of thumb-nail pictures on your computer. If you take a look at the results of any given foray into the field, you can deduce how you see, how you approach a picture or set of pictures. You can figure out what you want to do differently. You can even see your sense of composition evolve, right there on the screen. You can review your choices. Were they careless, haphazard? Or were they tight and to the point? Did you execute that mandate of good composition—in other words, take respon-sibility for every pixel? Or did you just let some-thing go, thinking: It will be okay?

Trust me, the editing process cannot put perfectly right a flaw that you bypass in your viewfinder, be it a small thing, like a tree branch coming out of someone's head, or a biggie, like a huge overexposed highlight patch at the edge of the frame. What you bypass in the field cannot necessarily be fixed on the computer.

Walkway, Yosemite National Park, California, 27mm, 1/40th at f/8, ISO 100

## POINT OF VIEW

Compose carefully! Look around the edges of the frame, not just in its large center. Move your feet; consider an alternate view.

Once you have decided where the camera is pointed and what exactly is going to be inside that little rectangle we look through (and after doing this for 30 years, I view the world through a rectangle even when I'm not shooting pictures), then and only then should you start considering the smaller details in the frame—what stays, what goes, what's emphasized.

Camera position is the whole deal. Everything flows from that. Just like having a point of view in an argument, it needs to be incisive, logical, forceful—it's your opening statement.

Williamsburg Bridge, New York City, 400mm, 1/500th at f/5.6, ISO 100

Golden Gate Bridge, San Francisco, 31mm, 13 sec. at f/22, ISO 200

# [CHOOSING AN APPROACH]

How do you decide which approach is the best for your subject? Urban environments can, for example, create special challenges but also rewards. The phrase "it's a jungle out there" can easily be applied to busy cities and towns when you have a camera in your hands. Traffic, lights, storefronts, power lines and crowds all compete for attention. You could just surrender to the visual cacophony and make your frame as busy as the city itself. Go with it, in other words. Jam as much bustling, energized sidewalk craziness into your picture as you can.

You could also look for the "unseen city." The beauty of the still camera is its unparalleled ability to observe and distill. While the city might be rumbling onward at full roar, you can find lovely subjects and pleasing compositions that people are quite literally walking by—or even on.

By being out on the streets before the city wakes up, you see that there is beauty and form in the buildings, the sidewalk newsstands, the avenues themselves. In this quieter realm, you and your camera can find light, shadow and color that make for striking compositions.

You and your camera can also find solitude and peace. Opposite, this lone, thoughtful person sits in a pew at St. Patrick's Cathedral in New York City. The simplicity of the composition reinforces the notion that, even amid the bustle, you can find a beautiful, subtle picture by concentrating, thinking—composing.

## JOE'S TIP

When venturing into the big city, or the countryside for that matter, a little research is called for. Know some places you want to go, keep a checklist, at least in your head, of locations where things are bustling (like a fish market or farmer's market) or sites where the atmosphere is likely to be quiet and easy (like a park in the early morning or a church in the late afternoon).

Travel light. Nothing blunts picture-making enthusiasm more quickly than carrying the photo equivalent of an anvil on your back. One camera, two lenses and maybe a flash in a small belt pack or shoulder pack will do fine.

Forget the tripod. Now, that's me talking—I hate to be pinned down to a tripod (I also hate to carry one). This has gotten me into trouble, being out there and wishing I had one. A tripod can be, at times, absolutely essential. Yet, remember, the mission under discussion is to wander, following your nose and instincts. It's hard to venture far, wide and happily when toting a three-legged monster. (We're also talking about capturing moments. Life happens, most of time so quickly that even the best of shooters miss shots they wish they had caught. You'll be setting up your tripod while the subject vanishes.)

CHECKLIST ☑:
☐ Wear good shoes. Not nice shoes but good, comfortable walking shoes that allow you to keep your concentration in the lens and not on your feet.
☐ Carry a cheap rain poncho in your small shoulder bag. Use it to wrap and protect your spare lens and leave the lens bag home. You don't want to be wrestling a lens out of a bag while the fishermen are unloading today's catch in beautiful golden light. And don't forget to pack a spare battery for your camera.

St. Patrick's Cathedral, New York City, 185mm, 1/40th at f/5, ISO 3200

"The beauty of the still camera is its unparalleled ability to observe and distill."

# RULES OF COMPOSITION

YES, I DID SAY EARLIER THAT "this is a game without rules," and that "rules are meant to be broken." But now we come to a section called "Rules of Composition." What gives? Well, with picture-making there remain a couple of tenets, or guidelines, that do make sense, over and over again. It's like getting eight hours of sleep at

night: This is wise, solid advice. After eight hours, you generally function better than if you had broken all of the rules and pulled a *Hangover* night and woken up with a tiger in your bedroom and no knowledge of how it got there. Similarly, if you obey certain rules of composition, you will generally be rewarded with better pictures.

NASA's Advanced Supercomputing facility, California, 16mm, 1/20th at f/4, ISO 200

Silhouette of fishermen, 27mm, 1/640th at f/8, ISO 100

## THE RULE OF THIRDS

One of the most basic rules of composition is known as the Rule of Thirds. To employ the Rule of Thirds, imagine that two horizontal and two vertical lines divide your image into nine equal sections (as in the picture opposite). Then, place your points of interest along these lines. Basically, this rule means: Locate some of your points of interest outside of or on the barriers of that center box. There is nothing wrong with the absolute middle, but pictures are often more dynamic when the dominant focus is off-center.

Observe this rule, if not slavishly, then certainly on a regular basis. It goes back, way back, to before you and I were born. It helped Renaissance painters arrange landscapes and portraits, and it can help you arrange your photos. Look at the photograph above, for example, and then imagine the fishermen in the boat smack dab in the photo's center. The result is less than compelling, and points of interest are forced out of the frame. If I had framed the boat in the center, the image would have looked lifeless.

Because the whole intent of this book is to get you out of the gate, psyched about opening the shutter and creating memories that will last, some of the ancient aesthetic commandments—things that have worked forever for people trying to make nice pictures—need to be followed, or at least considered. Obey the Rule of Thirds, and you will be excited by the photographs you take. You will, no doubt, ask yourself all of the other questions photogs ask constantly: Which lens should I use? Should I move to the right? Can I ask them if I can take their picture or will they beat me up? Go long glass or wide? Why am I so unsure of myself? Why doesn't this get easier? *Why am I doing this?* But start with the Rule of Thirds when you look through the lens, and you're ahead of the game.

It is such a powerful design formula that virtually every camera manufacturer offers a screen that you can drop into your viewfinder that divides that rectangle into thirds, both horizontally and vertically. I don't use them myself, preferring a blank slate (it fits my brain!). For me, being a bit of a traditionally trained journalist, the Rule of Thirds is pretty intuitive. Still, I like to pause every now and again to think about this rule, noting how well it usually works. Splitting sky and land on a 50-50 basis, for instance, often results in a static composition. Squeeze one or the other up and down into 1/3:2/3 ratio and feel your scene take on graphic punch.

Play with the thirds of the frame, up and down, left and right. You'll see your images change dramatically. You'll see them come to life.

Early morning light at the Masters Tournament, Augusta National Golf Club, Georgia, 19mm, 1/50th at f/8, ISO 100

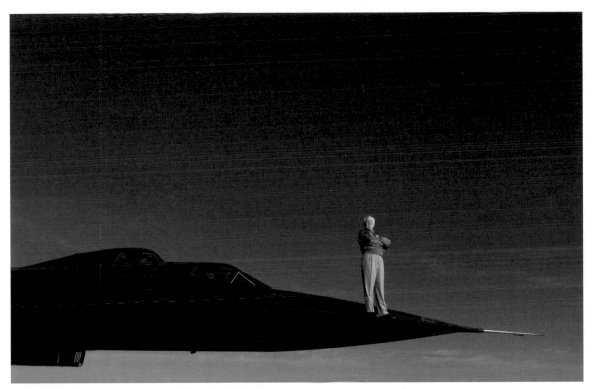

Pilot on the nose of a jet, 24mm, 1/250th at f/11, ISO 125

California's Palomar Observatory firing a laser into the heavens, 24mm, 30 sec. at f/4, ISO 400

Molten metal flowing from rail cars onto frozen tundra in Siberia, Russia, 20mm, 1/30th at f/4, ISO 200

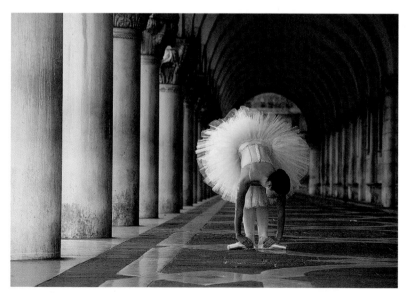

Dancer, 130mm, 1/40th at f/7.1, ISO 200

## DISTILL

Less is often more. When you place lots of elements into a composition, it can start to look like a patchwork quilt. Generally, you don't want your viewers to be playing *Where's Waldo?* Where should I look? What's the subject? The busier a frame is, the harder it can be to decipher. Even the effective Rule of Thirds won't help you situate everything.

Remember that you will not necessarily be there to narrate your pictures. You can't sit with everyone who examines your images and whisper over his or her shoulder, pointing out the area of the frame that you found interesting. "See that right there? The guy with the funny hat? Isn't he great?" Your pictures have to speak for themselves; after you create them, their lives are their own.

## FOREGROUND, MIDDLE GROUND AND BACKGROUND

For a picture to be effective compositionally, it has to offer a powerful, wordless road map to the viewer. It has to be readily apparent, through framing, light, color and arrangement of elements that someone is supposed to look right here, right now.

To that end, remember that there are not only areas of the photograph left-to-right and top-to-bottom but also three-dimensional regions in a photo: foreground, middle ground and background. Once again, you are responsible for all of them, and they all have to work in concert. A busy or blown-out background can kill an otherwise worthwhile foreground.

You can have the prettiest, sweetest scene in the world in front of your lens, but if you don't anchor your foreground with something of true interest, nobody's going to look. Take the picture below, of Anna Canning, a young blind girl on a raspberry-picking expedition, as an example.

Here, the large green leaves jutting into the foreground work with the smaller leaves of the background to embrace Anna in a verdant shelter. Golden light fills the middle ground to draw our eyes to her intent expression as she feels for the berries. All three areas work to engage us.

Good composition is the hook that impels viewers to sign on to your photographic adventure. You go out into the world and have these very normal moments—or frenetic and altogether magnificent adventures—and you duly record them in pictures. That set of pictures, being viewed by Uncle Joe or another Joe who wasn't in the rain forest with you, has to be strong enough to bring the birthday party or the Amazon River right to the living room. If you have framed these pictures correctly, you can make your viewer feel just as you did when you were making them.

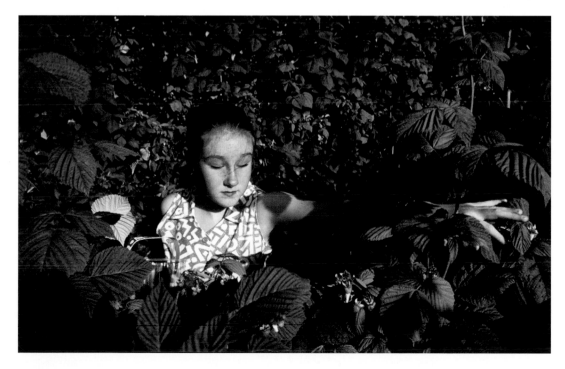

Anna Canning, 20mm,
1/125th at f/11, ISO 64

# [THIRDS, WORKING TWO WAYS]

When dividing your frame into thirds, it is important to remember that the Rule of Thirds works both horizontally and vertically. Our eyes are arrayed in our head horizontally, so it is more natural to be conscious of arranging things interestingly in panorama, or landscape mode, because that is generally the way we see. It is easy to forget that the rule is just as valid up and down as it is across.

When LIFE asked me to shoot a story on a strong woman, pro volleyballer Gabrielle Reece was an immediate choice. She was Superwoman, beautiful and athletic. I posed her as Atlas, substituting a gigantic inflatable volleyball for Earth. In the horizontal shot opposite, there is hard, late daylight coming from camera right, hitting her and the giant ball, and throwing a long, dynamic shadow across the desert floor. Placing her in the extreme right-hand third of the frame allows the shadow to play out and the coolness of the deep blue sky to vibrate and interact with the warm tones of the cracked orange earth of the dry lake bed. There are lots of things here for the viewer to absorb—color vibration, shadow games and compositional tension. They all derive from the camera's point of view and observing the Rule of Thirds horizontally.

I applied the rule in the vertical shot below, too. Gabby encounters the camera here in straightforward fashion, again heroically posed, holding up the volleyball-as-world. My camera angle is low, a useful tactic to use when working with athletes because when you look up at them, they will appear bigger than life. The desert is just a tone, striping across the bottom third of the frame, locating her. She gazes at the camera from the middle third, a simple blue sky framing her but not competing for attention. The top third is her burden, the curve of the volleyball.

Rule of Thirds. Remember that it slices both ways.

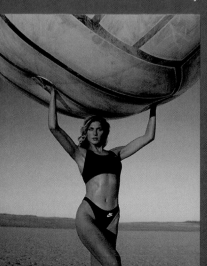

Gabrielle Reece, 105mm, 1/125th at f/11, ISO 100

## JOE'S TIP

To get tones, warmth and depth such as you see in these two frames of Gabrielle Reece, you have to wait for good light. If I had shot them at high noon, they would have ended up in the reject pile, and my not-so-patient editors would have yelled at me. So don't sabotage yourself before you even have the camera out of the bag. Go out in late afternoon or early morning. If you're shooting landscapes, arrive before prime time so you can stumble around and scout in bad light while you wait for good light.

If you're taking a portrait, factor timing into your arrangements. Tell your subject that the quality of light is all important to the photo— and to his or her dashing good looks. You're not lying or being difficult; it happens to be true. Appealing to vanity is one way to get someone up at four in the morning for a trek into the desert with you.

CHECKLIST ☑:

☐ Be careful when moving human subjects into the far, far edges of a wide-angle lens—their faces will stretch in unpleasant ways. It's best to use a moderate wide, not an extreme wide, if you are pushing folks into the corners.

☐ The Rule of Thirds applies to the composition within the rectangle, but remember: There are also three *depths* in the photograph: background, middle ground and foreground. When you're making a portrait, make sure your background is relatively simple and doesn't intrude upon (or indeed overwhelm) your subject. You'll want to keep the environment relatively sharp to lend setting, but make certain the background stays in the background.

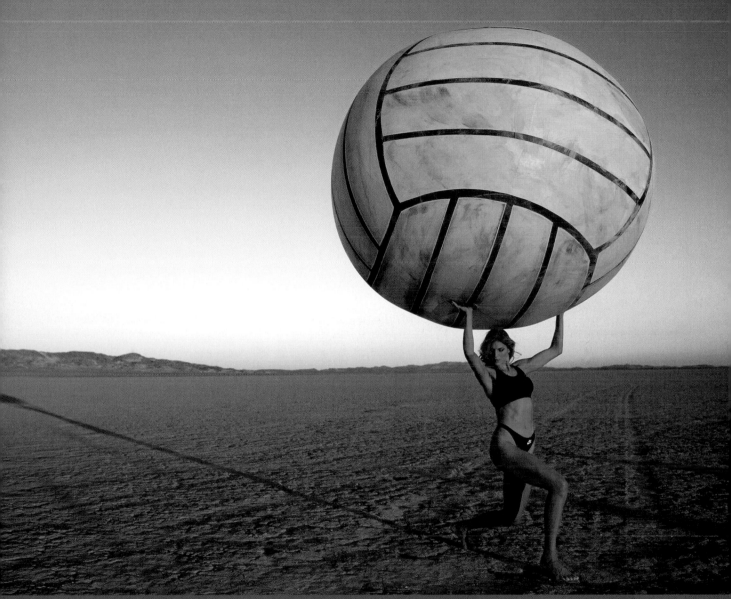

Gabrielle Reece, 28mm, 1/30th at f/11, ISO 100

# DO THIS FIRST

Test the waters, compositionally. Move the camera around, and move your principal subject left and right, up and down. Stay away from the common fault of putting your camera to your eye, your subject in the middle and going *click*. In other words, be as dynamic with the camera as you want your picture to be.

**"When dividing your frame into thirds, it is important to remember that the rule works both horizontally and vertically."**

# [SHOOT IT LOOSE! ROCK AND ROLL!]

Composition rules, as I have mentioned. But rigidity doesn't. Although it is important to know what's in your picture and to govern your frame well, do so benevolently, not with an iron fist. There are pictures out there you just might miss while you are setting up a shot and putting your lines in a row along with your ducks.

I certainly can be careless at times; every photog will be, eventually. There isn't a shooter out there who hasn't either grimaced or flat out shouted at the computer screen when seeing an unpleasant, jarring something-or-other pop up that he or she just plain and simple didn't see when the camera was to the eye. It *is* frustrating; when it happens to me, it prompts me to be really, really careful next time out.

There's nothing wrong with being careful, but there can be a lot wrong with being so meticulous that the world spins away in front of you while you carefully adjust your tripod. I teach a fair amount, and I have coached shooters on a location foray, then sat back and waited and waited and waited for them to release their shutters. Lots of dillydallying behind the lens. Lots of minute adjustments or waiting for a subject to move her pinky just so. It's something like watching a big-league baseball player go through his ritual before stepping into the batter's box. Hitch pants, adjust cap, roll shoulders, tighten Velcro on batting gloves, tap mud from cleats, hitch pants . . .

There have been times I have wanted to change the name of my location lighting workshops to "Just Take the *Picture* Already!"

So, although it is advisable to be careful out there, composing well and exerting patience behind the lens, it can be equally important to just let it rip. The cameras we have now are such finely tuned machines that they can usually expose and focus on their own. So take advantage, at least occasionally, of those systems. Get in the zone, know your exposure, let autofocus mode out for a healthy romp and just start shooting. I shot the picture opposite without the camera to my eye. This gentleman and I were having a lively conversation, and I was just about to push on (I had actually lowered my camera), when he simply cracked up laughing. I knew my focus sensitivity would grab his face and that my lens was wide

## DO THIS FIRST

When you want to enjoy a bit of spontaneous, rapid-fire shooting, prepare your camera for the task at hand. Set it on autofocus and take what I would call a "quickie Polaroid" of your setting, which will allow you to dial in the right exposure. Now put any concern about f-stops out of your mind, and fire away. This is an exercise in composition, not lighting, so think only about what you want in the frame. Later, analyze the results from that perspective: What's working compositionally—and what's not.

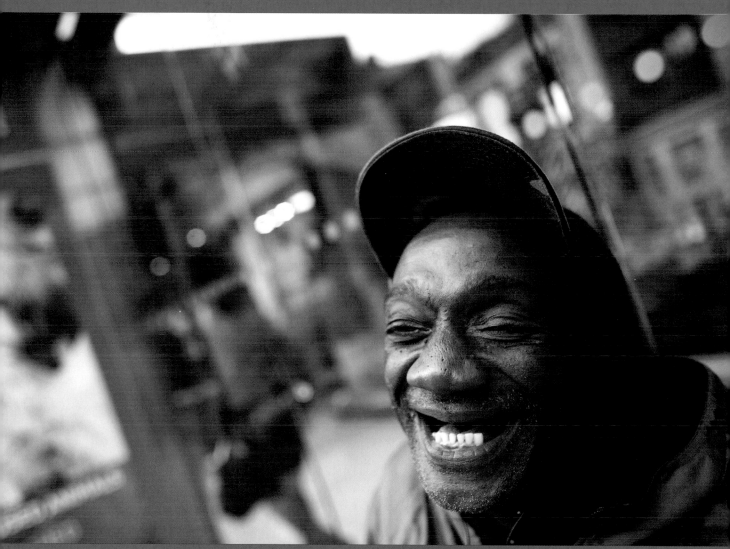

Having a laugh, New York City, 28mm, 1/400th at f/2.2, ISO 400

"There have been times I have wanted to change the name of my location lighting workshops to 'Just Take the *Picture* Already!'"

Street scene, New York City, 155mm, 1/2,500th at f/9, ISO 400

enough to establish the scene, so I just hit the shutter, set on consecutive high. I got several frames showing his amusement over this stranger with a camera, and this one is just cockeyed and off-kilter enough to reflect his exuberance. Shoot your next cookout this way, shoot from the hip. See what you get.

You can do the same thing anywhere. An excellent exercise for building your compositional muscles is to wander the streets, busy streets, and shoot pictures as you move through the crowds, without ever putting your camera to your eye. Keep moving, and keep shooting. Shoot a lot. Shoot all day like this. Then take a look at what you've captured. You may just surprise yourself that all that carefree clicking has yielded an energetic frame or two—or 20. The successful shots might be a touch out of focus and might not conform to the classic rules of composition. But an out-of-control adventure like this can liberate you. Go for it. Take your camera, and don't put it to your eye.

## JOE'S TIP

Sometimes when you pick up your camera, your aim is to carefully render a subject. Sometimes it's to capture a special moment. Sometimes it's to create something artsy. And sometimes it's just to have fun—a bit of a photographic lark. That's what we're talking about here, so adopt a loosey-goosey mind-set and a freewheeling plan to match. Having said that, make sure before you wade into any session of spontaneous shooting that you've got the right equipment and realistic expectations.

CHECKLIST ☑:

☐ If the camera is to your eye, do try to establish the crucial spot of critical focus on your subject's near eye.

☐ If you're shooting from the hip, burst the camera: Get off a single frame, then go to consecutive high. You will produce some out-of-focus frames as you move, but you'll likely get some sharp, sweet frames, too.

☐ Whether you shoot from the hip or with camera to your eye, use a relatively wide lens. You want to capture a scene, you want to bring things in, and it's virtually impossible to do this kind of broad, fast shooting with a telephoto.

Thaipusam festival, Kuala Lumpur, 200mm, 1/160th at f/2.8, ISO 800

# PICTURES WITHIN PICTURES

Cape Hatteras Lighthouse, North Carolina,
70mm, 1/2,000th at f/7.1, ISO 400

INDEED, AS THIS SECTION TITLE SAYS, there are often pictures within pictures. If you are in a place that you most likely will not be able to get back to easily, it is best to think aggressively and broadly, and not just content yourself with the "Oh, honey that's nice" roadside snap. If you can, get closer. Shoot that roadside pic, and then look for other things. Remember, the "big picture" is just the start of things.

## PEELING THE ONION

Lighthouses are obviously fascinating visuals and, given their distinctive architecture, are highly graphic subjects to shoot. Moreover, these beacons are usually located in pictorially intriguing places. They have great allure for a photographer; I'd love to have a nickel for every picture that's been taken of a lighthouse.

But for me, a people shooter, dealing with buildings, no matter how historical or pretty, can get boring, and quickly. Yet, when confronted with this barbershop pole of a lighthouse in North Carolina, I got excited: I had good light, a graphically strong subject and freedom to move my camera about. I promptly determined to come away with something that didn't look like the postcards they were selling at the gas station down the street.

First, however, I went ahead and shot the postcard. Done deal. This is advisable; pick the low-hanging fruit. Frame vertically, give the tower room to breathe at the top of the frame and arrange those wonderful clouds well. This is about patience and care behind the lens. At this time of the day, the light is good, and, if it

hangs around and doesn't disappear completely behind low clouds, it will only get better. You've got an active sky, so shoot—and wait. Shoot—and wait. The clouds will move, the sunlight will get richer and warmer. Be careful of your lines. To my knowledge, there is only one well-known leaning tower in the world, and it is in Italy, and it is not a lighthouse.

Shoot, and shoot some more. Think of this: How long did it take you to get to the lighthouse? How many hours did you drive? You parked the car and unloaded your gear from the trunk and maybe even set up a tripod. That's a lot of work for only 5 or 10 frames, so stick with it. Watch the light and the clouds change. The building doesn't budge an inch, but the changing atmosphere will allow it to express itself differently.

Closeup of Cape Hatteras Lighthouse, 155mm, 1/250th at f/8, ISO 200

Nauset Light, Massachusetts, 202mm, 1/320th at f/13, ISO 100

Wide-angle view of Nauset Light, 21mm, 1/200th at f/13, ISO 100

## THE NEXT SHOT

After you've covered the basics, go for something different. This is a game professional photogs have played forever. We shoot what is needed—we shoot "the assignment," the shot of record, the shot that proves we got there—and then we dive in and experiment.

Try a very long lens, if you have one. Or focus in close to the structure with something very wide and play with distortion. Think to yourself: *About a million billion photos have already been taken of this thing. How can mine be different?*

An exercise such as this will make you a better photographer—take you to the next level. On Cape Hatteras, I shifted to a long lens and wandered around the lighthouse, eventually finding the small, compositional exclamation point of the black window in the middle of the white sweep of the paint job. For this shot, shown on the previous page, I bull's-eyed the window, and let the building do the rest of the graphic work for me. There's no context here; I distilled the structure down to simple, pleasing blacks and whites. I already had the shot that shows it's a lighthouse. This one is about the character of the place, its uniqueness. (I really feel good about this frame. This view has been taken, I'm sure, only a couple hundred thousand times, not a million billion.)

Think of photo subjects as onions. You have to peel away layers. Shoot the outside, to be sure, then move in and peel back layer after layer. The picture that really rings true might just be living inside the picture you are already taking.

# [BULL'S-EYE!]

In describing the Rule of Thirds earlier in this chapter, I depicted the middle of the image as a no-fly zone. Stay out of the middle. Keep to the edges. There are very good reasons to do this: Locating your principal objects of interest or your human subjects consistently in the middle of that rectangular camera window will infuse your pictures with a static quality. This is to be avoided.

So it does make sense a great deal of the time to use the edges of the frame. The edges are where the most dynamic activity often occurs, and when you establish that, you create tension in the frame that can captivate and hold the viewer's eye.

As with most things photographic, though, this "avoid the middle, it's bad" rule is meant to be broken now and then. You will encounter subject matter, such as the picture below of a pastor in his church, that simply demands to be front and center in your frame. When handled well, a centered composition can be just as captivating as anything out on the edges. A well-done centered frame has impact. It's confrontational. It's a very loud message from you, the shooter, to the viewer. "Look here! I'm talkin' to *you*!" There is no escape from a powerful subject smack in the middle of the frame.

**DO THIS FIRST**

Ask yourself, as you contemplate the subject seen in your viewfinder, does this person command the center? Move the camera left and right to alter the scene, and watch your subject's message change. Does he or she demand to be in the middle to most forcefully speak to the viewer?

Pastor Grier, Augusta, Georgia, 18mm, 1/8th at f/8, ISO 100

Swimmer in training, 200mm, 1/250th at f/5.6, ISO 200

"The middle is the only place to put this guy. He is straight at me. There's no place here for the Rule of Thirds."

On the eve of the 2000 Sydney Games, I was given that wonderful assignment: Show us the limits of the human body. How fast? How high? How strong? I was to focus on the human machine and how hard it can be pushed. I spent a good bit of time photographing a variety of Olympic athletes as they prepared themselves for their quadrennial chance at glory. At the U.S. Olympic training facility in Colorado, I jumped into the pool, cameras and all, with the swimmers, trying to get a water-level view of their power and raw energy.

Putting the camera at the eye level of the athlete, in the middle of the action and exertion, is often an effective photographic vantage point. Hence, when dealing with water sports, you have to risk it and get the gear right down there with all the splashing and sloshing. In the photo on the opposite page, the swimmer is bearing down on the camera as he's being towed by a machine that is pulling him along at just slightly faster than his best recorded time. The machine pushes the athlete to match its pace.

The middle of the frame is the only place to put this guy. He is straight at me. The long lens (70–200mm zoom) magnifies him, making him seem closer than he really is, as if he's going to swim right over my lens. There's no place here for the Rule of Thirds. If I made him smaller in the frame, and off to one side, he would look, well, smaller in the frame and off to the side. He would lose intensity and impact. The only thing I would have in the rest of my picture would be empty water, and, as pretty as it might be, it would detract from my message—peak athletic performance.

Guess you could say I went with the flow. Sometimes the flow goes right down the middle.

## JOE'S TIP

All manner of physical endeavor, from sports to ballet, is about strength and determination. Quite often these elements combine to give you a subject so forceful that you simply have to put him or her front and center. Remember how you shared your kid's tension when you saw the gritted teeth just before the starting gun went off? Let's capture that in a picture.

First, get as close as you can. There's no sense of urgency to a shot of a swimmer taken from above. Get the camera down at the level of the activity. Bore in, either by moving your feet or via your choice of lens.

Watch for the moment. The leap. The throw. The pirouette. A tight shot of the racket connecting with the ball.

CHECKLIST ☑:
- [ ] Telephoto is the way to go. If you can't get onto the sidelines or onstage, this lens can take you there. Also, when intense action is heading straight toward you, a telephoto's reach and magnification allow you to fill the frame.
- [ ] As action barrels along, it's fine to use autofocus.
- [ ] Center your subject in many of your shots. Focus on the effort and highlight it.

# PLAY THE ANGLES

WHEN YOU TALK ABOUT COMPOSITION, you have to deal a bit with geometry. Thankfully, not too much, because I stink at math. But the viewfinder frame we look through is, after all, a rectangle. And the shapes we fill it with—intuitively, unconsciously or deliberately—are often geometric.

The clusters of ferns form triangles that create a dynamic composition, 19mm, 0.4 sec. at f/11, ISO 400

## COMPOSE DYNAMICALLY

Take triangles. They pop up quite frequently in effective photographic composition. The shapes of rooms and of certain elements of nature or landscape often form triangles. Or diagonals. Or leading lines. Or converging lines. These are all geometric elements that draw the eye, lead the eye or create dynamic tension within that basic viewing rectangle. It is how we arrange these points of graphic tension that will determine whether we succeed in our composition, and therefore involve and excite our viewers, or whether we bore them. Paul Simon once said

there must be 50 ways to leave your lover. I don't know how many ways there are to make someone leave a photograph, but dull, flat composition is a surefire one.

As a photographer, what you want to capture, besides the picture itself, is the attention of the viewer—your consumer. Whether it's an editor or Aunt Edith, you want to make the person look and then stay with you. Accept this, please: The world is awash in visuals. Magazines sit on racks by the hundreds, screaming for attention. Everybody's blogging, hoping someone will notice. News channels drone on 24-7. All of your friends want to show you their vacation pix. People are subjected every day to a veritable fire hose spewing visual information. They are overworked, overcommitted, overstressed and overexposed to imagery. And here you come along with your picture, asking them to spend some time with it. Good luck.

That luck improves if you compose dynamically. If you don't nail it on the graphics in a heartbeat, your picture is just a bunch of also-ran pixels as your viewer turns back to the latest news about Brangelina. Think of composition as the first impression you make on a first date. That impression had better be a good one, or that first date is also a last one.

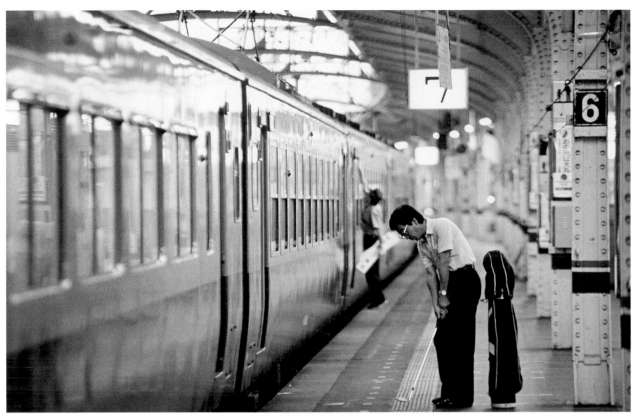

The receding triangles formed by the train and platform, flanked by the upright rectangles of the pillars, spotlight the golfer, 28mm, 1/250th at f/2.8, ISO 100

Play with angles and shapes. Isolate them, group them or make them lead the viewers where you want them to go. Use diagonal lines to break up that staid rectangle you are looking through. On these pages and the following two are some examples.

The green gaggle of ferns, opposite, is really a collection of triangles, arrayed so that they fill the frame with engaging, repetitive shapes.

The line of the train and the platform, above, brings you right to the subject, the golfer, practicing his game on the platform.

At a rock concert, right, the hot core of laser beams pulls you into the middle of the photograph, as the star leaves the stage.

Strong lines of laser light draw the viewers' eyes to a performer's silhouette, 28mm, 1/125th at f/5.6, ISO 200

A football player's hands form an upside-down triangle, 200mm, 1/25th at f/11, ISO 400

The cowboy's hat creates another triangle, 89mm, 1/120th at f/5.3, ISO 200

The minister's cruciform shape is repeated in her watery reflection, 85mm, 1/60th at f8, ISO 100

A former football player's hands at rest, above, make their own upside-down triangle. You get drawn to the shape and then get involved in the weathered hands, which tell a poignant story.

Above right, the angled brim of the cowboy hat makes its own triangular top. Those lines direct the eye, and the upside-down V helps keep you in the frame and involved in the rugged face.

The minister at right stands in a river with her face and hands lifted toward the sky. Her arms and body form a cross shape that's mirrored in the water. Imagine this photo if her hands were at her sides. It simply wouldn't be such a powerful, evocative pose. If that had been the case, I might not have shot the picture at all.

In the photo at right, an imposingly long stretch of park benches forms a riveting line that recedes into the far distance. The eye follows that line and encounters the lone graphic punctuation point: the early-morning visitor. Take him away, and the picture's impact disappears—it becomes just a bunch of empty lines. But now the lines lead to that man, and we share his bench with him.

In the photo below, the nose of this Guppy, a strangely shaped transport plane used by NASA, combines gleaming arcs and triangles. The sunrise shape pulls you straight to the featured activity: the early-morning cleaning.

Photographs, at the end of the day, just sit there, either on a screen or on paper. They don't sing and dance. They don't run and jump. It is an ongoing conundrum we always face as shooters: We hold in our hands a "still" camera, a machine designed to stop time and motion. So how do we make something static appear active and dynamic?

Good composition.

It can make a still photograph move.

A row of park benches forms a line to the horizon, 210mm, 1/160th at f/10, ISO 200

The glowing metal arcs of a NASA Guppy transport plane draw the eye to the worker's activity, 400mm, 1/250th at f8, ISO 100

# [WIDE COMPOSITION: STAY CLOSE]

As I've mentioned, wide lenses, especially if you are new to using them, can be problematic. Their wide embrace of a scene can inspire you as a shooter to take a step back and get everything in the frame. But when you look at the image later, it turns out you've got nothing of value in the frame. Wide lenses can be very seductive like that.

My advice? Don't step back, step forward. Push the wide lens in. If you stand there with a wide angle, photographing from eye level and middle distance, you court, if not disaster, then at least boredom. You're left with swaths of empty space in your picture that the viewer has to navigate to finally get to that small piece of the scene you wanted to highlight.

Further practical, technical information on wide glass is in the lens section of our book. But here, regarding composition, just remember to keep the frame lively. Manage it well. Push in, risk a bit of distortion and liven up an otherwise staid scene. Take extreme care with backgrounds! The wide view these types of lenses give you just gets wider as it reaches the background. If you're not careful, there could be numerous holes back there, such as hot patches of sky or annoying, distracting patterns and lines. I get pretty aggressive with my wide glass when framing a shot. I push it. Here and on the following pages, you'll find some examples.

With the Muppets, you're dealing in fantasyland anyway, and you want to emphasize all the saturated color and googly eyes. I filled the frame with characters and moved my wide lens in as close as I could. Nothing but Muppets!

## DO THIS FIRST

Before you shoot, know you are going wide, which has special considerations. The view you'll have will include a lot of stuff, and much of it will be relatively sharp and competing for attention. Don't just look at your principal subject or the middle of the frame! Do a survey of the whole picture, which means looking at the edges to make sure they aren't littered with visual junk.

"My advice? Don't step back, step forward. Push the wide lens in."

Jim Henson's legacy, 24mm, 1/60th at f11, ISO 100

Refugees, Africa, 20mm, 1/60th at f/8, ISO 100

As I've noted, a camera-toting journalist walking through a refugee camp in Africa attracts a lot of attention. The kids follow you. So do some of the adults. Here, I responded to the gaggle of fascinated faces and eyes by getting my 20mm lens right at the kids' level. The foreground is filled with faces and the background is filled with their home, at that time a makeshift camp for the displaced. Faces in a place.

## JOE'S TIP

Wide-angle lenses can embrace a world of visual riches and relationships. They can also give you a world of trouble, if not handled properly. That is why I counsel aggression with the lens. Push it in, maybe even closer than you think is reasonable. You can always pull back if serious or unwanted distortion occurs. Experiment! That ever-expanding view the lens presents is a great way to tell stories about people and places, but it is unforgiving to the careless.

One of its basic strengths—lots and lots of depth of field—is also one of the reasons wide glass demands a careful eye. Unlike telephotos, which tend to throw annoying background material seriously out of focus, the wider lenses allow that material to retain shape and form. The background can then compete with your foreground elements of principal interest, if you let it. But when you get close, you pare down some of the background. The result? A dominant, eye-catching foreground with a carefully orchestrated, supportive background.

CHECKLIST ☑:
☐ Try not to tip the lens. Tilting it up, down and sideways will increase distortion. Lines of buildings and rooms topple over and converge or fall away. If that is the desired effect, go for it. If not, though, manage the lens well. In a room, for instance, I try to line up an edge of my frame with a vertical line in the room—a corner, a window—and I find this helps me keep the lens straight up and down.
☐ Remember that your depth of field shortens when you get close with a lens, so adjust your f-stop accordingly to retain some of this DOF—if that will lend perspective to your picture.

Shooting vertically with wide glass can really distort your subjects, which can be off-putting. Yet, a touch of distortion, handled carefully, results in a strong graphic statement. At the Hindu festival of Thaipusam, a swirl of religious fervor, sweat, incense and body piercing, this young boy, right, looked on in wide-eyed wonder. By pushing a 14–24mm lens down at him in a vertical position, I was able to emphasize those amazed eyes and his wary expression.

Nose of an F-16, 18mm, 1/60th at f/11, ISO 50

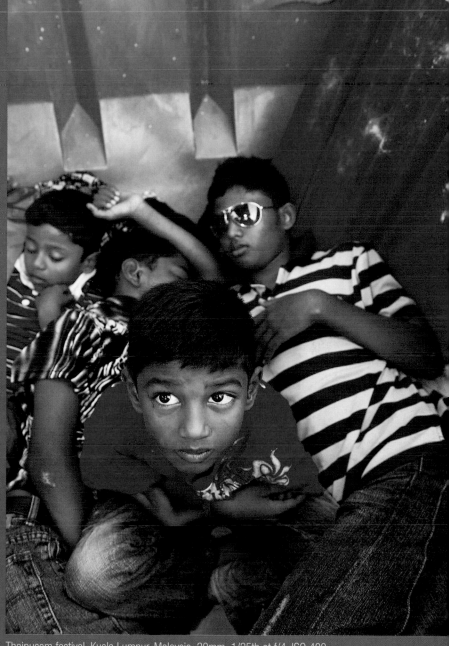

Thaipusam festival, Kuala Lumpur, Malaysia, 20mm, 1/25th at f/4, ISO 400

At left, looking up at a stark blue sky with an 18mm, the nose of the F-16 gets even more spacey and supersonic-looking, thanks to the wide-angle distortion and the vertical framing. The clean background keeps the graphics of the shot powerful, simple and to the point.

# PORTRAITS

To me, everything is a portrait. To quote friend and mentor Jay Maisel, "Everything has gesture." A person, a face, a rock, a tree—depending on how you shoot it, the subject expresses itself beautifully or not at all.

## GESTURE AND EXPRESSION

Life moves; we have to move with it. The human face is ongoing theater, filled with nuance, subtlety and emotion. Beauty abounds. We have to find it. I've had glamorous models in front of my lens who have turned out to be brittle and boring subjects. And I've met folks on the street who, without looking in any way extraordinary, captivated me—I simply could not stop taking pictures of them.

To be a good portrait photog, even of your kid or best friend, you need a camera, a relentless curiosity and a hungry eye, always roving and looking. Other paramount requirements include a sincere empathy for the human condition, a well-developed sense of humor and irony, an understanding of human foible and ego, the ability to strike up even the most cursory of relationships with

Portrait showing joy, 200mm, 1/200 at f/8, ISO 200

Portrait showing experience, 28mm, 1/400th at f/11, ISO 200

relative ease and the desire to tell stories. A pretty tough exterior, one that can handle rejection, helps—not to mention a level of confidence that pumps up and involves your subjects, making them, busy as they may be, willing to give you the time of day. You can say to your kid after her basketball game, "Give me a smile," and her answer might be, "No way, Mom!" You need to deal with that just as if the President of the U.S. of A. had said, politely, "Not just now."

You need passion. I swear some people, including my daughters, have given me time to work just because they sensed the urgency in my voice. I was able, somehow, to convey to them that this photo was important, that I needed to shoot it and that if they allowed it, I would do so well with it that the photo would become important to them, too.

Portrait showing contemplation, 200mm, 1/250th at f/22, ISO 200

The hard part is crossing the bridge, getting inside someone's natural barriers, making eye contact and gaining someone's permission without a word being exchanged, sensing body language and knowing when it's okay to approach and when it's time to back off. The sensitivity to know and respect boundaries is part of this, as is the grit to push beyond them when invited in.

You never want to push your subject around or trample his or her feelings or defenses. But you do want to get the true picture. It's not only professional photographers who find themselves in uneasy situations. An example: You're shooting your local high school football team on a regular basis. You know the players and the coach. Now

it's playoff time. The quarterback throws a touchdown, and you are shooting the smiles and the jubilation. Then, in the last minute, he throws an interception, which causes the team to lose. You are in the locker room, faced now, not with whoops and shouts of joy, but with dejection, maybe even tears. Do you leave? Do you back off? Or do you risk disapproval, maybe even a confrontation, by lifting your camera to your eye and continuing to record the story of that game? Are you here as a friend or a chronicler? Do you suck it up and shoot, or do you fade away into the night, knowing that what you captured was incomplete? Or do you find admittedly conflicted middle ground and work quietly, from a respectful distance?

All these questions! It's complicated being a photographer.

Portrait showing prowess, 26mm, 1/20 at f/5.6, 200 ISO

# TAKE A PIECE OF THE ACTION

A PORTRAIT CAN BE DEFINED in many ways. You don't necessarily need to see the subject from top to bottom to be moved, riveted or intrigued by who he or she might be. In fact, showing just a little can pique your viewer's interest and curiosity. It can also convey character.

I have always been a big fan of photographing hands. Hands can often tell the story of a life. What someone does helps to define who he is, as we've said, and what he does, he often does with his hands. Hands show the stresses, scars and grit of life. Think of hands on a baseball bat or the bow and neck of a violin.

Of course, if you are photographing a class of ballerinas, you may want to shift to the feet.

Hands of boules player between throws, 180mm, 1/250th at f/5, ISO 200

Hands holding stirrups, 200 mm, 1/125th at f/5.6, ISO 200

Dancers training at the Beijing Dance Academy, 27mm, 1/250th at f/4, ISO 400

# MOMENTS

WHEN I AM WORKING with subjects, trying to make a portrait, I stay alert. People will do the darnedest, most natural, effortless, compelling things, and you have to be prepared for it.

I keep my eyes on my subjects, even when I am changing lenses, or when one of them takes a cell phone call, or when we are just generally in between pictures. When they are not conscious of being photographed, they can simply revert to being themselves, and their gestures and body language become entirely natural. I have just about thrown myself at people when they behave like that, blurting, "Don't move! Please don't move!" Because in that off moment, they became a photograph.

Famous, true photo story: Ernst Haas, a wonderfully sublime photographer, was sent to photograph Albert Einstein. Haas's editor commanded him to "get a picture of Einstein thinking." Evidently Mr. Einstein was not cooperating, being very aware of the presence of a man with a camera. So Ernst asked him, quite innocently, where he had put a certain book. Einstein paused, and his fingers went to his chin in pensive fashion. His face said, "Now where did I put that book?" Ernst was ready, and he captured a photograph of Einstein thinking.

So keep your eye on your subjects. Be ready with a camera. The right gesture—the perfect moment—is fleeting. You see it, then you don't.

Boy praying, 200mm, 1/60th at f/2.8, ISO 100

Men in a steam bath, 35mm, 1/30th at f/2.8, ISO 200

New York City firefighters on a lunch break, 105mm, 1/160th at f/11, ISO 400

# HEROES

New York City fireman, 105mm, 1/60th at f11, ISO 100

THE HERO PORTRAIT has been with us since before Mathew Brady looked at Lincoln. You want a hero picture to be expressive and stirring. Often, a good strategy is to get the camera low, letting the subject appear larger—looming in the frame.

The quality of light is very important. The right light enriches and ennobles the hero's visage and gives the subject stature. Sunrise or sunset light can work well: The golden, angled light burnishes in a way that flat, cloudy light will not.

Include symbols. Flags, uniforms, sports gear—they all help you tell the story of accomplishment and daring, the story of an adventurous soul.

Now, then: What is a hero? Who is a hero? The three men on these pages—a firefighter, a jet pilot, an astronaut—surely fit the cultural definition. But when asked, many of us answer, "my mom" or "my dad" or "my best friend." Elevate this loved one. He or she is indeed a hero, so go for the hero treatment. Have your father hold his fishing rod or your girlfriend her violin. Pose your daughter with her soccer ball or stand your son in front of a wall filled with diplomas. Then wait for the golden light. And shoot from below.

Air Force pilot, 28mm, 1/125th at f/11, ISO 100

Astronaut John Glenn, 85mm, 1/125th at f/5.6, ISO 200

# SHOW ENVIRONMENT

AS I'VE SAID, sometimes what someone does defines who they are. Where you situate a person in a portrait is an extension of this thinking. Your subject's home or place of work can become an effective framework for your picture. In such a setting, your subject is surrounded by familiar stuff, stuff that he or she enjoys or relies on—stuff that is important. The environment helps define who this person is for your viewer.

Bookshop owner, 26mm, 1/60th at f/6.3, ISO 125

Dancer preparing for a performance, 21mm, 1/20th at f/4.5, ISO 100

So, show the environment! Not surprisingly, these kind of shots, as I mentioned in our Lens chapter, are called environmental portraits. Use the symbols available to you, the physical details, the wear and tear. This becomes your subject's stage. It also, being a familiar spot, might well serve your subject as a comfort zone. Do not criticize your kid's messy bedroom, though you might want to. Or for that matter, your crazy uncle's Mad Professor garage or workshop.

Elementary-school girl, Indiana, 105mm, 1/60th at f/4, ISO 200

**"I told her the best thing she could do for me. 'Ignore me,' I said. She did that really well."**

# [FIND QUIET MOMENTS]

Photographers always want people to do things. We believe actions speak loudly, and often they do. So we show up, camera in hand, and simply ask our subjects to go ahead and do something they find expressive of who they are. Time is compressed during these encounters, so basically the conversation goes like this: "What do you do that is interesting and would make a good photo?" Various activities are discussed and noted. The photographer then says, "Okay, all of these things sound good. Let's go do them."

In the midst of this rush to photograph what we perceive to be interesting, it is important to remember that you may be missing good portrait moments that could be had by simply doing nothing, by leaving your subjects alone, allowing them to figure it out. When they do, you hope that your camera is to your eye.

When LIFE sent me to photograph an innovative elementary school in Indiana, I followed one child. I told her the best thing she could do for me. "Ignore me," I said. She did that really well. In not much time, I had vanished from her consciousness. But I paid close attention to *her*, and I left with the lovely portrait we see on the opposite page.

## DO THIS FIRST

Be patient, unassuming and calm—even in the backyard with your kids. Become part of the furniture. When those around you forget that you're there (most important, when they forget there's a camera present), the charming, candid pictures start to flow.

## JOE'S TIP

What we're talking about here are situations where you're not imploring someone to say "cheese," but, rather, hoping for something subtler and more special.

CHECKLIST ☑:

☐ If you are trying to capture a quiet moment, find quiet light.

☐ A telephoto lens can be useful in allowing you to keep your distance yet come in close.

☐ Check your settings even before you start so you are ready to shoot. You never know when your subject might spontaneously strike just the right pose.

# GROUPS

I DON'T KNOW TOO MANY SHOOTERS out there who actually enjoy shooting groups. Let me rephrase: Most photogs I know would rather endure a short, brisk whipping than shoot a group photo.

## THE RULES

Consider these Joe's rules for group portraiture:

- Move fast.

- Be confident.

- Make it fun.

- Don't be afraid to make a fool out of yourself.

- Oh, and try to use good lighting, staging, arranging and camera work.

The whole camera, lens, light deal comes at the end of these rules. Does that mean they're not important? Hardly. But I want to emphasize the unique dynamics of group portraiture.

This kind of shooting is, first and foremost, an exercise in human relations. You, the photographer, have to be authoritative but approachable. You have to be commanding but self-effacing. You have to be funny and lighthearted but you need to get things done efficiently. You have to

Young gymnasts, 26mm, 1/160th at f/2.8, ISO 200

Jazz musicians, 28mm, 1/60th at f11, ISO 100

shoot like mad, really, really fast, but pay attention to details. You have to be a lighting director, cameraperson, set designer, social director, shrink and ringmaster.

And when the woman in the front row, the one dressed and shaped like a parade float and sporting the welder glasses that reflect all of your lights starts badgering you about how long this is going to take, you have to have the patience of Job.

Some more rules, practical ones:

Make sure all of your subjects can see the camera WITH BOTH EYES! If that guy in the last row sees the camera with one eye only, he'll likely think everything is cool, even though the person in front of him is blocking half of his face. Make people aware that both of their eyes have to see the camera. Shift accordingly.

Try to work with the existing light. If you are outside, pray for clouds. In bright overhead sun, try to put the sun behind your subjects. Though this situation is still problematic, it is better to have that nuclear bomb of bad light slightly overhead and behind your friends rather than in their faces.

Ask everybody to turn to the person adjacent and make final adjustments. With a big group, from back behind the lens, you can rarely see if so-and-so's tie is askew. Ask everybody to double-check and look out for his or her neighbor.

Dancers at the Beijing Dance Academy, 48mm, 1/20th at f/5, ISO 200

If you are using flash, try to bounce the light instead of using it straight on. If possible, get the flash (preferably *flashes*, plural) off the camera. If you use a straight flash, right from the hot shoe on the camera, and you have multiple rows of people, the first row will take the flash right in the face and heat up in your exposure. The back row won't get enough light and will also be shadowed by the light hitting the folks in the front row. So bouncing and, if possible, multiple flashes are the best way to go.

Break up your subjects' outfits! Don't let five people wearing jet black stand together. Likewise snow white. Make things irregular. Bring people with darker clothing or skin tones closer to the light source, and place people who are lighter in tone and clothing in an area where the light is not as intense. Balance the tones within the scene.

Make it fun. (I know I'm repeating myself, but it's a thought you should return to regularly when making group portraits.) Work as quickly as you can; you will have these folks only for minutes. Make every frame count. Project your voice, pointing right into the lens to signify that's where they need to look. Tell a joke. Kibitz. Single someone out who is loose and will respond well to banter. (You can pretty much tell right away who in the group you can josh with and who might help you coach the others. Find your alpha dog.)

Pay attention to the kids! If possible, introduce yourself and then try to REMEMBER SOME NAMES. People, especially kids, are surprised and inwardly pleased if you call them out personally. "Hey, Gladys, can you turn your shoulder a bit this way?" works better than, "Yo, lady in the third row in the pink outfit: Lose the hat!"

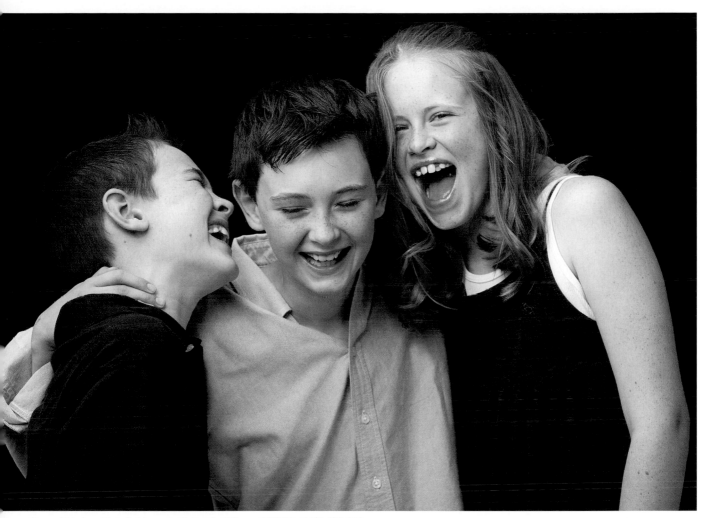

Young kids laughing during portrait shoot, 145mm, 1/250th at f/8, ISO 200

And, at the end of the process, get your group to do something exuberant. It can be in the form of a cheer or, if you are dealing with kids, maybe they can all high-five one another, hug one another, tickle one another, whatever. Let them know the picture-taking is over, and they can really go crazy. This is the group portraiture version of the "trash the dress" craze currently in vogue in wedding photography.

If you lead the charge and risk being goofy; if you passionately direct the action and make it apparent that you're having fun; if you act like this . . . then your subjects will, too. In addition to following your lead, they'll also give you more time than they might have otherwise. Precious time, as all time is before the camera—you and them, making memories.

Oh, and did I mention you should make it fun?

PART **SIX:**
# [JOE'S LAST TIPS]

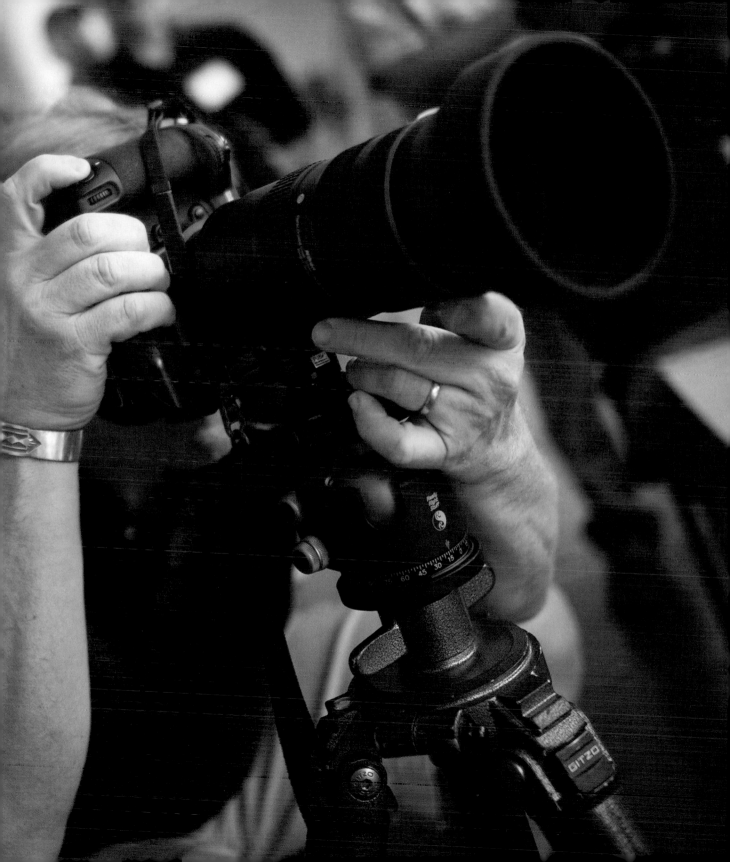

# HOLD STEADY

A CAMERA IS NOT A FABERGÉ EGG. It is not a delicate bauble, or a museum piece to be gazed at reverently. It's a machine, a tool. Nothing more, nothing less. Now, there are those who would wax lyrical about the legendary picture-creation abilities of, I don't know, some 1943 custom-built Leica rangefinder with the polished brass fittings and the lens made of crystalline glass forged in Hephaestus' fires. Such assessments make glasses steam and grown men and women swoon, and they induce unbridled rapture among those who passionately worship at the altar of gear.

These people are generally called collectors. Photographers, they ain't—not usually.

What best sums up my feelings about cameras came from legendary war photographer Don McCullin. He said, "I only use a camera like I use a toothbrush. It does the job." Amen.

My first motor-driven camera was a Nikon F with a detachable base plate filled with batteries. It was rugged and heavy, a great street camera. Marty Forscher, the legendary wizard of Professional Camera Repair on 47th Street in Manhattan, used to tell me, "You could hammer a nail with that camera!" Of course, he then urged me not to do that.

Maybe it was these beginnings, working with a metal monster of a camera that was like a shot

I support the camera on my left shoulder.

put with a lens attached, that first taught me the necessity of holding my cameras steady. Or it could have been my workaday beginnings as a newspaper grunt, where the only thing you gripped tighter than the camera and lens was the beer bottle at the end of your shift.

And conversely, perhaps it is the current gloss of computerized technology that has draped itself over all things photographic that has folks new to the game holding these machines delicately, gently, like a magic box in which the pixels gambol about like tiny woodland creatures.

Let's talk technique. Pick the camera up. Which eye do you bring it to? This will come naturally, something you do from the very first moments behind the lens, something perhaps embedded in your genes. I never thought about why, but from the first I put the camera to my left eye.

This, oddly enough, gave me an advantage in terms of holding cameras steady, even at slow speeds. (Right-eyed folks, keep reading, there are tips in here for you, too.)

Because of this quirk, the choice of left eye, I am able to bring my left side into play, leading with my left leg, assuming what is basically a boxer's stance. My left shoulder swings forward and slightly down, becoming a platform for the bottom of my camera to rest and stabilize against. The eyepiece goes directly to my eye, with my brow making contact with the prism head of the camera. My right hand grips the machine, index finger at the ready. My elbows tuck in to my sides and my left hand comes under the lens, where it supports whatever length of glass is attached to the camera. Exhale. Concentrate. Shoot.

I loop the camera strap around my wrist.

Bad idea for how to stand

Let's take the setup in steps.

I feel genuinely naked if my camera strap isn't looped around my left wrist when I prepare to look through a lens.

My left foot moves forward, bringing with it my left shoulder. (This move has an additional benefit in that my center of gravity is now more squarely under the camera.)

The camera rests there, on my shoulder, and my left hand comes under the barrel of the lens. It does not go over, or on top of the lens. In the photo below, look at where my elbow would go if I placed my left hand over the barrel. Two very bad things occur: My left arm, instead of supporting the whole deal, is out there flapping around like a chicken wing. And, with my hand on top of the lens, I'm actually increasing the weight I have to support. Not good.

Right-eyed shooters: You can do a modified version of my holding technique. Though the use of your right eye negates the support of the left shoulder, the basics remain the same. You grip with your right hand and support with the left. This brings both of your elbows into your sides. Now your body and arms are fully joined in support of the camera. Also, when you want to shoot vertical, rotate the camera, not your body. I see this mistake made all the time.

I mentioned center of gravity. Get it under the camera. Don't bend over or twist. A bad camera posture is a surefire ticket to chronic back pain and the chiropractor's office. If you are uncomfortable out there, your pictures will suffer because (a) you can't concentrate, and (b) you will be fatigued.

I can't emphasize enough the negative effect fatigue has on your picture-making abilities. If you are exhausted, if you're carrying too much gear and you're not holding your camera with ease and efficiency, that latte and the chocolate

Worse idea for how to stand

My arms are not helping to support the camera here.

Good idea for stable handling

Double grip for superslow shutter speeds

scone down the block at Starbuck's look mighty tempting. You begin to rationalize bad behaviors. *Ahh, the light's not so great. I'll come back out later. Let's eat!*

Economy of movement and handling the right amount of gear well can extend your field time and your patience behind the lens. These basics just allow you to have more fun. It's all good.

Now, your camera is properly at your eye. Relax. Exhale. Don't jab the shutter button. Squeeze it gently. Some folks advocate actually rolling your finger over the shutter release. That's fine. Discover what suits you. Just don't hit the shutter button like you're playing Frogger at a video arcade.

And remember this: Your first frame may (and I say *may*) have a tendency to be your least sharp. You're excited, maybe you saw something quick and you're trying to get the snap before the little kid bouncing the ball disappears around the corner, and you jab the shutter. That initial, kinetic impulse you impart to the button may be a touch more jagged than your subsequent clicks, when

your head and eye are, quite probably, more fully engaged and the camera is truly nestled in your hands. This isn't always the case, but it's something to be aware of.

Strategies for low-light shooting: Take everything I mention above, and add to them. Shift your camera off single advance to consecutive high. This will allow you to burst the camera. When you burst the camera, you increase your chances that one or more (with luck, many more) frames will be sharp. This would not apply, say, to a picture you might be making of a rock formation—something that does not move or talk back to you. But this is very handy when dealing with those most mercurial of subjects, people.

Another tip: See where my left hand is in the photo, left? It is crossed over my body and is clapped over my right, or camera-grip, hand. I employ this technique when I am feeling really skinny on shutter speed, when the shutter is set dangerously low and I know shooting this picture sharp is roughly akin to playing craps in Vegas. This double grip allows me to almost fold myself around the camera and lens. I don't need my left hand to focus the lens; the camera is doing that for me. I set my zoom where I want it, so I don't need adjustment there. I am free to use my somewhat functionless left hand as further stabilization. (Note: I never use this technique when I am using truly long glass. When the lens gets long, my left hand stays with it, underneath, cradling and supporting it.)

You never knew just getting your camera to your eye was an athletic event, did you? But there's a reason for the gymnastics: Sharpness is crucial. So is quality. Quality, as we know by now, is linked to keeping your ISO low, not bouncing it up to stratospheric numbers. Keeping your ISO low (or moderate) can lead you into the challenge of holding your camera at shutter speeds that are lower than most of the manuals recommend.

Once again, this late in the game, you are breaking the rules. Good for you.

# AT HOME AND ABROAD

ONE OF THE BEST PIECES OF ADVICE I can offer about walking around with cameras and lenses is: Look like you're not. And I'm not necessarily talking about extreme environments, in which there's risk associated with just taking a stroll, much less taking a stroll looking like an ambulatory promotion for Adorama Camera superstore. I'm talking about every day.

I could be talking about the local county fair or weekend carnival or farmer's market. Your photo shoot could be down the block, or it could be a place at the far reaches of several oceans. If you want your pictures to appear natural, unforced and unposed, blending in is the key. Even at the family picnic, you don't want the kids to worry that there's a picture-taker at work. The last thing you need to do is strut about, chest and limbs bristling with high-priced digital hardware. It draws attention when you don't want any. Hang a couple of cameras around your neck with appropriately gaudy manufacturer's logos all over the straps and that nifty vest from Orvis, the one with 33 pockets you now feel the need to fill with bits and pieces of photog junk—well, you might as well hang a cow bell around your neck. You're going to make everyone uneasy. Even your kid.

When taking travel photographs, for example, most times you are going to be eyeballed as a fish out of water. You should try to not be a strange-looking fish on top of that.

So think about the kind of pictures you want from this particular adventure. Are you envisioning environmental portraits, street scenes, cultural details? Will you be entering places of religious observance, where the premium will be on quiet and unobtrusive reverence as you make pictures? Or is the order of the day a double-decker tour bus where you'll have to reach into crowds and scenes without being right there on street level with the action?

Previsualize, in other words (this pertains to the backyard picnic, too). Plan carefully. For street photography, do you have a small phrase book and a

Looking like a complete newbie and an easy target

map that can be tucked away? Sunglasses, sunblock, ibuprofen, the phone number of the hotel? Identification? Cell phone? One that has GPS that before you left home you programmed to include the area of the world in which you will be wandering about?

These things can fit into a cargo pocket of your pants or shorts, or a very small, nondescript fanny pack. Your camera and lens, of course, are going to be bulkier. I urge you, if you're in any kind of exotic locale, to avoid working with a digital camera hanging around your neck. It will flop about your chest as you walk, and it's a certain "I'm a tourist" giveaway. It is also a possible quick trip to the emergency room if someone tries to snatch it, and it wrenches or wraps around your neck. (Don't laugh. I once had a colleague who worked in a country where street thieves were so adept at slashing handbag and camera straps with razors and making off with

the goods that my friend had his leather camera straps replaced with bicycle chains.)

I advocate, for most adventurous meanders, one camera and one lens. Zoom lenses are terrific for this mildly covert mission you have engaged in. If you are up close, a 24–70mm or a 24–85mm zoom is perfect. For longer work, 70–200 or 70–300 would work out fine. For the ambitious, who really wish to push their skills, prime, fast lenses that we spoke of earlier are wonderful environmental, scene-setting, "street" lenses.

Once you have decided how little or how much gear you are going to tote, carrying becomes yet another matter for discussion. I have managed to stay at least somewhat inconspicuous by slinging a nondesigner strap over my shoulder and letting the lens (particularly a longer lens) rest behind me, on my backside. Whichever shoulder I use, I generally keep the corresponding hand in a pocket, so I maintain

Trying to look inconspicuous

Walking with my camera slung over my shoulder

Secure your lens shade with gaffer tape to help keep it on.

contact with the rig and keep it close to my body. Occasionally, I even take my other hand, wrap it slightly behind me and keep contact with the lens this way, too. I'm at least not walking around with a blinking neon sign on my forehead saying, "Tourist Photog," or, "I'm Not From Around Here."

Another tip: lens shades. Use 'em. Why wouldn't you? But even though shades routinely come with the lens, many shooters ignore them. The lens shade protects the front element of the lens to a degree but, more important, it prevents light scatter from dancing across the glass surface of the lens and fraying at your photograph's contrast. (Any sharp, hard light that flares right into the lens, or even hits the front element at an unfortunate angle, will potentially degrade the image quality that your particular optic is capable of. The lens shade will help prevent this.)

Now, my experience is that most lens shades offered by most camera manufacturers are cheeseball pieces of junk. Plastic, with plastic mounts, they are primed, when they bump into stuff, to pop off your lens and clatter onto the floor—a bad move at midnight Mass.

To prevent this, I take small pieces of gaffer tape and leave them attached to the lens shade. Then when you affix the shade to the lens, just wad the gaffer tape into the seam between the two. The shade will stay on now.

To effectively observe a scene, don't make a scene.

# JOE'S LAST TIP

The last of the last tips:

- Shoot early.
- Shoot often.
- Shoot the stuff you love.

And, oh yeah, have I mentioned yet . . .

## HAVE FUN!

# GLOSSARY

HAVE YOU EVER GONE TO A PARTY at a neighbor's house and become part of a conversation that veers into terminology and turf you don't understand? Folks around you become engrossed by a certain arcane subject, while the half-smile freezes on your face, your head actively nods like a bobblehead doll's, and your eyes desperately search for the next passing hors d'oeuvre tray. The conversationalists might not even be mean-spirited or trying to prove they're superior, they just don't have the time or desire to school you on the lingo, bring you up to speed on the topic at hand.

This book is not that conversation. It has been designed, we hope, to be user-friendly and build photo skills from the ground up. To that end, we're going to collect here a bunch of terms and definitions, many of which will be reiterative if you've just finished our six chapters, some of which you will encounter in your camera's manual. I'll also share some field terminology, the tribal language of shooters everywhere. A glossary is a good place: a safe harbor to which you can retreat if the waters are getting choppy. Whenever you want a refresher or feel unsure about a certain topic, come on back here for support.

Let's get started. Alphabetical fashion works best.

**AF-assist illuminator.**  A beam of light the camera sprays onto the subject to help itself achieve focus in very dim conditions. Depending on the model and how you have your camera programmed, the AF-assist illuminator can activate automatically in low light. It will not be seen in the actual photo, though, because it shuts down as soon as the picture starts to be taken. The AF-assist illuminator is useful in low-light situations in which a camera's autofocus feature needs a helping hand. The "AF" in the name stands for "autofocus." *See* autofocus.

**aperture.**  An adjustable circular opening inside the lens that regulates how much light transits the lens and hits the sensor. It is basically a hole in the lens that you can control by making it bigger or smaller. A small hole allows very little light to reach the sensor; a big hole allows a great deal of light to pour through.

**artificial light.**  Light from sources other than the sun; usually refers to studio lighting or any interior or man-made lighting. Unlike sunlight, which tends to be relatively calm in terms of its color (warm, cool, neutral) the many sources of artificial light give the color wheel a good spin and can present themselves to your digital camera as various shades of funky. Get used to that, and be prepared to experiment with your camera's white-balance settings in response to things like cityscapes, building interiors and the like.

**aspect ratio.**  The ratio of a picture's length to its width. Digital images typically have an aspect ratio of 4:3. Old 35mm film has an aspect ratio of 3:2.

**autofocus.**  A camera feature that allows it to focus automatically. Autofocus systems consist of sensors that communicate with motors in the lens that lock on to a scene and snap the lens into sharp focus. There are camera models that have a "tracking" feature in which the camera will lock on to a moving subject and retain focus even as the subject moves. Autofocus effectiveness is highly dependent on the quality and quantity of light. In very dim situations, when the light lacks contrast, autofocus systems suffer, slow down or

misjudge. Virtually all of today's digital cameras can focus automatically, which in the past was the task—the responsibility—of the picture-taker.

**available light.**  Existing light surrounding a subject, not added by the photographer. Can be artificial or natural. Also called *ambient light* or *existing light*. Famous LIFE shooter Gene Smith, who paid no attention to textbook definitions, once defined his version of available light as "any *$%#@ light that's available." He used the sun, flash, flashlights, streetlights, you name it. And Smith made great pictures with his "available light," which was not nature's.

**backlighting.**  Light originating behind a subject. Good for drama, but sometimes tough to meter effectively. When you are shooting a seriously backlit subject, you are  breaking a time-honored rule: Shoot with the light, or shoot with the sun at your back. With backlighting, you shoot directly into a strong source of light. Backlighting calls for experimentation and bracketing. *See* bracketing.

Image shot with backlighting

**black card.**  A piece of black foam board, cardboard or anything else matte, black and non-reflective used to manipulate shots that require long exposures, such as fireworks.

**blown-out.**  A term used to describe the highlight area of an image when the exposure causes the highlights to appear pure white with no detail. Highlight heaven. Be careful! Blown-out areas of your picture can be really cool-looking, or just areas of devastation. These areas live at the right-hand side of the histogram, which I refer to as Ice Planet 255, where there is no sustainable pixel life.

**bouncing light.**  The process by which a photographer takes existing light and redirects it via a reflector or "bounce board." Can have the effect of "filling in" shadows or dark areas. Also refers to the process of taking artificial light, such as flash, and instead of using it in direct, harsh fashion, "bouncing," or reflecting, the flash off a ceiling or wall, thus making it softer and more natural-looking.

**bracketing.**  The process of shooting what is presumed to be the right exposure for a frame and then safeguarding yourself by shooting at least two additional exposures, one on either side of that "right" one, underexposing one and over-exposing the other. This is highly recommended for static subjects, such as rocks, flowers and mountains. People, well, people move, right? They change expression. Your kid gets handed the "Eighth-Grader of the Year" award only once. So bracketing in these fluid, moment-to-moment situations is dicey. You don't want the moment to be recorded on a bad or off bracket. So, when the chips are down and you have to get that shot, try to make sure you have dialed in the correct exposure, and be ready to make it. If timing isn't the key factor of your approach and success, by all means shoot up and down the exposure scale. It will not only ensure success for that particular

shot, it will also make you increasingly familiar with how the digital camera sensor performs in different lighting and exposure scenarios. Bracketing is education.

A subset of bracketing is *autobracketing*. This is a feature available on most DSLRs that you can program to automatically sweep through an entire range of exposures, one after another. You can dictate how many shots and the extent of over- and underexposure. This is very popular now with the folks who play with HDR (high dynamic range). *See* high dynamic range

**bulb (shutter speed "B").** A shutter speed dial selection that keeps the shutter open as long as you keep the shutter button depressed. Handy (make that essential) for nighttime shooting. Its name comes from the old days when the shutter on some cameras was activated by squeezing a bulb and then releasing it.

**camera buffer.** This is a holding pen, if you will, for the electronic, digitized information you just shot as that info moves from your camera to your memory card. Cameras and memory cards have a thing called "write speed" that, without getting too techy, is basically the speed at which all this precious picture information is transferred. Your rate of shooting pictures will almost certainly, on occasion, outstrip the speed at which the digital data is moved from the camera to the card. This is where the buffer comes into play. The more expensive the camera, the bigger the buffer and the more pictures you can shoot before your camera cries, *"¡No más!"* and locks you out. If you are frantically punching the button while your kid is blowing out the candles, and the camera is not taking pictures, you probably overshot the buffer. Most cameras will hold anywhere from 5 to 25 files in the buffer. High-end camera models hold a lot more than moderate or basic models. (It, of course, depends on the size of the file you are

shooting. Raw files, being larger, will fill up your buffer more quickly than basic JPEGs.) If you are locked out, it really just means waiting a few seconds (or a few dozen seconds) to let the camera recover and clear the buffer, which allows you to once again rip through frames.

**camera obscura.** Basically, an optical device, usually a box with a lens adapted on a hole, that projects an inverted image of the outside view. In the early 1800s, French photo pioneer Nicéphore Niépce began using a camera obscura with photosensitive material inside to produce what is generally acknowledged as the first photographic image. I occasionally use this term to describe some of the work I currently see.

**camera shake.** Movement of a camera when the exposure is being made that results in a blurred or unsharp image, especially at slow shutter speeds. Shaking hands, unsteady tripods and surrounding vibration can all cause camera shake. How much camera shake, or blurriness, you inflict on your picture can often relate to how many cups of espresso you've consumed.

**catchlight.** The reflection of a light in your subject's eyes. A tiny spectral highlight that sparks the eyes and creates a bit of drama. It often directly reflects the source of light, such as a window or a flash. Currently, catchlights, always just a bit of a given, are the subject of much discussion among photogs. Some like catchlights, others don't. There is a lot of postproduction going on nowadays, so these little splashes of light are now often altered or eliminated. My opinion? Let the catchlights roll. They are what they are.

Catchlight reflected in the eyes

**chimping.** Looking at each frame right after shooting it. *Click, click, click! Ooh, ooh, ooh!* This practice originated with the LCD. It reflects the compulsive, absolute need on the part of many shooters to check out the picture they just shot. Be careful with this. It is a distraction. The best picture may be occurring while you are looking at the last one. You'll have more time to truly contemplate results—and to learn—later.

**closeup.** A picture of a subject that fills the frame. Most of your human subjects will object to their closeups. Flowers? Go for it. They can't complain about it. For that matter, neither can your dog.

**composition.** The arrangement of the elements of a scene, including the subject and other objects, within the background, middle ground and foreground. Very important.

**contrast.** Refers to quality of light and how quickly a scene rotates from bright highlight into black. A sudden, sharp change from light to black—high contrast. Gradual—medium contrast. Almost no change—low contrast. Photogs describe these conditions in very colorful terms, many of them unprintable, depending on how the light suits their assignment and if it is good to work with at that moment.

**crop factor.** This is all about sensor size. There are many DSLR cameras available now that have a full-frame sensor, which is very close to the dimensions of the 35mm film camera. But there are also lots of models that have a smaller sensor, which produces a "crop," or "crop factor." The image will appear magnified, but it is really not. It is simply the smaller sensor at work, taking a smaller piece of the scene.

**cropping.** Removing parts of an image's edges in order to improve the composition. Cropping

means that when you had your camera to your eye, you were constrained and couldn't move or you had the wrong lens on or you were JUST PLAIN LAZY. Cropping *in* the camera is vastly preferable to post-click cropping at your computer. Cropping after the fact means that your picture is on the operating table, and you, no longer the *artiste*, are now a surgeon, determining how to painfully save this patient.

**dedicated flash.** An electronic flash unit, designed to work with a specific model of camera, that integrates with the camera's exposure meter and exposure controls to allow the fully automatic use of the flash.

**depth of field (DOF).** The range of distance in a scene that appears to be in focus—it's basically what is sharp in the picture. By that I mean acceptably sharp, which stops short of critically sharp. In portraiture, for instance, critical sharpness should fall right at someone's eyes, whereas the shoulder or the tip of the nose could be acceptably sharp, i.e., within depth of field. DOF will vary according to how close the camera is to the subject, the millimeter length of the lens and the aperture opening of the lens. Quick hints on DOF: A long lens, wide aperture and close proximity to the subject will yield a very shallow depth of field. Shorter lenses, narrow or small aperture and a bit of distance to the subject will increase the depth of field. Getting to know how much or how little depth of field individual picture scenarios require is just a matter of practice and time behind the lens.

**diaphragm.** An adjustable set of overlapping, movable metal blades (usually six or seven but can be as few as five or as many as nine) inside a lens that determines the amount of light entering a camera. The diaphragm controls the size of the hole, or aperture, thereby permitting more or less light to pass through the lens to the viewfinder.

**diffuser.** A light softener. Ever see the effect of a naked incandescent bulb in a lamp? Hard shadows, tough to look at. Put a lamp shade on. Ah, that's better. You have just diffused the light. There are many types of diffusers on sale in the photo marketplace. There are also ad hoc diffusers around the house—a white handkerchief, white bedsheets or pillowcases, vellum or tracing paper, a piece of copier paper, a window curtain. Just about anything that transmits and spreads light and has no color to it can, in a pinch, be used as a diffuser.

**digital single-lens reflex (DSLR) camera.** A digital camera with only one lens for both viewing and picture-taking. In both film and digital versions of SLR cameras, an image is reflected onto a viewing screen by a movable mirror inside the camera. The mirror flips out of the way just before the shutter opens, allowing light to strike the film or sensor.

**diopter.** Eyeglasses for your camera. Many models have a little button right by the eyepiece that you can adjust for your eye. Helpful for us older folks.

**distortion.** Refers to what occurs from using certain kinds of lenses. Wide lenses produce "distortion" when they are used close to a subject (a relatively normal nose suddenly looks like a ballistic missile) or pointed around at extreme angles (otherwise straight buildings look like they are about to topple over). Long lenses produce compression, which is a type of distortion that "stacks up," or compresses, a scene. (Think of telephoto shots down a busy Manhattan avenue. The hundreds of people actually out there walking all of sudden look like thousands because the long-lens perspective squashes them all together.) This type of lens-based distortion is either purposeful and has graphic intent that assists the photo, or it is just plain bad camera work—the result of careless or inappropriate lens use.

And there is lens distortion of the technical sort, which relates to certain lenses and their construction. There are two major types of distortion: *Barrel distortion*, which is present in small amounts in some wide-angle lenses and very noticeably in fish-eye lenses. Here, the straight lines near the edges of the frame bow outward from the center to form a barrel shape. With *pincushion distortion*, which is present in small amounts in some telephoto lenses, the straight lines near the edges of the frame bend in toward the center to resemble the sides of a pincushion. These lens aberrations obviously occur more often in the all-purpose, zoom-it-from-here-to-there cheaper lens options. Better lenses, with good glass and good construction, will skirt most distortion issues.

**EV button.** A button that allows you to adjust the exposure up or down, according to your taste, even when the camera is in an automatic metering mode. The camera will often look at a scene and be unduly influenced by big areas of shadows or highlights. It can be fooled, in other words, and yield a bad or incorrect exposure. You can correct for this in manual mode by changing either your shutter speed or your f-stop. In an automatic exposure mode, the way to alter the camera's exposure reaction is to use this button, generally located in a handy position near the shutter button itself. *See* exposure value.

**exposure.** This is basically how much light hits the sensor. You'll hear the terms "bad exposure" and "good exposure" as long as you shoot. With practice—and some luck—you'll produce more of the latter. Generally, the exposure is described by the time it took to make it. "That was a two-second exposure." To further refine and describe the shot, you can add in the f-stop that was used. "I shot that at 1/60th at f/5.6."

**exposure value (EV).** Denotes all combinations of a camera's shutter speed and aperture that give

the same exposure. The proper exposure value for any given scene is the one you think looks best. EV is arrived at by determining the appropriate f-stop and shutter speed combination. The choices you make for the "appropriate" specific shutter speeds and aperture openings will often be determined in reaction to your subject matter. For example, shooting a horse race will require a fast shutter speed, which will in turn influence your choice of f-stop. A majestic landscape may be better shot with lots of depth of field, resulting in the selection of a small f-stop, around f/16 or so. That will pretty much dictate that your shutter speed be somewhat slow, which will then require you to use a tripod. All of this photo *stuff* is, as you can see, interrelated and will become more intuitive as you practice regularly.

**external hard drive.** A small, portable storage device for digital information. As your picture-making prowess increases, you will take more and more pictures worth saving, requiring more and more digital storage space. These small, affordable hard drives are a good solution for storing all of this newly minted digital information. If you try storing all of the photos on your laptop or home computer, it will slow down and eventually fill up, and then give up. An external hard drive, able to connect to your computer via cables, is the answer. Though physically small, they can store lots of ones and zeroes. (There are drives now out there that can store 500 gigabytes and still fit in your pocket.) External hard drives are just about essential now because the higher-end digital cameras are producing larger and larger files. They have to be put somewhere. (And they have to be backed up! So don't put all your stuff on just one drive. If there is a given about hard drives, it is that they will eventually fail! So storage on multiple drives is a good strategy.)

External hard drives

**field of view.** The area of a scene that a lens sees. This is determined by focal length: A wide-angle lens, which has a short focal length, sees more of a scene than a telephoto lens, which has a long focal length. Also called *angle of view.*

**fill flash.** A light source that illuminates an area of a photograph that would otherwise be too dark. The operative word here is *fill,* which connotes the fact that the resulting exposure is a mix of the ambient conditions "filled" or assisted by a source of artificial light, i.e., a flash. A full-out flash exposure looks and feels different from a fill-flash exposure.

**film speed.** The measure of how sensitive the film is, or how quickly it can react to light, often quantified as its ISO (International Organization for Standardization) number. Film speed is particular to the type of film you use—if you're still using film—and is not changeable with the flick of a button, the way ISO can be changed in today's digital cameras. *See* ISO.

**fish-eye lens.** A wide lens that generally has a coverage of about 180 degrees. It is *très* cool to use selectively, but with that superwide view comes something that needs to be managed carefully—distortion. Try shooting somebody's portrait with this type of lens and you'll quickly see why it's called a fish-eye. *See* distortion.

**flare.** Uncontrolled or powerful light hitting the lens at a bad angle and creating a very bright spot or lines in your photograph is called flare. Point a wide-angle lens at the sun, and you'll find out about flare. Flare is not always a bad thing, but it's generally a wise idea to avoid it in most instances. Use lens shades! They will generally help control flare. Specifically, if you want to employ flare in your composition, ask yourself before clicking: Why? And now, how? *See* lens shade.

**flash.** A light source used to produce instantaneous illumination on the subject of a photograph. Many cameras have built-in flashes, but separate flashes are also available, often referred to as "hot-shoe flashes" or "speed lights." These external flashes offer the photographer great creative freedom in the way the flash light interacts with the subject. They are also the source of great terror among new camera users, given the split-second, apparently uncontrollable burst of light that attends flash photography. Relax. Flash is—or certainly can be—your friend.

**flash sync speed.** This refers to the speed at which the flash will synchronize with a shutter speed of your choosing. When using a flash, you have to coordinate it with the action of opening the shutter to get its full exposure effect. This can be pretty straightforward at mid-range or low shutter speeds, but it is a crucial thing to pay attention to at higher shutter speeds. In most cameras, the upper limit of proper sync is around 1/200th or 1/250th of a second. Go above this, and you will start getting dark or underexposed frames, meaning the shutter opened and closed too quickly to get all of the flash. There are high-speed flash modes available in certain cameras that allow flash operation at extremely high shutter speeds. Read the manual about these modes.

**flat light.** A quality of light that is lifeless and has just about zero contrast. Often associated with heavy cloud cover.

**focus cursors.** These are movable little doobers in your viewfinder that direct the sensitivity of the autofocus system right to where you want it to go, presumably the area of critical focus in your picture. With different camera models, there is a thumb pad or a wheel in the back of the camera that enables you to move them around. Be careful with them! Read the manual.

There are different types of autofocus systems. Some enable one point of focus, which is represented by that glowing cursor. Other modes enable a group of cursors, all of which are sensitized. Still others activate the entire field of potential autofocus coverage and have features such as "lock on" for moving subjects and face recognition. Each of these requires experimentation, so that you learn which one suits particular scenes or subjects. Point-and-shoot cameras often offer focus options, such as "landscape" and "portrait." See *autofocus.*

**frame.** The extent of the picture, including the subject, foreground and background. When you put your eye to the viewfinder, you are "framing" your picture.

**frames per second (FPS).** Describes how fast you can take pictures. There are cameras on the market that will fire really fast, making as many as eight or nine pictures per second. Other cameras, depending on type and price, move quite a bit slower than that. A fast frame rate is handy for shooting sports, of course, and any other fast-moving subject. You can regulate the frame rate by dialing in single or consecutive modes on your camera. Some will have three choices—low, moderate and fast advance. Fast is the noise you hear in the background of all of the movie scenes in which there are photographers milling about, trying to get a picture of the politician or the perpetrator. It sounds exciting at the cinema, but be careful: Fast advance can fill up your memory card mighty fast, giving you a new challenge to solve.

**f-stop.** The clicks on the aperture dial that open and close the diaphragm blades of the lens. Among the most common f-stops are f/2.8, f/4, f/5.6, f/8, f/11 and f/16. These are "full" stops of light. As you can see, each f-stop number is approximately 1.4 times larger than the one

preceding it, and each full click from one stop to the next either doubles the light going through the lens or cuts it in half, depending on which way you are clicking. The smaller numbers, somewhat counterintuitively, denote the larger lens openings. Conversely, the larger the f-number, the smaller the lens opening. Also called *f-number.*

Gaffer tape

**gaffer tape.** A heavy-duty photographer's tape that is easily removed. Not to be confused with duct tape. If you want to induce the ire of your subject and have no desire to be invited back to the home/location/executive suite you have just been photographing in, use duct tape, which leaves a sticky residue or outright pulls away the surface of whatever it has been stuck to. Duct tape will remove paint, wallpaper—you name it. Gaffer tape is movie tape, really. A bit pricey at the camera store, but worth it because, although it is strong, it will generally not do damage to whatever you apply it to.

Also, in a pinch, it will be a quick fix for your camera, tripod, lights, battery packs, stands and just about anything else on a shoot. There's literally nothing on location that can't be made better by an application of gaffer tape. The world of photography spins on this particularly sticky item.

**glass.** Photog slang for "lens." The term *fast glass* refers to lenses with wide aperture possibilities. *Long glass* refers to telephoto lenses, usually starting around 135mm and up. *Wide glass* refers to wide-angle lenses, used for a scene-setting type of picture, which shows a lot of the environment. *Bad glass* describes cheap, slow or unsharp lenses. As in, "They couldn't make a decent ashtray out of the glass in this lens." (These are the second-rate lenses often seen advertised in the backs of the photo mags. If a lens seems too good to be true at the advertised price, it generally is.)

**gray card.** Literally, a gray card. Photographers sometimes use gray cards as targets to ensure a consistent exposure or to correct the white balance of their photographs. Photographers who use this type of assist in determining an exposure are generally studio shooters, or outright control freaks. Ever see a gray card out there on the 50-yard line or in the middle of a street riot?

**hard lighting.** Bright, intense light that causes sharp, dark shadows.

**high dynamic range (HDR).** A process in which shooters take numerous different exposures of the same thing, and then, in post-processing, combine them all into one picture. Again, this is not recommended so much for people photography. (Those darn people! Why won't they just stay put!) But when presented with a static subject, such as a landscape, this can be a very effective tactic to expand the camera sensor's dynamic range, which is limited. It should be said: The ease and current popularity of this technique has prompted many picture-takers to shoot subject matter that should have been left alone.

**highlight.** The brighter areas of a photo, which are sometimes tough to control. A "blown" highlight refers to an area in the photo that has no detail and is not recoverable in postproduction. Blown highlights are generally not desirable, but then again, depending on the aspiration, could be really striking (think certain kinds of fashion photos). Most often, though, an out-of-control highlight in someone's glasses, or right smack in the middle of a forehead, is not a good thing.

**histogram.** A graph of the shadow-to-highlight values of a picture. As is true with graphs in general, a histogram is pretty boring but can provide useful information, taken in proper doses. Some shooters are slaves to the histogram. Others don't give a hoot. I tend to be in the latter category. In a

histogram, black is 0 and dead white is 255. In the middle, not surprisingly, live all the more moderate tonalities. Understandably, the camera's meter, which I tend to think of as a bit of a herd animal, likes to cluster in the middle, never foraying out to the edges where bad stuff could happen. The middle of the histogram is safe and reproducible. A classic histogram looks a bit like a bell curve, with a lot of values right there in the middle, tapering to the ends or extremes. Yet, a lot of interesting photos are out there on the edges. So use the histogram as it was intended—an informational guideline, not the holy grail of exposure.

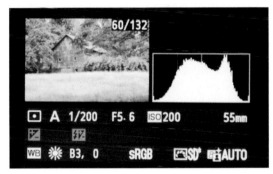

Histogram, upper right, on camera LCD

**hot shoe.** A slotted bracket that connects an external flash or other device to the camera, located atop the viewing prism, or viewfinder, just above where you look through the camera. The hot shoe provides an electrical connection (hence the word *hot*) between a flash (or other accessory, such as a radio-remote flash controller) and the camera. There's so much to be said about what a hot shoe can do, well, there's a book's worth of material. At least I thought so, when I wrote *The Hot Shoe Diaries*. Hope you like it.

**ISO.** Refers to the sensitivity of the chip, or sensor, and expresses in numeric fashion the "speed" at which the sensor will accept light. Obviously, high ISO numbers, such as 1600, will enable photography in low-light conditions. In bright sun,

ISO 100 or 200 is plenty. "ISO" comes from International Organization for Standardization.

**JPEG.** Also referred to as "jpg" (pronounced "jay peg"), this is a very popular file format for digital photographs. Other formats are available, such as TIFF, but JPEG and raw are by far the most popular. Think of the difference between these two this way: The raw file is the block of unshaped marble that comes out of the camera relatively untouched, to be sculpted later, by you, in the computer, using the miracles of post-processing. The JPEG comes out of the camera already chiseled and shaped. All that extra stone is already gone forever. You can make some fairly minor alterations at this point, but the basic work of crafting the file is done in the camera. In some ways, because a JPEG is a finished file in the camera, it forces you to get everything right at the moment of exposure.

The raw file generated by the camera has lots more potential information than the JPEG. The JPEG is "compressed" in the camera. It is a smaller file and a highly efficient way to shoot. But, because it is a relatively done deal, packaged and compressed in the camera, it does not carry with it nearly the color information and post-processing possibilities the raw file does. With the raw file, if you make a mistake, you have a good shot at correcting that after the fact. (For instance, imagine shooting outdoors all day with the white balance set for indoor lighting. All your pictures have an off-color cast. With raw files, you can, in postproduction, redirect the white balance to the proper color cast or color temperature with a click of a button. That's not possible with a JPEG. It is what it is, and the possibilities to reshape it after a shoot are far more limited.) JPEG, by the way, is an acronym for "Joint Photographic Experts Group." They meet every month and compress files. A wild bunch indeed.

**Kelvin temperature.** The temperature of light. Named after Lord Kelvin, it is a scale that calls out

various types of light in degrees, or degrees Kelvin. Normal old daylight is generally around 5,600 K. Tungsten or incandescent pulls in about 3,400 K. The lower on the scale, the warmer or more red the light; the higher, the more blueish in cast. Remember it this way: By going up in Kelvin, you're heading to heaven and blue sky. The lower the Kelvin, the more probable that your picture's headed straight to the red fires of hell.

**lens shade.**  An accessory affixed to the end of the lens, used to reduce glare and prevent lens flare. Generally made of plastic or rubber, a lens shade can look like a simple cone that either screws or bayonets on to the front element of the lens. Some are more complex shapes, known as "flower," or "tulip" hoods. These are cut in an irregular shape so they don't compromise the view of zoom lenses as the angle of view changes or widens. Also known as a *lens hood. See* flare.

**lens-stabilizing system.**  These are lenses that, by pushing or sliding a button on the lens itself, can engage an onboard system of stabilization to combat camera shake. There are specific moves being made in the lens, but just think of this as a gyroscopelike device inside the lens that helps you hold it steady. In the early days of these lenses, it was always advisable to turn off the gyro systems when mounting the camera or lens to a tripod. Now, many models automatically sense the stability of a tripod and shut themselves off. The biggest dogs among many in the camera world are Nikon and Canon. Nikon calls its system VR, for "vibration reduction." Canon calls its version IS, for "image stabilization." I'm sure there are other names out there. Also please note: With point-and-shoot cameras, the stabilization is often activated in the camera, not the lens.

**liquid crystal display (LCD).**  This is the little hi-def TV on the back of your camera. It possesses the strange power of a Lay's

Nikon VR lens

potato chip: Once you start looking at it, you can't stop. For good reason. It is an excellent way to check your sharpness, see the frame and make some quick field judgments about what to shoot next. As everyone counsels, it is not a great way to judge exposure. The LCD is very limited, and what looks good there might not look so good when you launch the image back at your computer. Yet, there isn't a shooter I know who doesn't keep tabs on his or her ballpark exposure by glancing at the LCD.

In many camera models, the brightness of the LCD is adjustable. Try to fine-tune it so that it looks at least a bit close to what your files look like back at the home computer. If it is way too bright, for instance, it may push you to underexpose your images, which may make for an unpleasant surprise later when you try to work the files.

**live view.**  A way to compose your photograph without putting your eye to the viewfinder. In this mode, you actually preview the shot you are about to make on the LCD. The camera's image sensor bypasses the mirror (which reflects the image up to the viewfinder) and sends the view the lens sees directly to the electronic display at the back of the camera. Most point-and-shoot cameras operate this way, but now many newer DSLRs offer this as an option.

**macro lens.**  Lens optimized for close work. There are different millimeter ranges that work best for certain types of subject matter, but generally macro lenses have really close-in focusing distances. Really good macro lenses are generally wonderfully sharp but often react more slowly in autofocus mode than all-purpose lenses. Remember depth of field decreases dramatically when using a lens superclose to the subject!

**macro photography.**  Taking pictures very close in, or of things that are really, really small, like

bugs. This often requires specialty lenses (see previous entry), especially for images where the subject appears close to life size in the image.

**manual.** The booklet that comes in the box with your camera—not "manual exposure" or "manual focus," noble exercises that they are. This is *the* manual. You should read it, and you should take it with you. I am not embarrassed to admit I pack manuals when I travel. They stash conveniently in a bag, take up no room and weigh nothing, but, man, can they save your butt in the field. So, when you get the camera, read the manual. Take it in bite-size pieces. Then, when you confront some perplexing situation in the field, go back and read the section that pertains to it again. And again. This will make your future responses more intuitive and fluid. As with many things in life: Read about it, do it, read some more and keep doing it. You'll get better at it. Guaranteed.

**memory card.** The storage devices for digital images; the images can be erased, and the cards reused many times. The most common memory cards are Secure Digital (SD) and Compact Flash (CF). I'm not going to write a paper on the performance characteristics of these different cards, but there are some things you should know.

Depending on which camera you decide to purchase, it will use either SD or CF. SD cards are generally used in the point-and-shoot-type of camera and the more budget-minded, smaller DSLRs. They can store a lot of photos, but their "speed" is generally slower than CF cards. These cards scare me because they are so small, but they are generally dependable and have adequate storage capacities.

Most professional-model cameras will use CF cards, which nowadays have high storage capacities and fast write speeds. Pro shooters are all about speed; they want the images to move quickly through the camera buffer to the card, and they demand that the card then quickly download imagery to a computer. CF cards are ideal for this, and manufacturers compete to bring faster and faster cards to the market.

For most purposes, here's the best advice I can give: Use a name-brand card. There are lots of knockoff flash memory and memory cards out there. They will corrupt easily, and you will lose images. Dependable cards will cost a bit more, but you don't want to lose your kid's first-place finish at the state track finals to a bad card.

**metadata.** Information, such as camera settings and exposures, embedded directly into a digital image file. All of the information accompanying captions in this book is metadata.

**meter (metering).** The meter is the device that measures the amount of light in the frame—or parts of the frame—that you're trying to shoot, and metering is the act of gauging and using this device. It wasn't too long ago that in-camera meters were notoriously undependable. That fact necessitated the use of handheld meters, which were generally quite good. Now, however, the in-camera metering systems of DSLRs are very, very good. Highly sophisticated and sensitive, these meters will give a fine result most of the time.

There are options for meter modes as well. *Multipart* or *matrix meter mode* will look at all or most of a scene while evaluating the proper exposure response. But you can also shift the meter into *center-weighted metering mode*, which looks at the middle of the picture, or *spot-metering mode*, which looks at just a small spot when taking the reading. An appropriate scenario for using center-weighted metering is a backlit situation, in which the camera has a tendency to be influenced by the bright light behind the subject and therefore renders the subject dark. The center-weighted aspects of this mode will favor that darker subject matter and strive to render the subject properly. Spot-metering mode evaluates just a minuscule area in the whole frame. This is

handy during, say, a theater production, when the whole stage is dark save for the lone dancer or actor in a bright spotlight.

**mirror lockup.** A feature allowing you to lock the little mirror inside your camera up and out of the way after the scene is composed and focused. When you look through your camera, you see the scene via this mirror, which is in front of the sensor. For every exposure you make, that mirror has to swing up and out of the way, which can produce tiny amounts of vibration within the camera. This is not crucial when shooting at fast shutter speeds but is potentially damaging for precise, critical work such as closeup photos and long exposures. Mirror lockup prevents potential loss of sharpness owing to minute amounts of shake, rattle and roll produced by mirror motion.

**noise.** A "noisy" file is one that is filled with digital grain, or noise (which does not mean loud, raucous color—often a good thing). Noise basically looks like mushy, grainy, weird color blotches in your picture. Poor exposure control can lead to noise in your pictures, as can high ISO and long exposures, such as those employed during nighttime shooting. Some cameras have in-camera noise-reduction features that are designed to eliminate noise buildup. There are also software programs you can use after the fact, in postproduction.

**normal lens.** A lens with a focal length around 50mm, the middle ground between wide-angle, shorter lenses and telephoto, longer lenses. Normal lenses produce pictures that look normal, as though the viewer were standing where the camera was held.

**overexposure.** Too much light hitting the sensor. Overexposure produces a file, or photo, that has very little detail and appears bleached or washed out. Predictably, underexposure produces the opposite effect.

**panning.** A technique to convey motion. During the exposure, the camera is moved, or "panned," with the subject. Done properly, this results in a sharp subject and a blurry, or "moved," background. Showing motion with a still camera is hard to do, but this approach can get across the idea of a fast-moving subject. A couple of things to be aware of: Your shutter speed has to be set to allow blur. Very fast shutter speeds stop everything. Recommended panning speeds are from 1/60th of a second all the way to 1/8th or 1/4th of a second, depending on the speed of the subject. Another thing: Panning works best with a crossing subject, not one that is approaching the lens or moving away from it. A crossing subject will stay in the same line of distance, relative to the camera position, and thus will require no change of focus.

Also—be aware of your backgrounds. Panning works best if the blurry background is uncluttered and somewhat subdued in tonality.

**panoramic camera.** A specialized camera that takes in extremely elongated fields of view. Also called a wide-format camera, it generally has an aspect ration of 4:1 and higher, covering a field of view of up to 360 degrees. Sometimes just referred to as a "pano camera."

**pixel.** Pixels are the tiny dots that—in very large numbers—make up a digital picture. The term *pixel* stands for "picture element." This isn't a technical explanation, but I tend to think of a digital snap as a giant mosaic: All of these millions of multicolored bits combine to create a densely detailed representation of what you saw.

**post-processing.** These are all of the things that you do (or could do) to your photographs after you take them but before you print or publish them. The modern world of post-processing and the manipulation of photographs is sometimes referred to as the "digital dark-room," a realm of delight and illusion. All

digital pictures generally require some postproduction, which can take the form of basic retouching work, such as sharpening, burning and dodging, increasing or decreasing saturation or contrast adjustment. (Note: Some of those terms are right from the old-style black-and-white darkroom in the basement.) There are vast numbers of post-processing adjustments now available through extremely powerful software programs such as Photoshop, Aperture and Lightroom, to name but three. With these programs, an experienced retoucher can completely alter the look and feel of a photograph, eliminating and adding elements, changing color tones, extending color schemes and backgrounds and introducing special effects. A picture can be made to have little remaining relation to the real-world scene originally rendered.

**prime lens.** This is a lens that does not zoom, or, in other words, a single-focal-length lens. Historically these lenses were considered better optically than zooms, which tended to be slower, darker and less sharp than primes. Nowadays, zooms are generally considered to be just as good as primes. Primes are still important, though, as some of these fixed-focal-length lenses will be considerably "faster" than most zooms. Examples would be such lenses as a 24mm f1.4 or a 50mm f1.4 or a 200mm f2. If you want maximum aperture for low-light conditions, or minimal depth of field for selective focus, primes are an excellent option.

**raw file.** A digital file format that contains untouched, "raw" pixel information straight from the camera's sensors. *See* JPEG.

**reflector.** Anything you can get your hands on that reflects light. It can be a formal, store-bought piece of gear, like a Tri-Grip reflector, or it can be a piece of cardboard lined with white

Reflector

copier paper. The board can also be wrapped in aluminum foil for a tremendous "bounce" of light. (Obviously, a white board will be subtler.) There are reflectors out there that have shiny gold surfaces. The light reflected by these will be warm in tone and have a slightly yellowish cast.

**resolution.** This, the number of pixels contained in a digital image, is the salient statistic in today's pixel wars. One camera comes out with a billion pixels, the next feels compelled to counter with two billion, a number professing to yield far superior sharpness and clarity. My opinion? We've all got enough pixels. Forget the numbers. Just go shoot pictures. Make them good. The pixels will love you for it, and they'll do their part.

**Rule of Thirds.** This is a basic rule of composition, good to have in the back of your head when you are sizing up a scene. Ever play tic-tac-toe? X's and O's? Imagine seeing that grid dropped into your viewfinder. Then you have the Rule of Thirds, horizontally and vertically. It is a dynamic, visually interesting way to frame a scene. Look at each square, and see what's in it. Look at your primary subject, and perhaps place it out of the center, building dynamic relationships with secondary subjects that then come into play elsewhere. Remember, though: This is one of our rules without absolute rules. Don't pass up a good photo just because it doesn't set itself up in the Rule of Thirds grid. And if a subject demands the center by sheer force, yield to it—and you'll be happy with the result.

**selective focus.** A technique in which the photographer keeps the subject in sharp focus and everything else in the frame fuzzy and out of focus. It's a wonderful way to direct your viewers'

attention to right where you want them to look. When using the selective focus technique, and the subject matter is the human face, make sure that the point of critical focus is on the eyes.

**self-timer.** An option that inserts a delay between the moment you depress the shutter release and the instant the camera takes the picture. If you want to put yourself in the group shot, or record your presence at the Grand Canyon, this is the way to do it and has been for a long time—since well before the digital age. How long to program the delay for? Well, how fast can you run?

**sensor.** Basically, this is digital "film." It's the device in the camera that records the image you see and converts that into ones and zeroes, or an electrical signal. There are a couple of different types, one being a CCD (charge-coupled device) and another popular one called a CMOS (complementary metal-oxide semiconductor). By comparison, Kodachrome just sort of rolls off the tongue, but the good news is, you don't really have to worry about what's in there, other than to be mindful of . . .

**sensor cleaning.** This is something that must be done periodically, otherwise your sensor, and hence your image, will look like a car windshield after driving on the highway on a hot Georgia night. Splatter and splotches everywhere. Many camera manuals will tell you to send your camera into the manufacturer's service center for sensor cleaning. Which is fair enough, but also turns a three-minute do-it-yourself exercise into a several-day (or several-week) interval during which you don't have your camera.

Typically, the dust we see on our photos isn't environmental dust, as one would think. More often than not, it's actually metal shavings that come from taking lenses on and off the lens mount. Because a sensor is an electronically

charged device, when you take a photo and the mirror exposes it, those metal shavings can very easily get sucked right in. Obviously, the last thing you want is to spend tons of time "de-spotting" your picture. (Cleaning up one picture is no big deal. But if you are shooting dozens or hundreds of pictures at your niece's wedding, cleaning them up will become a black hole for your time.)

In other words, if you shoot a lot, learning to clean a sensor is essential. At my studio, we use a cleaning kit made by a company called Visible Dust. The kit consists of an LED-lined loupe to see inside your camera, a brush to clean the sensor, as well as swabs and a cleaning solution, should you need to go further. As with all things photographic, there are many different methods and products out there for cleaning sensors, and there are also online tutorials to coach you. Or you could go in for a quick lesson at your local camera shop. The main thing is to overcome your fear of messing with that delicate piece of electronics known as the sensor. Relax. When you clean the surface, you are actually cleaning what's called a low-pass filter that lays *over* the sensor. You never touch the actual element. I guarantee that, with practice and caution, you'll get the hang of this very necessary task.

**shooter.** Photog slang for "photographer." As in, "He's a good shooter."

**shutter.** The tiny device that, when closed, keeps light away from the sensor. Think of it as a curtain on a window: Opening the shutter means you are taking a picture. The shutter is the curtain over the sensor. Open the curtain, light comes in, close the curtain, light goes away, you make a picture. Simplicity itself!

**shutter speed.** This simply refers to the duration of an exposure. Fast speeds are usually 1/250th of a second up to 1/8,000th of a

second, and these fast shutter speeds are generally used in bright conditions. Darker environments demand slower shutter speeds, ranging down from 1/30th of a second or so all the way to 8 or 10 seconds, depending on subject matter. Shutter speed is a critical issue because it will directly impact how sharp your photos are. The slower the shutter, the more chance of camera shake. Shooting sharp at slow shutter speeds requires practice. *Dragging shutter* refers to lengthening your shutter speed as the conditions get darker. As in, "It got so dark out there I had to drag my shutter all the way to 1/4th of a second!"

**sidelighting.** Lighting whose source is located to the side of the photograph's subject or subjects. Duh!

**soft lighting.** Diffuse or relatively dim lighting that doesn't create dark or clearly delineated shadows. Think cloudy day. Think soft window light in a pub.

**stopping down.** This is the process of making the f-stop smaller, which means clicking toward the bigger numbers, which means making the aperture (hole in the lens) tinier. Stopping down the lens allows in progressively less light.

**teleconverter.** This small, barrel-like tube contains its own lens element that couples the main lens and the camera together and increases the focal length of the lens. Used for telephoto work, it can take a 300mm lens and make it function as a 400, 500, 600 and more, depending on how powerful the teleconverter is. Caution: Purchase a teleconverter made by your own camera system. Third-party teleconverters tend to degrade sharpness and lens performance. Also, be aware that teleconverters cost you in terms of f-stop. Usually, you will lose at least one f-stop or more, again, depending on the conversion factor of the teleconverter.

**telephoto lens.** This lens with a very long focal length is able to magnify—or zoom in—on distant objects. A telephoto lens lets your eyeball travel across the street or onto the field. This lens has to be held and handled carefully or many out-of-focus pictures will result.

**tripod.** A three-footed device upon which a camera can be mounted for increased stability. As I've written, I have a love-hate relationship with my tripod. I hate to carry it, feel limited and less than fluid when my camera is locked down on it and, then, when I realize how badly I need it right then and there, I am passionate about it. When I leave it behind out of laziness and then need it, I get mad at it, not me. Tripods are a pain to carry around. They draw attention and often prove unnecessary. But tripods do what they claim: They give you a stable platform to shoot from, define your camera's point of view and are worth their weight in gold in the beautifully murky predawn light when you don't have a prayer of holding your lenses steady.

Perhaps this is not the best use of a tripod. Tripods are stablest when they are set up firmly on the ground.

    Buy a good tripod—a name brand. The reputable manufacturers often give you a lifetime warranty.

**underexposure.** An effect achieved when there is not enough light in a photo. The opposite of overexposure. Measured underexposure (like measured overexposure) can be useful, producing a desired, calculated effect. Serious underexposure produces a muddy file, dark and without sharp detail.

**view camera.** This is a bulky camera with an accordionlike attachment between the lens and the viewfinder, capable of producing truly grandiose imagery. The historically significant view camera has long been associated with Ansel Adams types who own pickup trucks, supersturdy tripods and constitutions that allow them to get up very early in the morning and set out for places like Yosemite National Park, where, if you get in their way with your quick-as-a-wink digital camera, you will hear about it.

**viewfinder.** You look through this when you shoot. The more expensive camera models have 100 percent viewfinders, meaning that what you see is what you get. Other models don't show the whole frame, perhaps about 95 percent or so of it. This can lead to surprises later in the digital darkroom. So be careful when using your viewfinder.

**vignetting.** The term refers to a gradual darkening of your image at the corners and edges. There is no need to worry much about this with today's highly engineered lenses, but there are cameras out there, including certain panoramic cameras, that produce significant vignetting that needs to be corrected. One reason I tape my lens shades to the barrel of the lens in the proper position: If you are walking and you bump the shade out of its optimum position, a very visible vignette pattern at the edges of the frame could be the result. You will most likely shoot several frames before you notice the uneven shadows; if you have not experienced this before, you might think your camera is screwing up or is broken.

**white balance.** A process by which the photographer strives to "correct" lighting conditions so that colors appear lifelike whatever the type of light in which the photograph was made. Light has color, and different lights have different colors. Daylight has different color casts depending on time of day and atmospheric conditions. Artificial light also has particular color casts, such as fluorescent, which gives a distinct green tinge to images. With a digital camera, you can compensate for these different color casts by clicking a dial.

The camera's brain is fine-tuned and adaptive, so there is a white-balance feature called "auto" in most cameras. This means the machine itself will sense the environment it is looking at and try to return to you a pleasingly neutral result. This mode works fairly well in many scenarios, but not all. Experiment with white balance. Dialing in the "wrong" white balance in certain situations may give you interesting results—as has been discussed.

Also, if you are shooting raw files, you can change things up later in the computer. I have heard many times, "Hey, I'm shooting raw, it doesn't matter what white balance I use!" That's fair enough, but as with elements of composition, it usually pays to correct white balance in the field, arriving at the appropriate settings when you are out there with the camera in your hands. First, it will save you time: You won't have to make all those color shifts later in the computer. But more important: Being aware of light—its moods and colors, its qualities and intensities—is part and parcel of becoming a good shooter.

**wide-angle lens.** A lens with a relatively short focal length but an extended field of view. As we discussed at length in our section on lenses, wide-angles are essential, but dangerous, and can sometimes prove useful in situations that might surprise us, such as portraiture.

**zoom lens.** A lens with a variable focal length. There are, predictably, wide-angle and telephoto zooms, which cover essential focal lengths at either end of the scale. Both are pretty indispensable. The beauty of modern zooms is that many are so good and so efficient, you, the shooter can go out with just two lenses in your bag and feel covered for just about any situation.

# INDEX

## A

Adams, Ansel 9
aperture 13–14, 18–19, 22, 25, 36, 40, 42, 44, 62, 65, 84, 85, 88, 90, 91, 95, 98, 103, 106, 107, 112, 114, 117, 119, 121, 122, 124
aperture priority mode 37, 39–41, 44, 49, 102
Auto ISO 49
Avedon, Richard 9

## B

backdrop 50, 78, 80
background 37, 39, 40, 41, 51, 53, 64, 71, 72, 74, 77, 81, 88, 91, 98, 114, 106, 121, 137, 170, 189, 190, 206, 208, 209
background paper 76
Beauty Lite III rangefinder 142
Bernstein, Leonard 98–99
Biden, Joe 172–173
black-and-white photography 14, 67, 170–175
black card 64, 67
blurring 37, 125
bracketing 33, 67, 137
Brady, Mathew 218
brightness 168
Brooklyn Bridge 64, 66, 67
Brownie camera 9
burning and dodging 67

## C

cable release 48, 64, 66, 122
camera gear 233–235
camera holding 230–233
Canning, Anna 189
Cape Hatteras Lighthouse, North Carolina 196–198
center-weighted-metering mode 62
cityscape 29, 31, 39, 41
cloud cover 22, 28, 29, 33, 42, 61, 73, 153, 162, 164, 172, 196, 197
color 13–15, 22, 28, 29, 32, 50, 53, 61, 62, 64, 65, 153, 166, 175
    brightness of 156, 166, 168
    emotional impact of 14, 157, 160, 162, 169, 172–175
    hue 156, 159, 161, 168, 169
    saturated 28, 32, 51
    saturation 156, 162, 168
    temperature of 157, 158, 161
color palette 158, 160, 161, 162, 163
color temperature meter 61
color wheel 156–159, 161, 164, 165
composition 14, 15, 94–95, 178–179, 181, 188–189, 194, 198–201
    centered 199–201
    dynamic 202–205
    rules of 184–195
consecutive high 120, 126, 179, 194
contact sheet 179, 180

## D

darkroom 8, 9, 10, 67
depth of field 14, 37, 88–91, 95, 98, 103, 112, 114–117, 119, 120, 122–123, 125, 137, 208
digital age 67
distortion 100, 102, 103, 198, 206, 209
Diwali, the Festival of Lights 42
Domingo, Placido 81
DSLR 25, 36, 37, 39, 65, 68, 70
duct tape 11, 76

## E

Eastwood, Clint 27
Einstein, Albert 216
equipment 64, 74–77, 109, 110, 182, 194
exposure 13, 14, 18–19, 31, 33, 34–35, 36, 38,

39, 40, 44, 45, 48, 49, 51, 60, 64, 67, 107, 112, 124, 125, 137
   automatic  20–21
   long  47, 48, 49, 66, 67
   manual  22–25
   normal  34
   overexposure  13, 25, 33, 34, 35, 44, 65
   underexposure  13, 25, 32, 33, 34, 51, 53, 162
exposure value compensation  39, 40, 41, 44, 51, 69

**F**

fast glass  62, 107
field of view  86–87, 96, 112
fill card  30, 72, 76, 164
fill light  33, 77
film camera  48, 136
film photography  8, 9, 10, 18, 86, 112, 136
fireworks  64–67
flare  53, 76
flash  33, 65, 68–75, 80, 121, 153, 182, 226
   hot-shoe  70, 74, 226
flash card  64
flashlight  34, 58, 64, 68
Flickr  9
fluorescence  *See* light, fluorescent
f-number.  *See* f-stop
focal length  86–90, 105, 110, 114, 145
fog  45
foreground  14, 32, 39, 50, 51, 53, 55, 65, 66, 67, 88, 90, 91, 94, 95, 98, 100, 114, 137, 145, 170, 189, 190, 208
form  46, 53, 146–153
Forscher, Marty  230
Fourth of July  64, 67
frame  25, 37, 42, 44, 45, 95, 97, 98, 178
framing  44, 64–65, 95, 96, 104, 121, 134, 137, 140, 145, 178, 185, 199, 206
f-stop  8, 13, 15, 22, 36, 37, 39, 41, 44, 45, 49, 84, 85, 90, 91, 95, 107, 109, 117, 119, 122, 124, 125, 137, 208
   full stop  13, 25, 40, 124

**G**

gaffer tape  11, 67, 76
Giuliani, Rudy  78–79
Glenn, John  219
golden hours  27, 28, 134, 161, 164, 218
*Golf Digest*  78

**H**

Haas, Ernst  216
*Harry S. Truman*, USS  80–81
headlamp  64
Henson, Jim  207
high-key image  34–35
highlight  30–35, 56, 136, 144, 146, 167
histogram  34, 35
home studio  74–77
Hope Diamond, the  12

**I**

improvisation  48, 80, 110
Instamatic  9
ISO  13, 14, 15, 18–20, 22, 25, 49, 62, 67, 69, 112, 120, 121, 232

**K**

Kodachrome film  170

**L**

landscape  68, 92, 93, 95, 96, 190
LCD  34, 39
Leica M4  172
lens  14, 18, 36, 37, 44, 47, 48, 49, 62, 65, 70, 84–87, 145, 153
   fish-eye  100, 102–103
   macro  119, 121–123
   normal  80, 96, 110
   portrait-length  76, 80, 96
   superwide  100, 103
   telephoto  12, 14, 62, 64, 65, 90, 92–93, 104–113, 117, 145, 153, 194, 198, 201, 208, 223
   wide-angle  14, 80, 90, 92–96, 98, 101–102, 145, 153, 190, 194, 198, 206, 208, 209

wide-angle zoom 64
zoom 14, 65, 80, 93, 94, 107, 109, 145, 234
lens shade 53, 235
LIFE 12, 15, 55, 59, 81, 162, 175, 223
light 15, 42, 51, 73, 142, 146–153, 190, 225
artificial 51, 58–61
attributes of 14, 28
backlight 32, 34, 41, 69
bounced 72
bright 42, 44
candlelight 42–44
colored 47, 48, 58, 60, 62, 63
color of 13, 29, 69, 72, 150, 164
dappled 33
daylight 13, 28–29, 58, 60, 61, 107, 142, 150
diffused 29, 31, 73, 80, 148, 162
direction of 20, 29, 69, 161
fluorescent 13, 29, 58, 59, 60, 150
frontlight 33
hard 29, 30, 32, 41, 51, 131, 142, 146, 151, 153, 164
harsh 80, 164
incandescent 13, 58, 59
language of 28, 134, 153, 162, 166
low 13, 44, 46, 47, 48, 49, 153, 232
main 77
man-made 58
muted 32
quality of 28–29, 29, 69, 131, 137, 144, 190, 218
sidelight 33, 41, 56, 80, 131
sodium vapor 29
soft 29–31, 46, 56, 72, 73, 131, 148, 151, 153, 164, 170
spotlight 21, 62, 63
sunlight 13, 19, 21, 27–33, 42, 53, 58, 147, 150, 153, 162, 164, 165
theater 21, 62–63
tungsten 13, 29, 58
window 21, 31, 56, 60, 73
lighthouse 196–198
light shaper 75, 77
light stand 76, 80

Lincoln, Abraham 218
Loengard, John 175
long glass. *See* lens, telephoto
low-key image 34–35

**M**

macro photography 14, 84, 89, 90, 118–123
Macy's 162, 165
*Madame Butterfly* 62, 63
manual mode 22–25, 36, 39, 65, 85, 107
McCullin, Don 230
McGwire, Mark 105
metadata 66
meter 34, 35, 36, 37, 39, 40, 42, 44, 51, 53
metering mode 34, 44
Michelangelo 97
middle ground 137, 189, 190
mirror bounce 120
Moab, Utah 23, 24, 50, 93
monopod 109
Monument Valley, Utah 18, 19, 20, 21
motion, framing of 124–127
Muppets 206–207

**N**

*National Geographic* magazine 27, 110, 134, 150
National Geographic Society 27
Nauset Light, Massachusetts 197–198
Niépce, Nicéphore 19
nightscape 31
noise 49, 67

**O**

ORBIS Flying Eye Hospital 56
*Othello* 81

**P**

panning 125
pattern 14, 119, 131, 138–145
*People* magazine 170, 171
Pfeiffer, Michelle 12
Photoshop 136, 178
photo studio 78, 81

P mode  12, 19, 21, 22, 25, 36, 45, 49, 107
portrait  8, 29, 30, 31, 34–35, 37, 42, 44, 75, 76,
        80, 92, 96, 114–117, 118, 134, 137, 190,
        210–219, 223
    classic  15
    environmental  15, 92, 97–99, 220–221
    group  15, 37, 92, 224–227
    hero  218
post-processing  180
preparation  27, 62, 64, 112, 121, 126, 151, 175,
        182, 190, 223
Prince Paul  173–175
push-plunger  48

R

rain gear  64
reflector  30, 164
reflector board  65, 72
Ringling Bros. circus  173
Rule of Thirds  15, 185–188, 190,
        199, 201

S

sand  30, 131
seamless paper  76, 78
selective sharpness  114
sharpness  13, 36, 39, 48, 88, 91, 110, 112, 114,
        117, 125, 137
shutter priority mode  37, 41, 49
shutter speed  13, 14, 18, 19, 22, 25, 27, 31, 36,
        37, 39, 40, 41, 44, 47, 48, 49, 62, 67, 85,
        107, 110, 112, 120, 124–125, 126, 137
silhouette  21, 32, 51, 53, 54, 65, 146, 203
Simon, Carly  170–172

snow  30, 45
spectrum  29, 61
speed light  70, 71, 72, 73, 75, 76, 77
spot metering  44, 45, 62
Stolley, Dick  170
street photography  233
sunrise  26, 27, 28, 32, 50, 51, 134, 146, 147, 153,
        161, 164, 218
sunset  27, 28, 31, 51, 53, 134, 164, 167, 218
Sydney Games  201

T

Tarahumara Indian tribe  161
texture  119, 130–137
theater lighting  167
Torre, Joe  78, 79
travel photography  233
tripod  27, 48, 64, 66, 76, 78, 109, 110, 112, 120,
        122, 134, 182
Tri-X film  170, 171
twilight  27

U

umbrella light  74, 76

V

viewfinder  15, 22, 25, 56, 68, 199

W

Weill, Andrew  169
white balance  13, 29, 31, 58, 59, 61, 62
wide glass. *See* lens, wide-angle
wildlife photography  108
Wright, Tricia  97